THE OLD WAY OF SEEING

THE OLD

For information about permission to reproduce selections
from this book, write to Permissions, Houghton Mifflin Company,
215 Park Avenue South, New York, New York 10003.

Library of Congress Cataloging-in-Publication Data
Hale, Jonathan.
 The old way of seeing / Jonathan Hale.
 p. cm.
 "A Richard Todd book."
 Includes bibliographical references and index.
 ISBN 0-395-60573-3
 ISBN 0-395-74010-X (pbk.)
 1. Signs and symbols in architecture. 2. Architecture —
Psychological aspects. I. Title.
NA2500.H25 1994 93-23722
720.'1'9 — dc20 CIP

RRD 10 9 8 7 6 5 4 3 2 1

Book Design by Robert Overholtzer

For information about this and other Houghton Mifflin trade and reference
books and multimedia products, visit The Bookstore at Houghton Mifflin
on the World Wide Web at http://www.hmco.com/trade/.

Excerpts from *Frank Lloyd Wright Speaking*, copyright © Caedmon, are
reprinted by permission of HarperCollins Publishers, Inc. All rights reserved.
Excerpts from *Drawing on the Right Side of the Brain*, by Betty Edwards,
copyright © 1979, 1989 by Betty Edwards, are reprinted by permission of
The Putnam Publishing Group. The passage from Klaus Hoppe, "Psycho-
analysis, Hemispheric Specialization and Creativity," *Journal of the American
Academy of Psychoanalysis* 17 (2), Summer 1989, is reprinted by permission.

JONATHAN HALE

WAY OF SEEING

A Richard Todd Book

HOUGHTON MIFFLIN COMPANY

Boston · New York 1994

To my teachers

CONTENTS

ILLUSTRATIONS

THE OLD WAY OF SEEING

1

Light and Shade, Walls and Space

There was a time in our past when one could walk down any street and be surrounded by harmonious buildings. Such a street wasn't perfect, it wasn't necessarily even pretty, but it was alive. The old buildings smiled, while our new buildings are faceless. The old buildings sang, while the buildings of our age have no music in them.

The designers of the past succeeded easily where most today fail because they saw something different when they looked at a building. They saw a pattern in light and shade. When they let pattern guide them, they opened their ability to make forms of rich complexity. The forms they made began to dance.

About a hundred and sixty years ago, early in the Victorian age, the old way of seeing began to go out of American design. With it went the magic, and with the magic went the old feeling of being in a real place. Only a few specialists retained the creative gift that had once been commonplace; a few scholars studied and preserved the ancient principles.

We live now in the world Victorian inventors dreamed of, the world of flying machines, automobiles, and hundred-story buildings. But unlike the Victorians, or even the Americans of forty years ago, we are jaded; we disbelieve their dream. We are far from thrilled at the prospect of the next big new building; we do not believe the latest style is the real thing at last. What is our dream? It is the dream of a magic world, a real world that comes alive.

The difference between our age and the past is in our way of seeing. Everywhere in the buildings of the past is relationship among parts: contrast, tension, balance. Compare the buildings of today and we see no such patterns. We see fragmentation, mismatched systems, uncertainty. This disintegration tends to produce not ugliness so much as dullness, and an impression of unreality.

The principles that underlie harmonious design are found everywhere and in every time before our own; they are the historic norm. They are the same in the eighteenth-century houses of Newburyport, Massachusetts, in the buildings of old Japan, in Italian villages, in the cathedrals of France, in the ruins of the Yucatán. The same kinds of patterns organize Frank Lloyd Wright's Robie House and Michelangelo's Capitol. The disharmony we see around us is the exception.

If a building makes us light up, it is not because we see order; any row of file cabinets is ordered. What we recognize and love is the same kind of pattern we see in every face, the pattern of our own life form. The same principles apply to buildings that apply to mollusks, birds, or trees. Architecture is the play of patterns derived from nature and ourselves.

To design harmoniously is a natural ability. There may be a few people who really cannot design, and there are some who can become great masters. Like speech, design requires great skill; and we are meant to be very good at it.

Design is play. The geometric elements of a building are the mate-

rial the designer plays with. Design is intuitive. But intuition follows natural laws. To design intuitively is not to lose control but to guide unconsciously. It is safe to turn the design process over to intuition. In a way it is unsafe not to, for without intuition the result is anomie, "therelessness." Intuition is the practical way to design patterns, and what we call intellect is the practical way to write specifications or arrange for fire egress. Intuition is innate judgment.

To make a design come alive through play, you shift your idea of what a building is, to see that, as Le Corbusier said, "The elements of architecture are light and shade, walls and space."

Intuition is not raw feeling. When you turn design over to intuition, you imbue the design with a system of proportions. Proportion, how one shape relates to another, is at the center of the old way of seeing. Mastery of proportion demonstrates a kind of judgment that goes far beyond what your "practical" side knows how to do. In a sense, using intuition is far *more* practical than any other method of design. Intellect calculates effect, intuition organizes shapes. Effect has its place; function has its place; keeping the rain out has its place. But we are too good at keeping the rain out; it is almost the only thing we do. The goal of design is not to find the correct proportions; the goal is to express life. It is not necessary, it can be counterproductive, to try to *be* lively, interesting, mysterious. To make a building that comes alive, it is, above all, necessary to play among the patterns.

Intuition makes contact with nature, without sentimentality or understanding, without praise or worry. Keep it light! says intellect. But it isn't always light. Sometimes it's dark. Sometimes it's heavy. Keep it all, says intuition.

When my first client said to me, "All architects have their heads in the clouds," I resented the remark, which is to say I heard it as he meant it, as negative. But I have since come to see that it is fine for architects to have their heads in the clouds, so long as they have their

feet on the ground. Maybe some of the time they should have their feet in the clouds, too. I think society has need of more visionaries.

It is a function of buildings to unite the visionary and the practical. To be visionary doesn't mean to fly after the nearest whim. For the designer, "vision" is a sense of how it will *be* to be there: what is this place?

If you don't have a vision, if you stay down too close to earth all the time, then you can't see where you are — and the term is no longer strictly a metaphor, for we all carry the image of the earth seen from space. We all have seen where we are, and it is our job to come to terms with it. When we get our heads up in the clouds, following our intuition, we can create the sense of reality. That seems paradoxical, but only because we are unaccustomed to respecting intuition. That is where we get the power to create places that are worthy of the place we really are in.

But most of the time, the designer's feet belong on the ground; and that means, among other things, that each building need not look like nothing else ever built. Novelty, expressionism, bizarrerie can be quite wonderful, but it is possible to design buildings that look like buildings, that express how they are used and how the materials are put together and that at the same time embody the inner vision. Vision doesn't have to be sweeping. The biggest mistake designers make in our time is to think that design is outside of everyday, normal life. Even greatness is not outside of daily life.

In America we don't encourage vision. We have lists of things we want, things we expect, things we don't want; and we have plans for how to get or get rid of them. We have methodologies for creating the sense of home, the sense of community. But the harder we try, the less we hear the old laughter.

The age that is passing was an era of problems and solutions; the sense of place was one problem to be solved. Intuition was outside the

equation. If times have changed enough, it will be easy to reintegrate intuition into our daily lives, and so recapture the old way of seeing. We are no longer distracted from our sense of loss by a belief in inevitable progress. Now that we have built the world the nineteenth century imagined, we notice the pain of what is missing. It may be that the hardest part has been waking up to a world we have made so cold, so dangerous.

A great building can give us the same exhilaration we experience in a natural landscape. We expect that of great buildings; but we tend to forget that a townscape of ordinary buildings, embodying the same principles, can also exhilarate us — exhilarate, and make us feel we belong.

In a townscape of disharmonious buildings, such as is common today, we feel no mystery, no promise. We are not intrigued; there is nothing to explore. When we walk among our buildings, we give our attention to signs and symbols, comfort and utility. The average street, the daily landscape, becomes more and more bleak or foolish or menacing.

When we visit the old towns, when we go into an ancient cathedral, when we see a masterpiece by a twentieth-century architect, we notice something most of our buildings lack. As we look at these places we know something is absent from the everyday buildings of our time — the suburban house, the office building, the mall. And we accept this lack. We may complain about it, but in the end, we don't expect our buildings to have that spark we see in the buildings of the past. Theorists tell us we should accept the "Ugly and Ordinary" building. We assume there must be an unbridgeable gap between what our age builds and what was once produced with a light touch, as a matter of course. But there were once, and there can be again, interesting, even magical, ordinary buildings.

Not very far back, as recently as two lifetimes ago, virtually all buildings were designed to common visual principles derived from natural forms and supported by a long tradition of geometry and measure. That tradition was a starting point. Most design today works without such a starting point, and so tends to go nowhere.

Play created the beauty of the old traditions. Even the designers of the formal Georgian style played a game of nuance that brought their houses alive in the same way the subtle widening of an eye, the tilt of a brow, animates a face.

Today we have lost the old traditions. We replicate old styles only as symbols to invoke the lost magic. But no matter how authentic the details or how "good" the proportions, all the life of a design must come straight out of the designer. The rules are in us. The designer's intuition resonates with what we all know.

The intuitive way of seeing was not consciously taught or followed. It was not a secret — although mystical meanings ascribed to some of the ancient ratios were held secret. It was not tradition of style or structure that made it possible for a building to come alive. The old way of seeing came naturally to any builder who assumed that a building was a pattern.

When, a hundred and sixty years ago, the old way of seeing began to go out of architecture, there was no way to explain the problem. That something was missing seems to have been clear enough to many observers at the time. It seemed design talent had drained out of the culture. How could this be? Why were we now unwelcome among our own buildings?

Solutions proliferated: what architecture needed was to be rich, or simple, or correct, or functional. The Doric style was forthright and democratic; but the innocent Gothic was more pious and mysterious; but the Roman was stronger. Several styles often showed up on a single façade. The twentieth century created a new manner of

designing meant to rise above region, time, or style — the International Style.

The attempts to bring design back to life were by no means all failures. In the late nineteenth century the Arts and Crafts movement, for example, regained the old feeling. Machines had denatured design; handcrafting could revitalize it. Talented artists created truly beautiful objects and buildings. Sixty years later, other talented artists of the Modern movement embraced the machine and produced other beautiful designs. What remained consistent was that beauty had become the province of specialists. For a hundred and sixty years, designers have scrambled for new styles, methods, systems, that would put the life back into buildings. Great ones have achieved it, but they are gifted; lesser designers are expected to make dull buildings.

Building composition is thought to be a rare and special art, and those who have the old vision often live up to that expectation; their work is deliberately eccentric and elite. But the obligation to be always new, as if strangeness were the same as freshness, is a burden. The point of view that leaves out composition is the same way of seeing that puts the designer outside the practical world — on a pedestal or in a garret. Within this frame of reference, preoccupation with form looks artificial; form, if it is perceived at all, is icing on the cake. The designer is seen to be either a great artist, and therefore beyond understanding, or effete. Either way the designer is outside the concerns of the real world. Many of our most talented designers have no influence beyond a small coterie of followers. If there are arts that can flourish on the edges of society, architecture is not one of them. Lurching from one style to another, under pressure to be creative, which means different, but at the same time practical, economical, contextual, even the best architects have a hard time producing places one would really want to be in.

The broadest purpose of a building designed in the intuitive way

was simply to *be*. Today every aspect of a building is *for* or *about* something else. It is a product of intellect. Intellect, not intuition, dominates design at every level, from the routine commercialism of the tract house to the thousand-page building code to the hermetic erudition of the academic journal.

Intellect has its place. But we do not know when to stop analyzing. Although I learned many things in architecture school, I have never forgotten that Le Corbusier, Frank Lloyd Wright, Mies van der Rohe, did not go to architecture school. Architectural education needs more of what they knew.

But I do enjoy the analytical process of uncovering the hidden patterns in buildings, the regulating lines that connect key points. To me, they are the secrets of what a building is. It is a pleasure to make visible and follow the diagonals until they make a triangle that aligns beautifully several different parts of a building; or to reveal a great circle that happens to touch on three or four key elements — and all these connections invisible, *almost* invisible. The eye can almost put them in. The underlying patterns are just beyond consciousness, like the intuition that created the design in the first place. To search out the patterns is like seeing a photographic print come up in a darkroom. It is always a little new, a little exciting, to see the invisible suddenly rise to the surface, to see the confirmation of one's own intuitive pleasure in the design: Oh, yes, this is why it works!

At the core of this book is what I call its *Premise*. It is a theory, a central guess. There is evidence for a good deal of what I propose. But at certain points the evidence peters out, and I am left with descriptions of experiences that may or may not be agreed upon: the "feeling of place," the "magic" or "aliveness" of a building, "intuition." Some of what I say will never be provable; but also the study of the intuitive visual mind is new and incomplete; much more may yet be defined

than we now know. And I believe we already know enough to bring architecture back to life.

PREMISE
- An intuitive sense of form is available to all designers.
- The innate design sense becomes usable when the designer perceives the building to be a pattern of light and shade.
- When the building is designed as a composition of related forms, it is informed by a system of proportions.
- The designer's knowledge of this system may be conscious or unconscious.
- The essential step is the decision to see the building as a visual pattern.
- A simple but fundamental shift in the paradigm for "building" can give direct access to these universal principles of form.

This is a book about vision; and it is a book about magic — magic in everyday life, magic in the things that we make and in the places that we make. This is not a recipe book or a step-by-step guide. I cannot promise that everyone who reads this book will "have" the old way of seeing. It is a description of a way of seeing and its implications: what happens when you look at buildings as light and shade, walls and space; what happens when you don't.

> For although it would be foolish to hope that a purification of the sense of sight can liberate and save us, any more than anything else is likely to, it might nevertheless do much in restoring us toward sanity, goodwill, calm, acceptance and joy. Goethe wrote that it is good to think, better to look and think, best to look without thinking.
> — JAMES AGEE, *A Way of Seeing*

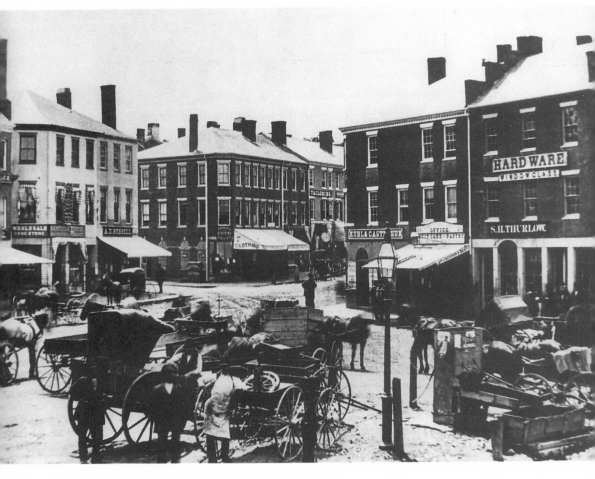

When Newburyport's commercial center burned to the ground in 1811, it was rebuilt all at one time. In this 1860s view, the streetscape is joyfully alive. The buildings use the same proportioning system as well as the same materials, yet each one is different. Here a window is left out, there an arch penetrates the lintel line; some buildings are painted, others are left natural; there are awnings, signs, lamps, a clock, a barber pole.

2

Ordinary Places

Newburyport, Massachusetts

Everywhere one goes in Newburyport, one senses there are discoveries to be made — inside each house or around each corner. There is order, but what one experiences is not discipline but pleasure, curiosity. One is comfortable among the houses. Many of them could be called Colonial, but they are different from what is built today under that name, not so symmetrical, less neat; and they have been added to, often in styles quite different from the original. They are mixed together, buildings of different eras, uses, materials. A brick house of the 1850s stands next to a four-square wooden house of 1790, which is across the street from a 1750s gambrel with an 1840s bay window. But, always, every element holds to principle, so that the place feels strong, and does not disintegrate into blandness.

In 1800, Newburyport was a thriving city, but by 1875 it had been passed by. For a hundred years almost nothing was added or taken

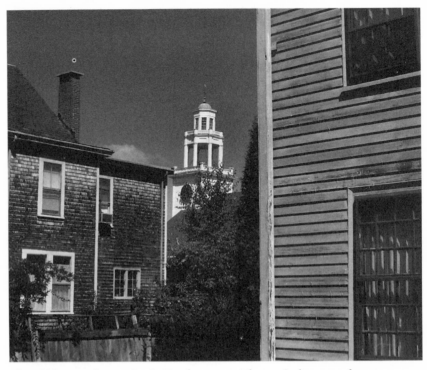

The old harmonies survive in Newburyport. The eye is drawn to the tower; the houses are a hundred and fifty years apart, and the tower is of 1848 atop a church of 1756, hidden beyond the trees.

away; the town survived in genteel shabbiness, until a renewal project fixed it up during the 1970s. Newburyport today preserves the old spirit of harmony, from the time before it was lost to everyday American architecture.

At the center of town is Market Square, the commercial core. The square differs from the rest of the town in one striking way: all of its buildings are of the same materials and are built in the same style and to the same height. This is because the city's commercial center burned to the ground in 1811 and was rebuilt all at one time. Within the uniformity of size and style, each building manages to be a little different. Each is a variation on a theme.

The rebuilders of Newburyport in 1811 did not stay up nights worrying about how to avoid visual monotony in their new business center, any more than others in their town had worried about "context" when they built their homes in the latest style. If Newburyport stood out in its day, it was for its commercial success, and not for any unusual beauty; it looked very much like other prosperous towns. What sets it apart today is its completeness; everywhere in Newburyport the old way of seeing predominates.

Jaffrey, New Hampshire

In the town of Jaffrey, there is a big white eighteenth-century meetinghouse. It is grandly spartan in the New England way. Reticently in the background, behind trees and telephone wires, is a smaller church of brick. It is much the more interesting.

The brick church is a mixture of power and weakness: awkward and secretive and brash and cheerful. The church was built in 1831, when architecture was on the edge, about to lose its grasp of the old way of seeing. Maybe the date explains the building's failings and its attraction. It has an ungainly Gotho-Palladian tower — you can understand why people ran wires in front of it. But from close up, you don't see the tower; close up, the façade is sweet and strong and subtle.

At the center of the façade two windows are set close together under a half-circle fan. They look almost wrong, and yet they fit. On a photo, I draw diagonals through the windows, and suddenly two equilateral triangles appear, the point of one balanced on the tip of the other. The base of the bigger triangle is a great stone step (it took fourteen oxen to haul it over the shoulder of Mount Monadnock).

The pattern is so striking it appears to have almost a mystic signifi-

The First Church, Congregational, in Jaffrey, New Hampshire, built in 1831. The pattern of regulating lines is so striking it appears to have almost a mystic significance. Was the pattern purely intuitive and unconscious? Was it a symbol legible to initiates? Whether the designer knew he was creating the pattern is less important than that the pattern is there.

cance. Was the pattern purely intuitive and unconscious? Was it a symbol legible to initiates? It matters less which came first, the pattern or the designer's knowledge of it, than that the pattern is there. It is what makes the building come alive; it is the reason people love it: "Never was there a building which down through the decades has received more tender loving care than the brick meeting house," says a local history.

But, one wants to know, were these hidden lines ever meant to be seen? Is it a deliberate geometric message? In a medieval church, it would have been: every dimension and proportion having its meaning. No, this energetic, simple, vibrant geometry is as simple as a child's blocks . . . And yet one is reminded of the Masonic pyramid symbol, the eye-pyramid on the dollar bill.

The designer was a thirty-one-year-old itinerant builder, Aaron Howland. He knew what he was doing when he made those patterns. Did he know he knew? He *must* have known he was composing. The geometry is too clear to be entirely accidental. He knew about geometry, as any builder did, in 1831. But, one remembers, the regulating lines are invisible. They are only hinted at in the upper fan in the white wood gable, formed by the chord of the upper circle and triangle, and in the great granite step. What is beyond doubt is the pattern itself, the pleasure of organization, color, texture; it is very much like a piece of music.

The Jonathan Stone House

On a suburban street in Belmont, Massachusetts, is a house with a certain charm and grace about it. The house is very simple, just a lot of windows and a couple of doors. It was built around 1775 for Jonathan Stone. Surrounding the Stone House are 1920s Neo-Colonials, still prim and perfect after more than sixty years. But it is the old house we look at. Next to it the twentieth-century houses are bland and awkward. They don't have the old smile.

Underlying the design of the eighteenth-century house was a system of proportions. It guided the location of the windows and doors, the dimensions of the walls, the line of the cornice, providing a discipline so strong that to leave out certain elements merely enlivened the

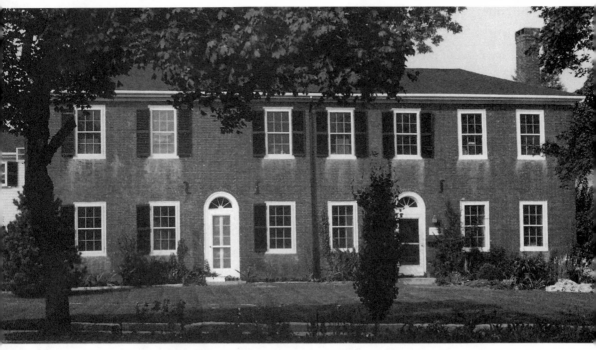

The Jonathan Stone House in Belmont, Massachusetts, built about 1775, and a Neo-Colonial house next to it. In the midst of suburban Belmont, the simple 1775 brick box is magnetic, while the 1920s Neo-Colonial next door is routine. The old building is a geometric pattern; the newer house is a system, not of shapes, but of emblems, whose purpose is to evoke certain reactions.

effect. The house, however simple, was designed as a form, a pattern in light and shade. By contrast, the façades of its neighbors are group-ings of standard Coloniana: decorative shutters, eagles over the front door. The builder of the old house was not an artist struggling to ex-press life in his design; the warmth and vigor of his work are natural results of his way of seeing. In 1775, to see that way was a matter of course. The harmony of the eighteenth-century house was common-place.

The house appears to be missing a window above the door on the left, one bay out of the eight. But nothing is missing. The façade is re-ally a double composition, a five-bay house on the right and a two-

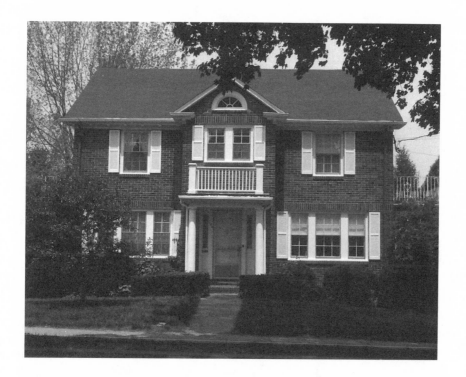

bay addition on the left. Cover the left side at the left door, and you see a conventional five-bay house. The left door looks like a symmetrical mirror of the right door, but it is not; it is the dividing line between the two parts of the house. The addition must have been made close to the time of original construction, as the brick on both sides matches. Perhaps it was even built at the same time, but in the pattern the left side is a "wing," added on. It is a joke: the symmetrical façade that isn't.

When you start leading the eye this way, involving it in a play of conundrums and patterns, the eye expects to go farther; it wants more to look at: so the streaks and blotches become fun, the brick's warm red color and slight unevenness is satisfying. It isn't just the interest of shapes and colors that attracts the eye, it is the contrast between the order of the pattern and the disorder of the stains and flaws.

The years haven't mellowed the Neo-Colonial houses; they have no

patina and never will. The Neo-Colonials "age" their walls with broken bricks or uneven colors in order to look historic and give some texture. But their way of building isn't a game or a gift, and the eye is disappointed.

The owner of the Jonathan Stone House makes changes and repairs from season to season. Sometimes the shutters are on, sometimes they are off, sometimes, for months at a time, half the shutters will be missing, sometimes a solid door covers the French door on the left. The house benefits from these variations; they all fit within its pattern, so they add interest.

On the adjoining lot is a Neo-Colonial, circa 1925. Try leaving half the shutters off *it!* Its red brick is variegated to imitate patina. It has the six-over-six sash of its neighbor, and at the top is a fanlight almost identical to the one that is the focus of the Stone House. But no pattern radiates from it; this fanlight is just a decal. Lines drawn from it through the upstairs window corners do not connect with key points on the lower windows. Nothing joins the fanlight to the upper and lower windows.

As in almost any house, there *is* an urge toward composition, even if form is no longer the guiding force. Regulating lines firmly tie the upper windows at right and left to the triple windows below, and to the front door. But other major elements are left floating. The quirks and mistakes and omissions of this façade do not add intrigue, as they do in the Stone House, because they are not contained within any overall pattern. Effect comes first. Where the windows of the much larger Stone House are all one size, the Neo-Colonial has four window sizes. A tremendous weight of detail — sidelights, a columned portico with a balustrade, the fanlight in a pediment — tells one to look at the front door. But all these devices make no pattern, so the entry is dull. One is much more intrigued to see what might be inside the simpler door, down the street.

Funny that people should call the style "Colonial." The last thing America wanted to be in 1775 was colonial. But really, "Colonial" is a meaningless word; it is a name and a style meant to soothe by evoking old reassuring emblems.

Aurora, New York

On the main street of Aurora, a bank and a post office stand about a hundred feet from each other. The bank was built around 1850. It has the attenuated, overscaled windows of its time, but it is designed in the old way; the façade is a pattern based on the diagonals of the gable. You feel pleased to be near such a building; you find yourself looking its way; you recognize the neighborhood by its cheerful face.

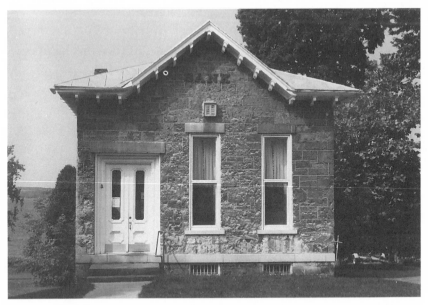

The little bank (circa 1850) is a hundred feet, and a hundred and twenty-five years, from the post office. It is designed as a pattern, in the old way.

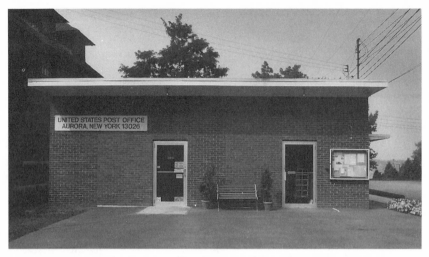

In Aurora, New York, the post office (circa 1975) has almost no pattern. You walk right by as if it weren't there. Its blankness makes the bench and potted plants look surreal.

The post office is from around 1975. I stayed next door to the building for three days before I noticed it at all. It is almost devoid of pattern. A bench and two potted plants float in front of this blankness. We are surrounded by such buildings. Reality has faded gradually over the last century and a half, so that now only smudges and patches remain. Only occasionally, one can still see the old smile, disembodied.

Belmont Centre

> For the first time in human history, people are systematically building meaningless places.
> — EUGENE VICTOR WALTER, *Placeways*

There is almost no one on the street. A woman polishing her door keeps her back to me. A mailman looks through me. I notice a furtive

face as I pass another door. I am photographing the Neo-Colonial houses of Belmont. Every house, every hedge, is perfect. Only the shadows are wrong, somehow negative — empty holes in an empty landscape. The sunlight is harsh, the shadows are threatening. I wonder if someone might call the police, but I dismiss the thought: only in Beverly Hills. But no, as I get back to my car, two policemen pull up in a squad car and ask me what I am doing walking around Belmont with a camera. The station has received two calls.

I go on to another part of Belmont — warning the police, this time — to photograph the eighteenth-century Jonathan Stone House. The gardener smiles and tells me to take all the pictures I want. A neighbor greets me; another invites me in. Why are these people friendly, when others in the same sort of neighborhood had set the police on me ten minutes before? Not until that night do I realize that it is because the old house is beautiful and the newer houses are not. There had been an obvious reason to photograph the old house and an equally obvious reason not to photograph the other houses. The owners knew their houses were dull, designed to be undistinguished in every way: not grossly awkward, not too small, not too large. The owners assumed I could be up to no good, and in a way they were right. I was there to show what was wrong with their houses.

In such a streetscape, nature is just so much decor. The expression of intuition, of human nature, is banished. What the houses express is control. Design is turned to a single purpose, to prevent the unexpected. What the houses omit is life.

"Normalcy" came to the American suburb after the First World War, and it stayed. "Normalcy" — the word is just right for that ersatz architecture, the "little white house in Wellesley Hills" of Leonard Bernstein's catty song from *Trouble in Tahiti*. Each house is a picture of a house, tidy and acceptable, but not quite "there." Everything is the same, even though each house is a little different from its neighbors. To be identical would be to break the spell; to be an

accurate rendition of a real place, a town must make some show of variety.

The houses seem all alike because they are illegible as compositions. The incomplete, unrecognizable patterns, up and down every street, become a kind of noise; and the babble of symbolic messages becomes another. Visual noise, and the absence of visual play, causes the sense of empty sameness. The problem is not that the houses are too similar in style or shape; the architecture of ancient tradition is often highly uniform. The houses of eighteenth-century Belmont were more alike than those of twentieth-century Belmont, and they were plainer, as well.

The Neo-Colonial houses are the landscape, but we do not see in them the patterns we know to expect in a living landscape. They are not altogether disorganized, but their patterns are deformed and compromised. Compared to the forms of art or nature or the buildings of former times, they are like freaks. Conflicting geometric forces vie with each other for control of a façade, like the jealous stepsisters in *Cinderella:* "No, me! No, me!" Three unrelated sets of geometric rules will apply to windows on a wall with only five windows in it. A major focal point, a "bull's-eye" window, say, will float alone, while powerful regulating lines converge on a blank area three feet away from it. The disconnected patterns are like a series of sentences that don't form a paragraph.

The eighteenth-century house is the imprint of its builder's mind; it comes from his own bodily perception. The harmonies of its walls derive from the proportions of the person who designed it. The builder shows himself to us in his house. Does it reveal too much? Is the designer too exposed in such a process of design? Is that why modern builders shy away from the old way of seeing?

The builders of modern Belmont show me only masks, and that implies fear. They seem to have some weakness to hide, something to

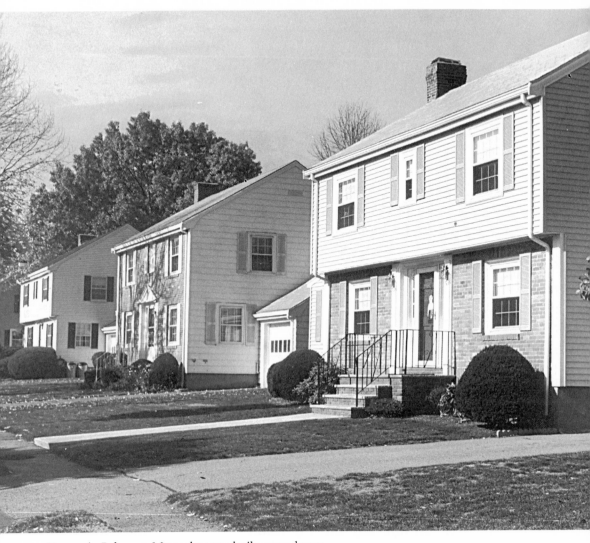

Houses in Belmont, Massachusetts, built around 1970.

protect. The twentieth-century houses express no physical image of their designers' minds or bodies — or of *my* mind or body. The Neo-Colonial wants something from me — is it approval? It is full of messages about prosperity and propriety and the American Way, but, in

the end, the messages are just patter. The point is simply that I am being talked at. There is not one moment when these houses just *are*. The landscape is always "on." Quiet Belmont is a high-stress town.

What is revealed in the Stone House, what is concealed in the new houses, is the human mental and bodily pattern; its tension and its imperfection, the harmony, not just within the house but with ourselves. The old house is as highly conventional as the new ones, yet the sense of the person who made it comes through. As a form, the old house reveals a simple sort of mastery. It has only the formality of its street façade for a mask — the traditional symmetries — and even the mask is subsumed in transparent patterns, and in those what we recognize is strength.

There is a kind of desolation in much of the American landscape — built and natural — as many visiting Europeans have commented. We are too used to it to notice most of the time, until an artist like Edward Hopper points it out. But the desolation Hopper catches has an aura of sadness, an ache, a premonition of death; it is painful and it is real. In the blackness of Hopper's shadows are mysteries of life and death. Hopper stays away from the faceless suburb. Artists who do go there find it bizarre. Diane Arbus, who was attracted to the grotesque, was the photographer of suburbia, as Susan Sontag has said. The artist Joseph Cornell seems to have been at home in such surreality; he lived in a neighborhood of breathtaking blandness, on Utopia Parkway — a suitably surreal name. I can't come to terms with such emptiness; I need to be away from it. I avoid such neighborhoods; their unreality gives me a sense of anxiety in the pit of my stomach. Why go to a place that is nowhere?

Is there a cure for suburbia? If seeing buildings as compositions again becomes the norm, people will reject as monstrosities what they now think of as normal. But the shift, when it happens, may be easy enough. One will not change oneself; one will change, instead, what

one thinks one is looking at. The medicine will be a hammer and saw. It won't be necessary to change the style of the house, but only to re-arrange a window here and there, move a door, add some trim. Belmont could be brought alive. The result won't be Fallingwater, but it will be a house you can look at and even, perhaps, photograph.

One might think that the people of Belmont deliberately chose poor design. But the lines of their clothing are far better than the lines of their houses. And in the driveways of those houses are truly elegant Tauruses, Audis, BMWs.

People do have innate standards, but most do not know how to get at them. It is hard for people to separate the important from the unimportant, the primary geometry from the secondary applied symbol, if they do not know about pattern. When there is no play of form, people just look at other things, and they simply do not realize that the pattern is not there. But they do know *something* is missing from their houses, as my walk in Belmont showed. The process of making pattern is unconscious, but the *fact* of pattern has to be made conscious, so that people can know what to choose. In this commercial culture, you can have any style, any effect you want — but you have to make the choice to have pattern.

Pattern is very simple. It is very easy. It is already there in us: we *want* to make patterns. The routine houses of suburbia are full of patterns, although they are incomplete. Pattern is the norm. Even now, even in our time, which seems so lost, pattern is still, under it all, the norm.

3

1830: The Loss of the Old Way of Seeing

There is a line of demarcation, a time when the old way of seeing began to be lost. The turning point for architecture was the decade of the 1820s. After 1830 the former sure touch started to waver; everyday architecture began to slip; and charm, pleasure in the thing itself — material, shape, shadow — were less often to be found. Buildings began to strike poses or else fall into routine. The poses could be very beautiful, and the routine — as in the endless repetition of factory bays — could have a power of its own, but the meaning of design had changed.

Before 1830 pattern dominated design. After that time, use — including the creation of effect — took over. Pattern is an end in itself. The creation of effect — whether it is "honesty," "reality," or "liveliness" — has a motive, to influence the observer.

The style that announced the new priority was the Greek Revival. Around 1830, giant columns began to show up on the fronts of houses. The pillars represented heroic democracy, a greatness of vi-

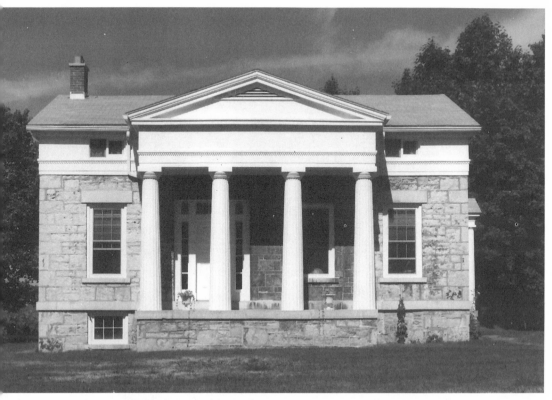

A Greek Revival building (1840) in Union Springs, New York. The new style puts symbol ahead of pattern. The mini-Parthenon front porch, representing heroic democracy, has become more important than the house itself. A column blocks the front door.

sion that many at the time felt was slipping away from America. The Greek Revival could be quite beautiful in its cool clarity of line and form. The shapes were grandly simple, and designers sometimes went to extremes to keep them so. Upstairs rooms were cast into shadow under the deep colonnades; windows might be made tiny or eliminated altogether in order not to disturb a cornice line. Jammed behind the unyielding simplicity of the façades were bedrooms and smoky kitchens, or counting rooms and tellers' wickets — the "Gre-

cian" vogue came first to commercial buildings. Proportion was not abandoned. A high elegance of line was sought: perfection. But the sheer size of the shapely forms could be disturbing. The "temple" stuck onto the front of a little house or shop was like an eighteenth-century entry porch suddenly inflated, often to take up the whole façade. The style was elegant, austere, and dramatic. It did not abandon the ancient play of shapes, but it was the first style to make message more important.

The Greek Revival swept across regions, traditions, and building types; it was the first national building style. Greek Revival houses were frequently called "end-houses" because their gable ends often faced the street in the aggressive stance generally reserved for public and commercial buildings during the previous century. Modest Greek Revival buildings sometimes dispensed with columns altogether and made do with corner pilasters. "Temple-fronts," people also called the houses; however, the immediate model for the Greek Revival house was not a temple, but a bank.

The building that started the vogue was the Second Bank of the United States in Philadelphia, designed by William Strickland in 1818 and completed in 1824. Other architects, such as Benjamin Latrobe, had designed Greek Revival buildings as early as 1798. But it was Strickland's building that set off the explosion. The leading advocate of the style was not the architect, however, but his client, Nicholas Biddle. Biddle made Greek architecture a personal cause. "The two great truths in the world are the Bible and Grecian architecture," he wrote. He was the patron of other conspicuous Greek Revival buildings. In order to preserve the lines of the temple of learning Biddle built for Girard College of Philadelphia in 1833, all the upper classrooms had to be lighted by skylights. Also in that year, Biddle encircled his wife's pre-existing mansion outside Philadelphia with white columns and crowned them, like his bank, with a Parthenonian pedi-

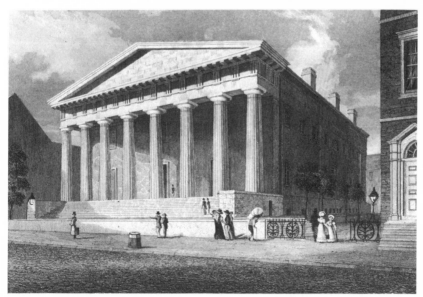

The Second Bank of the United States, Philadelphia, designed in 1818 by William Strickland, probably under instructions from Nicholas Biddle; it was completed in 1824.

This late-twentieth-century bank in Saratoga Springs, New York, is not meant to be seen for itself but only to evoke certain responses through visual codes.

ment. Thomas U. Walter, who later designed the U.S. Capitol dome, was the architect for both the mansion and the college building. The white columns stood for purity, and they also stood for power; they announced that power could *be* pure.

The Greek Revival opened the way to the multitude of styles that characterized the Victorian age. Each style was a way to produce a different group of effects. A building would try to evoke the *meaning* of domesticity or financial security or religion. There are so many beautifully proportioned Victorian buildings that I will not call them exceptions, but the trend away from harmony of line and shape began in Victorian times. "Victorian" was an era and an attitude rather than a particular style. The era was roughly 1830 until 1910 (Victoria reigned from 1837 to 1901). The attitude was to put effect first. Beauty or ugliness was not the issue; posing was the point. After 1830 architecture became self-conscious.

Two New England carpenter's handbooks, the first written in 1793, the second in 1834, show how the vision of everyday design changes. In 1793, there is still mystery in the geometry of architecture:

> The uses of Geometry are not confined to Carpentry and Architecture, but, in the various branches of the Mathematics, it opens and discovers to us their secrets. It teaches us to contemplate truths, to trace the chain of them, subtle and almost imperceptible as it frequently is, and to follow them to the utmost extent. [Peter Nicholson, *The Carpenter's New Guide*]

In 1834, the focus of design is no longer play but professionalism, not exploration but accuracy:

> If the builder attempts to apply the rules of Geometry to his art, without the knowledge of theory, his efforts will prove abortive; or should he at all succeed, yet his work would be void of proportion and in-

complete. It is only by a competent knowledge of this science, that the Architect can accomplish his work in a simple and elegant style; or the Artist so construct his lines as to be able to complete his design. [Chester Hills, *The Builder's Guide*]

In 1793 design is an adventure; geometry "discovers secrets," and it teaches us to "trace the chain" of "truths." In 1834, "it is only by a competent knowledge of this science, that the Architect can accomplish his work." Geometry is a set of rules that must be followed properly to produce a "complete design." Correctness has superseded inspiration. The designer in 1834 is, above all, careful to avoid making mistakes. It is typical of that frame of mind that he feels a sense of time pressure, a concern lest the design not be completed, while the 1793 designer delights to follow the possibilities "to the utmost extent."

In comparison to today's design, the average buildings of 1830 are superb. What carpenter's handbook today talks about geometry at all? Harmony, or, at least, elegance, was then still admired, and geometry was still important. But the 1834 author had lost the former self-trust, and the freedom it had given.

The two handbooks express only a change in point of view, not a change in construction method, or in the structure of the carpentry profession, although some changes were on the way. It was around 1834 that the "balloon frame" of standardized lightweight components, such as two-by-fours, was invented in Chicago; but there is not much chance Chester Hills had heard of the system at the time, because the balloon frame did not come east for another twenty years. And the new construction methods, when they did come, did not cause the change in point of view. Even today, carpentry is not far removed from the craft of 1793. Any builder who has access to the old way of seeing can adventure amongst the truths of geometry as Peter Nicholson did.

In 1829 Thomas Carlyle wrote, in *Signs of the Times,* "It is the Age of Machinery, in every outward and inward sense of that word. Wonder, indeed, is, on all hands, dying out. . . . What cannot be investigated and understood mechanically, cannot be investigated and understood at all." Carlyle was writing about England and Scotland, but what he said applied as well to America. Buildings became more literary and informational than visual, and reading became the mental process to perceive them. A hundred years after Carlyle, Lewis Mumford wrote, "What we cannot read we cannot see." Many architects after 1830 carried on the old way of seeing beneath screens of practicality or sentiment or erudition or professionalism. The generation after 1830 were the first professional architects in America. Biddle's protégé, Thomas Walter, was a founder of the American Institute of Architects. The new professionalism tended to separate visual thinking from daily life, but it also preserved the old way of seeing as a specialty. However, relatively few buildings — either before or after 1830 — were designed by architects, and in our age fewer still can be considered architecture as Le Corbusier defined it. Today, most buildings are not patterns in light and shade but images attached to functions.

Many observers were aware of what had been lost. Richard Upjohn, who designed New York's Trinity Church in 1839, wrote, "Might we not gain a valuable lesson while contemplating these works of our forefathers? . . . Will we not see by comparing them with the works of our own hands that their authors regarded the law of harmony between a building and its surroundings better than we do at the present day?"

For the first time, architecture, or much of it, came to be despised. James Fenimore Cooper in 1836 ridiculed the pomposity of the temple-houses: "[The] children trundling hoops before their doors, beef carried into their kitchens, and smoke issuing, moreover, from those unclassical objects' chimneys" belied the formality of the style.

Alexis de Tocqueville sneered at the "wooden palaces" he saw outside New York in 1831, and others made fun of what they called "the Greek mania" and "the Greek Temple disease."

The Greek Revival had largely run its course by 1850, but the changed way of seeing remained. On many houses, towers now took the place of the big porticos. There were Gothic towers, Italianate towers, Second Empire towers, Romanesque towers, Queen Anne towers. Mansard roofs were another way to make the grand gesture. When the effect was well done, as many times it was, the design might yet be harmonious, fascinating, and full of vigor. But pattern now was found under or around or behind symbol and story.

An old stereopticon photo of Lowell, Massachusetts, shows the Prescott Bank Building, when it was new, around 1865. It is High Victorian, not quite halfway in time between the beginnings of the Greek Revival in the 1820s and the Neo-Colonials of the 1920s. On either side of the bank are shuttered, somnolent houses, built only twenty years earlier but closer to the old way. The man lounging in the door in the photo is as tall as one of the windows of the neighboring older building, but the windows of the new building are much taller. The bank is more energetic than its neighbors, but something about its design is at once alarming and funny. The roof is seventeenth-century French, by way of Napoleon III — it is really a third-story wall tilted back to make a roof-effect; the dormers are more or less medieval; the columns are off-the-rack Renaissance.

The former easy discipline has cracked, but the building is not completely out of control. The cornice does hold to the line of its neighbor. More important, there are strong regulating lines — one pattern at human scale, and another, the dominant system, at the giant vertical scale of the high windows.

Why are those high windows — why is the whole building — a little frightening? Is it because the designer has dug up so many differ-

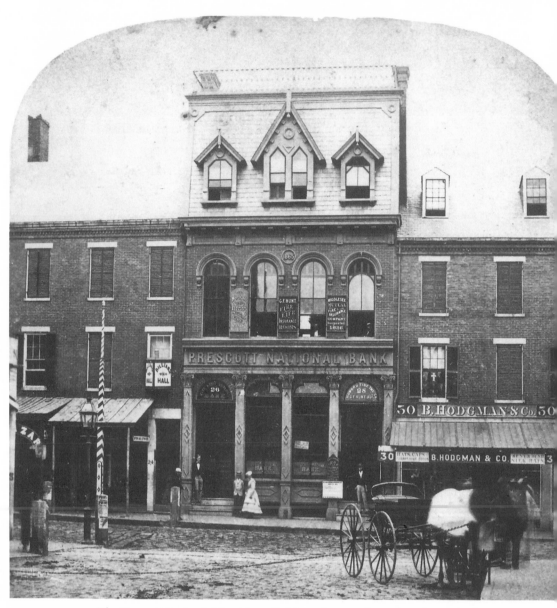

The Prescott Bank of 1865 at Lowell, Massachusetts, is a prima donna on its street; and that is allowable for a bank. However, it sings in four styles and two scales at once. Its aggressive indecision is disturbing and funny. But there is still a strong geometric pattern, so the sense of place is not lost.

ent styles? Or does it have more to do with the proportions, those windows squeezed and stretched out of relation to human size and shape?

But many Victorian buildings are very beautiful. On the main street of Newburyport a house of about 1860 sits upon a little hilltop. It has big square bay windows, a flouncy cupola, festoons of white-painted trim. It is, also, a composition of sure-handed integrity and richness, and it is a pleasure to look at. At the bottom of the same hill stands a big seventeenth-century house. It rambles interestingly; there is some mystery in its shadows. But it is dour — a very serious house. There is more of the age-old sparkle to its Victorian neighbor.

As for the numerous ugly buildings of the Victorian day, they could have done far worse than to look awkward or scary or strange. Nineteenth-century buildings were still, usually, "there." It might not be a "there" you would always want to be in, but it was a lot better than the "nowhere" the twentieth century was to build.

The Victorians did not *want* to produce hideous or fatuous or pompous buildings, any more than twentieth-century designers wanted to build deserts. The loss of harmony in architecture after 1830 was recognized immediately, but the idea that a particular state of consciousness was needed to design a harmonious building was not understood. When the paradigm for buildings shifted, there was no way to explain what had happened, because the earlier teaching of harmonious design had centered upon the rules of geometry, not upon a way of seeing. It was thought that those rules were only applied *to* design, not that they could come *from* the design process.

In the years leading up to 1830, there were hints of what was to come, sudden jumps into the new way of thinking. For example, the gridding of Manhattan began around 1810, amidst strong objections, as an 1893 history describes: "Irate landlords assailed the surveyors with dogs, hot water, cabbages, and other distressful methods."

The grid plan was an ancient system — the Greeks had used it — and it was not new to America: Philadelphia and Savannah were grid cities. But the New York plan was different. The grid was not an enclave within a natural topography. The map, with its letters and numbers, took notice neither of land nor of history — past or to come. The historian John Stilgoe writes, "The old reliance on natural edges and shapes passed; legislatures charged surveyors with creating a graph-paper-like skein of townships. . . . By 1820 the grid concept was permanently established in the national imagination."

The new plan seemed efficient, yet eighty years later the towers of Manhattan's financial district first sprouted not from the grid but from the old hodgepodge of lanes and alleys. Business thrived in the lively places; the grid was superimposed upon business as it was stamped upon the island itself.

As early as the 1780s, house plans had become more rigid. The Georgian style was more formal, more symmetrical, and also more private than its predecessors, which grew casually, in the medieval way. Instead of bursting into the kitchen, a visitor would now enter a separate hall. In 1830, the columned exterior seemed again to turn outward, but it was a gesture of power, not greeting.

Around 1800, well before academies of architectural education were established in the United States, a change occurred in Paris that was to affect the teaching of architecture in America. The new theory was expressed in two books by the teacher-architect Jean-Nicolas-Louis Durand (1760–1834), who wrote, "The source of beauty in architecture is economy joined to fitness" and "Architects should concern themselves with planning and with nothing else." William Ware, who founded the first American school of architecture, at Massachusetts Institute of Technology in 1868, echoed Durand: "Architecture may be called the prose, as sculpture and painting are the poetry, of art." There is plenty of poetry, both good and bad, in Ware's own buildings, such as the Ruskinian Gothic Memorial Hall at Har-

vard (see the illustration on page 139). Durand's designs, on the other hand, are dull. Yet Durand's influence persists to this day.

Historians trace the mechanization of thought long before the nineteenth century: to the clocks of medieval monasteries, to Gutenberg, to the cogitations of Descartes, to Newton's perfect universe. Some see its beginnings in the agrarian revolution thousands of years ago. But these changes of consciousness did not undermine architecture. Until 1830, styles changed, but there was still magic in almost any American house or barn or shop — magic and harmony. The old contact with inner pattern still lived; architecture still played; it still expressed the ancient physical and mental awareness of mystery.

Some might argue that what I call a loss is nothing but a shift to an equally valid viewpoint. Others say the old buildings we see and love survived because they were the best of their time. Many of the poorest buildings *are* gone, but why is the most beautiful house in wealthy twentieth-century Belmont two hundred years old? And poverty can be a friend to old buildings. We have Newburyport not because it was revered and cared for but because it was allowed to collect cobwebs for a hundred years. Did industrialization inevitably bring about a coarsening of taste? Around 1830 people began to believe, as both John Stuart Mill and Tocqueville wrote, that magic was not to be expected in everyday life, that dullness was the price of comfort, or of social equality. I do not see it that way.

"The history of architecture is the history of the world," the architect A. W. Pugin wrote in 1835. Our age still looks at architecture in the changed way of that time. What happened in 1830? It becomes more possible to answer that question if the change is seen not as some cataclysm, but as the moment of acquiescence to a series of changes, great and small.

It seems odd that we can date the loss of the old way of seeing so specifically. But the change is right there in the buildings: those big columns have something to prove, or hide. Around 1830, architecture

becomes performance. Why? What *was* the history that broke the old way of seeing?

Quick as one can say "Industrial Revolution," one seems to have the answer. But in 1830, America had barely begun to industrialize. More than ninety percent of Americans still lived on farms or in tiny villages. Canals and steamships had been built, and the new textile mills of Lawrence and Lowell, Massachusetts, but not much else that we would call industrial; there were only the rawest beginnings of railroads. The shift to the new way of seeing seems more to parallel than to follow the rise of industry. It could be said that like the new architecture, the machines, factories, inventions of the time expressed a deeper change that had already occurred.

While America had barely felt the Industrial Revolution, a commercial revolution had taken place during the first decades of the nineteenth century: the rise of corporations and banks, a shift of financial power away from farms and families who bartered within small communities to institutions, often located in remote cities. There were eight times as many banks per capita in 1850 as in 1800. In 1830 the United States was not yet urban or industrial, but, as the historian Jack Larkin puts it, "A large number of rural Americans were working more calculatingly and less socially." "Calculating" is the new way of seeing in a word.

In 1826 Amos Lawrence, one of the first American industrialists, worried, "I now find myself so engrossed in [business's] cares, as to occupy my thoughts, waking or sleeping, to a degree entirely disproportionate to its importance. . . . Above all, that communion which ought ever to be kept free between man and his Maker is interrupted by the incessant calls of the multifarious pursuits of our establishment."

In 1831 Alexis de Tocqueville arrived in the United States, where he travelled for a year. In 1835 he published *Democracy in America*. The accuracy of Tocqueville's observations has been startling Americans

ever since; he seems to have visited our own time. Tocqueville argued that democracy led to the commercialism he saw everywhere, but he did not say that capitalism *was* democracy. Emerson, Tocqueville's contemporary, wrote, "The nobles shall not any longer, as feudal lords, have power of life and death over the churls, but now, in another shape, as capitalists, shall in all love and peace eat them up as before." Tocqueville and Emerson saw that the new commercialism put calculation ahead of spirit. But Tocqueville believed that commercialism came out of democracy, while Emerson said it was inimical to democracy, that democracy was essentially the expression of spirit. He wrote:

> 'T is the day of the chattel,
> Web to weave, and corn to grind;
> Things are in the saddle,
> And ride mankind.
>
> There are two laws discrete,
> Not reconciled —
> Law for man, and law for thing;
> The last builds town and fleet,
> But it runs wild,
> And doth the man unking.

Tocqueville argued that democracy itself was to blame for what he saw to be the low standards of American culture. He believed that "collective mediocrity," as Mill called it at the time, was inevitable.

To some in 1830, no single individual symbolized Tocqueville's "despotism of the majority" more than Andrew Jackson, who was president from 1829 to 1837. A central event of Jackson's presidency was the Bank War, a fight by the new populism to limit the new corporate power. A single bank, run by one individual, had become immensely powerful in the national economy. Jackson was determined

to break that power. His opponent was Nicholas Biddle, and the bank in question was the same Bank of the United States that had introduced the new way of seeing into American architecture. The building was the visual expression of a transformation that had come over America; and the Bank War was its political and economic expression. Biddle was the sort of person who can epitomize an era, be its lightning rod, invent its symbols. He came up with the style and the issue at the moment of the turning point.

Most of the public sided with Jackson in the Bank War, but even though the Greek Revival was closely identified with Biddle, the style did not fall from favor. It continued to be the American style of choice throughout the Bank War, and the new values it represented were only strengthened in the styles that succeeded it. Jackson won the Bank War, and Biddle's career was wrecked, but banks and corporations were now in power as they had never been before.

The new economy, which Jefferson had warned against, made the individual more and more dependent upon large, impersonal institutions, and it created, or sharply increased, a social hierarchy based upon wealth. Most Americans seem to have felt they had no choice but to accept the change. As Arthur Schlesinger, Jr., puts it in *The Age of Jackson,* "The fears of Jefferson were now actualities. One handled fears by exorcism, but actualities by adjustment."

Carlyle wrote at the time, "Wealth has more and more increased, and at the same time gathered itself more and more into masses, strangely altering the old relations, and increasing the distance between the rich and the poor." As in England, and for similar reasons, wealth in America was now distributed far less evenly than it had been a few decades before. Betsy Blackmar describes the new social division of New York City: "[By the 1830s] it had already become clear . . . that though New York's social classes still lived within walking distance of one another, the social distance between them had grown immeasurably."

The new commercialism, and the stratification it brought, was not limited to New York or Boston — where social division became particularly pronounced — or to the hierarchical factory towns. It came to farms and villages as well. As Larkin writes, the Greek Revival "gave architectural form to the advance of commerce in the countryside."

Most Americans denied that the nation had stratified into new economic classes, that such inequality could be; America stood for the most radical personal freedoms in the world. Perhaps their denial was an adjustment to reduced personal power.

Work and daily life began to change profoundly. Many at the time complained that the fun seemed to have gone out of life. Around 1840 Horace Greeley (1811–1872) wrote that during his childhood there had been "more humor, more fun, more play, more merriment . . . than can be found anywhere in this anxious, plodding age."

Clothing for both men and women went from color and play to a heavy seriousness. The man who in 1815 might have worn trousers of lemon yellow and a coat of cerulean blue began to wear only brown or gray or black. The woman who had worn a light clinging gown in 1815 was hardly visible at all under the billows and bonnets of 1840.

This change was part of a newly general prudery. The master bed, which had commonly taken a place of honor in the parlor, was removed from view. Sex came to be widely thought unhealthful, and marriage manuals that had encouraged sexuality were replaced by tracts about its evils.

Amidst the new prudery and seriousness, there was also more emphasis on order. Slovenly front yards became neat, and white picket fences enclosed them. Houses looked snappy in the excellent new white-lead paint. Drunkenness had been endemic, but alcohol consumption dropped by more than half under pressure of the newly powerful temperance movement.

The factory was the change in work life at its most intense, although in 1830 America, factories were more harbingers of things to

come than typical workplaces. At first, the long hours seemed like farm hours; the first factory workers were said to be "tending" their machines, like farmers watching their flocks. But by 1830 workers were "operatives." The schedule was rigid and endless, and the operatives had no way to vary their tasks or the rhythm of their labor. As on the farm, whole families often worked together, but without the former self-respect or satisfaction in the work. John Stilgoe quotes a Connecticut manufacturer in 1835: "The usual working hours, being twelve, exclusive of meals, six days in the week, the workmen and children being thus employed, have no time to spend in idleness or vicious amusements."

America was still a rural society in 1830, but the number of Americans living in towns had begun to increase sharply during the 1820s. It was the beginning of the urbanization that has never stopped. The population was increasing very rapidly, from 3.9 million in 1790 to 12.9 million in 1830, and it was very young; the median age was less than sixteen. A high birth rate, not immigration, accounted for the increase. The high rate of growth surely made it easier to overturn the old way of seeing, for the people who were building in 1810 were a minority by 1830.

New words came into the language to express the new way of thinking: "idealistic" (meaning unrealistic) arrived in 1829, and "utilitarian" (to mean merely material) in 1830. The Industrial Revolution was named in 1829. "Intellectualism" was coined in 1829, and "aesthetics" (as the study of taste) in 1830. "Eclecticism" came to architecture in 1835. "Self-consciousness" came into the language in 1837. "The key to the period [1820–1840] appears to be that the mind had become aware of itself," wrote Emerson in 1876. An old word that had meant "right-angled" took on its modern meaning in 1828: "normal."

Lewis Mumford, in *Technics and Civilization,* calls the time since 1830 the "neotechnic" period. The neotechnic is the age when the in-

ventions of such visionaries as Roger Bacon and Leonardo da Vinci began to come into daily life. Mumford notes such inventions as the water turbine (1832), the reaping machine (1831), chloroform anesthesia (1831), the sewing machine (1829), and the dynamo (1831). Steam automobiles chuffed along the new highways of England until the railroads deliberately put them out of business. In 1832 Charles Babbage's automatic calculator was built. When Samuel Morse invented the electromagnetic telegraph in 1838, everyone said it was only a matter of time until voices would be transmitted by wire.

Louis-Jacques-Mandé Daguerre was a painter obsessed with verisimilitude. In 1822 he created the Diorama, a Paris theater in which a *trompe l'oeil* set was the entire show. It was a huge success. Yet at least one critic saw in it the emptiness that was to haunt the new way of seeing: "The idea produced is that of a region — of a world — desolated; of living nature at an end; of the last day past and over." In 1837 Daguerre invented the photograph. Mumford writes, "The camera-eye that developed with photography brought about a new self-consciousness . . . not self-examination, but self-exposure."

In 1828 Hector Berlioz wrote his first masterpiece, *Eight Scenes from Faust;* in 1831 Goethe completed his last, *Faust.* The Faust legend obsessed artists and writers; in dozens of works they told the story of the modern predicament: in gaining the power of industry, the world was sacrificing its soul. It was not the new machines themselves that were feared — there were not yet very many — it was machine thinking. "The age of arithmetic and of criticism has set in," wrote Emerson. And Carlyle wrote, "We see nothing by direct vision; but only by reflection and in anatomical dismemberment. . . . This deep, paralysed subjection to physical objects comes not from Nature, but from our own unwise mode of *viewing* Nature."

How must it have felt to watch the age-old sense of place, the sense of self, disintegrate in a generation? "I was myself last night, but I fell

asleep on the mountain, and they've changed my gun, and everything's changed, and I'm changed, and I can't tell what's my name, or who I am!" Washington Irving set "Rip Van Winkle" in the 1770s, but the story describes vividly the change of consciousness that had occurred in the twenty years leading to its own time, 1820.

As the last of the great old patriots of the Revolution died out, the 1820s looked back often to the 1770s, the heroic age, a lost time of courage. The grand simplicity of the Greek Revival was a picture of that former integrity. In 1823 John Lowell, ill at ease in his new role as industrialist, wrote, "I happen to have lived . . . in a *middle* generation, between the revolutionary patriots, & the *modern* man." He appears to have thought the "modern man" would find a way to come to terms with machine thinking. But no such way has ever been found.

The social historian Karen Halttunen writes of 1830, "The question 'Who am I?' loomed large; . . . and the question 'Who are you really?' assumed even greater significance." The way to remedy the lost sense of self, the way to create a sense of social place, was to adopt an attitude of complete honesty "by donning 'sincere' dress, adhering to 'sincere' forms of courtesy, and practicing 'sincere' bereavement." Looked at this way, the Greek Revival, representing heroic purity, might be called the first "sincere" style of American architecture. The Gothic Revival, the second, represented innocence of spirit. The Neo-Colonial house of the modern suburb is a form of such "sincerity." It stands for homespun tradition. But as André Gide said, "One cannot both be sincere and seem so."

When the old way of seeing was displaced, a hollowness came into architecture. Our buildings show a constant effort to fill that void, to recapture that sense of life which was once to be found in any house or shed. But the sense of place was not to be recovered through any attitude, device, or style.

4

The Principles of Pattern

*Nature is the model, variable and infinite, which
contains all styles.*

— AUGUSTE RODIN

Regulating Lines

To explore the regulating lines in a building is to delve into the guiding thoughts, the connections, the happy coincidences, that make up its design, for these lines organize the geometry of forms. The lines are usually, but not always, hidden; they may come to the surface in gables, for example, or decorative elements. When we analyze a building, the regulating lines show up like the tracks of particles in a cloud chamber, traces of the designer's ordering thoughts. The regulating lines merely connect the parts; to read them is not to solve the mystery but to be presented with more and more mysteries. We are well equipped with an unconscious (or at least nonverbal) ability to recognize such relationships and to figure them out during the design process.

The presence of regulating lines does not necessarily mean the building is a harmonious composition, because another part of the

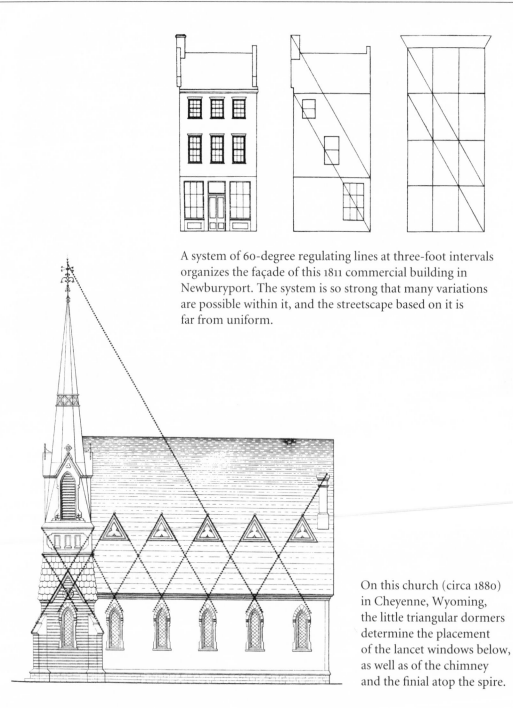

A system of 60-degree regulating lines at three-foot intervals organizes the façade of this 1811 commercial building in Newburyport. The system is so strong that many variations are possible within it, and the streetscape based on it is far from uniform.

On this church (circa 1880) in Cheyenne, Wyoming, the little triangular dormers determine the placement of the lancet windows below, as well as of the chimney and the finial atop the spire.

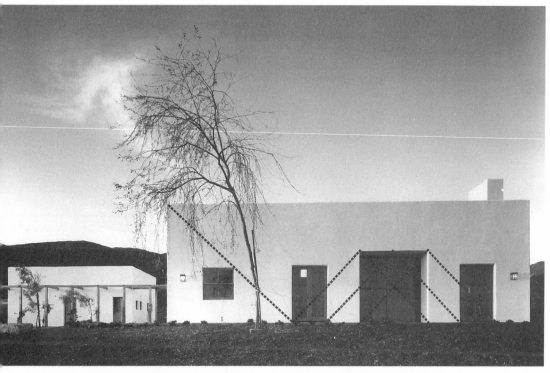

Regulating lines at 45 degrees organize four simple openings in a plain white stucco wall of the O'Herlihy House, Malibu, California (Lorcan O'Herlihy, architect, 1989).

building may have regulating lines that define conflicting shapes, or may have no regulating lines at all. Almost every building has the rudiments of pattern. It is hard to draw a rectangle and divide it into completely disharmonious segments. It is hard to make something with no pattern at all. The mind balks.

The most common type of regulating line is a diagonal connecting key points on a rectangle. The eye relates any element placed along that line to the whole even if the line is invisible. The regulating line might become the diagonal of a window; it might continue up beyond the wall to determine the shape and location of the chimney.

Lines parallel to it might become the roof slope. The roofline, carried through space to the ground beyond the building, might determine the location of a gate or an outbuilding, or it might point to a natural object such as a boulder.

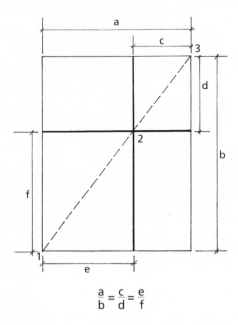

$$\frac{a}{b} = \frac{c}{d} = \frac{e}{f}$$

The diagonal marked 1-2-3 is the regulating line. Shapes relate to one another when at least three points line up on a regulating line. One of those points can be the invisible center of the shape that contains the other shapes.

From any point on the diagonal, lines parallel to the sides of the rectangle create two new rectangles of the same shape. For shapes to relate to one another, at least three key points have to fall on the regulating line. One of those points may be the invisible center of the overall shape.

Regulating lines are usually the diagonals of the rectangles that comprise an elevation; but they can be circles or semicircles. The lines often form a diamond grid on the façade, but they can take other patterns, such as a sunburst fanning out from an arch or radiating down

from a key point, as they do from the cross over the campanile at the Mission San Gabriel in California (see page 55) and at the Jonathan Stone House in Belmont.

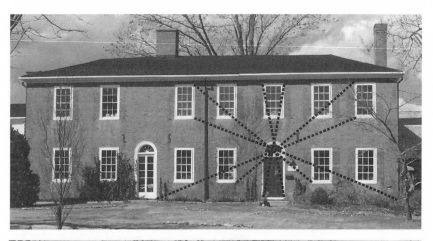

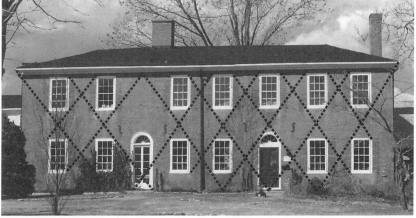

On the Jonathan Stone House the unseen rays of the underlying pattern tie all five bays of the right side strongly to the half-circle fanlight above the right-hand door. Under the radiating pattern a regular diamond grid marches along, comes to a stop at the left door, then picks up again for the last two bays. The ratio of the rectangles these diagonals determine is 1 : 1.414 ($\sqrt{2}$), which the Romans favored. The regulating lines call out key points — corners, midpoints, tops — in the pattern of windows. The window spacings vary by as much as 15 percent, so the lines sometimes miss their mark.

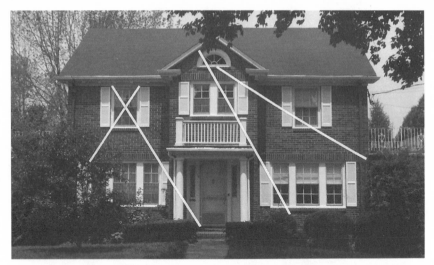

The 1920s Neo-Colonial adjoining the Jonathan Stone House has no overall pattern. Its central fanlight doesn't connect to other elements, and a diagonal through the two center windows also leads to nothing. Note the similarity to the double windows and fan at Jaffrey (page 14). Regulating lines do link the upper and lower side windows and the front door. The goal is to "look Colonial," not to create a form.

The lines among key points on this 1930s house in Belmont are as random as pick-up sticks. The result is not so much ugliness as boredom.

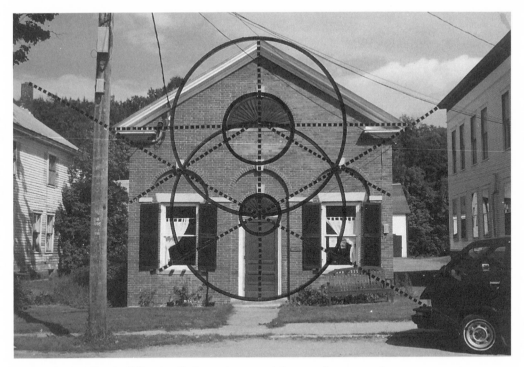

On this little office building in Chelsea, Vermont (circa 1825), two overlapping circles form the ancient vesica piscis shape, and they set up a system of 30-degree regulating lines. The arrangement is too neat to be purely intuitive. The likely source would have been a pattern book. But there is enough play to keep it lively. Whether the builder or the pattern book maker did the playing doesn't matter. Unconsciously the photographer (the author) joins in the game, making the building's diagonals the basis of his picture.

The regulating lines of the buildings I design make patterns very much like those in other buildings. This says to me that my mind works the same way as other designers'. In my own experience, and from what I can tell of others', the pattern of regulating lines is usually unknown or only partially known, to the designer. To set out deliberately to design to a predetermined pattern risks losing the connection with intuition; it can lead to dead designs, because the source of the most exciting inspirations is unconscious. But there are exceptions. In

designing renovations or additions or infill buildings, the first task is to figure out the pattern of the old building, if it has one.

In many sacred and public buildings of the past, the patterns of regulating lines were deliberate because the shapes and ratios often had symbolic meaning. It is a sign of the mastery of the old designers that they could be aware of the patterns and not lose the magic. Analysis of regulating lines can be useful in one's own work when some part of the design doesn't seem to fit. But in making the pattern conscious, one risks having the design go stale. I believe the best time to analyze the regulating lines is after the structure is built.

Two Examples from My Experience

Sometimes the designer arrives at patterns through slow deliberation, but often they are created very rapidly. Photographers produce highly ordered compositions, unconsciously, in a few seconds. The pattern for a house I designed in Hamilton, Massachusetts, came to me in an instant, fully developed. I was dissatisfied with what I had designed so far. The house had a very elaborate floor plan on multiple levels, and instead of pulling together, the different parts seemed to be flying apart in every direction. The exterior looked boxy and complicated and dull. The plan was workable, but the elevation had to change. The house needed a strong pattern to tie it together. Riding on a bus, I suddenly had an idea, and I just drew it. That was how we built the house.

Three years later I analyzed the façade and found that a pattern of regulating lines organized the whole elevation. My primary conscious act was deciding to *have* a new design. It took me a long time to absorb, consciously, all the elements of the house, but I do not believe my mind labored slowly and silently behind the scenes to make them

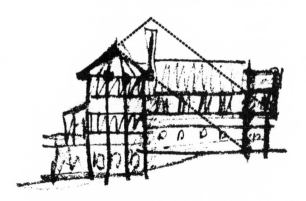

Regulating lines, invisible and unconscious, organize the design in the earliest thumbnail sketch of the house in Hamilton, Massachusetts (Jonathan Hale, architect, 1985).

into a pattern. I believe the process of seeing all the implications and relationships happened extremely rapidly, once it began. It is no coincidence that the design came to me on the road rather than at the drafting board. Watching the world move by can stimulate visual intuition.

A sunburst of regulating lines radiates from beneath the central gable of a house I designed in Cambridge, Massachusetts. Radiating patterns of this sort are sometimes found in stone arches; the joints between the stones form lines that connect distant points on the façade above. In the Cambridge house the pattern was a response to the client's request for a central gable that would be a focal point. In this case, there was no single moment of inspiration; the design came out of a series of sketches. All I did consciously was to move the elements of the house around until I liked them. The result is the same kind of pattern that organizes the campanile at the Mission San Gabriel. But neither I nor, I suggest, the designer of the campanile, made that pattern consciously. The house was designed and

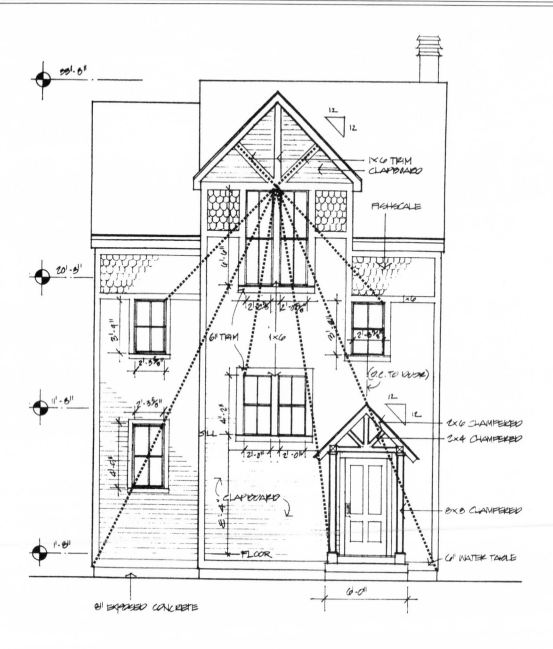

The regulating lines on this house in Cambridge, Massachusetts, radiate from the central gable, determining the key points of the façade. The client had requested a focus at the gable. The conscious process of design was simply to move the windows around until they looked right (Jonathan Hale, 1988).

the working drawings were completed months before I drew the diagram of the regulating lines onto them.

How do you fit the elements that make up a façade — those doors and those windows — into a proportioning system? Will you be able

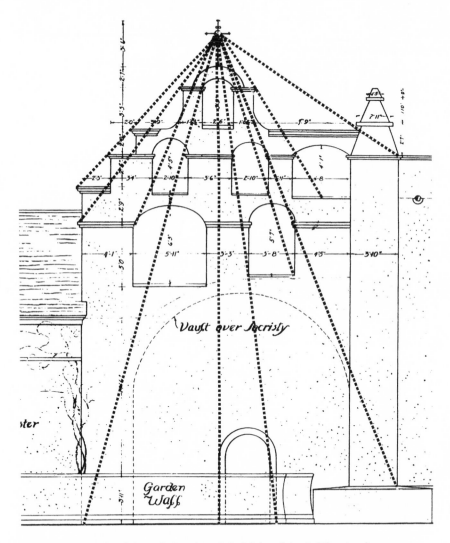

On the campanile of the Mission San Gabriel (1771) in California, the pattern radiates from the center of the cross, connecting the centers and spring points of the arches, corners of openings, and steps in the wall.

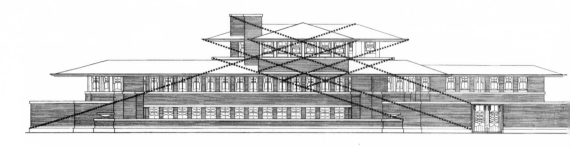

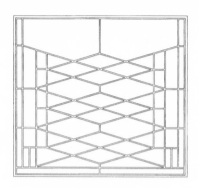

The windows of the Robie House in Chicago (Frank Lloyd Wright, 1906) are a play on the regulating lines that govern the façade.

to find a window that does just what you have in mind? How can you *compose* when most of the elements of a building come out of a catalogue? I have found that the windows in catalogues are usually harmonious forms. They are designed to the ancient proportions. For example, most of the Neo-Colonial windows and doors in the Andersen catalogue are variations on the famous Golden Section, the ratio 5 : 8, or, more precisely, 1 : 1.618. The window shapes may have been taken from eighteenth-century models, or their designers may have gravitated to the Golden Section, as people often do without being shown any models.

If you don't find what you need in a catalogue, you can have a window made up. For the little Cambridge house I used standard cata-

logue windows, except for two (the high, narrow windows at the top). Everything else came right out of a box. The designers of those windows — they were Marvins and Broscos — knew, without thinking about it, what would be likely to work, and, in the same way, I knew how to use them.

Regulating lines can work in three dimensions. No house has a more three-dimensional exterior than Frank Lloyd Wright's Robie House in Chicago. Its roofs slice across the air; instead of walls, it has columns and fins and floating planes. Yet the street elevation organizes perfectly into a two-dimensional system of regulating lines. The key points fit within a diamond pattern very much like the pattern of the Jonathan Stone House of 1775. The Robie House is conceived within a two-dimensional grid *and* a three-dimensional grid. It works both ways, like a multilayered ticktacktoe game. On the Robie House exterior, you see all three dimensions at once; at the Stone House, you see only one flat façade at a time.

In my own designs, I have found that elements in very different planes are also organized according to a flat system of regulating lines. The eye, seeing the finished building, compensates for the differences in distance, to make the necessary connections.

Proportion

Proportion is the relation between two ratios: for example, *a* is to *b* as *c* is to *d*. In a building, *a* might be the width of a window, *b* its height, *c* the width of the wall in which the window is placed, and *d* the height of that wall. The window and the wall have the same proportions.

A proportioning system is a framework. Departures from it may introduce excitement precisely because they differ from an under-

standable order. Openings in the façade — doors, windows — may follow the pattern, or their placement can be syncopated or purposely discordant. When changes are being made to a finished building, the pattern makes it possible to unify the alterations with the existing fabric.

Like other living things, the human body contains a rich system of proportions. When regulating lines are applied to the human body and face, one finds an absolute symphony of proportional harmonies. The following are a few of the simplest and most common: the height from a person's head to the feet equals the distance from fingertip to fingertip of the outstretched arms; the genital area is at the midpoint between head and feet; the ratio of the distance from the feet to the navel to the person's overall height is the Golden Section, $1:1.618$; the human body has numerous Golden Section proportions and permutations.

Proportion is to architecture as the scale is to music. Ratios are the strings of the harp on which you play the music. If you don't have a harp, or if you don't tune it, you are not going to get much music. You may get some interesting strange plunks and clanks — and some music, and some architecture, does that. But in our modern age we still love to hear or see the old systems of harmonious proportions. We prefer music based on the diatonic, or other harmonious scales because those scales come from harmonic laws that are inherent in living nature. What I call magic in architecture is not prestidigitation, not supernatural emanations, but music. But the kind of power you can get in music is lost to architecture if you leave out the harmonic relationships only proportioning systems can provide. Proportion is the nature of architecture. There is an innately understood grammar of shape. And that grammar, unlike speech, is expressed in all living things. Euclidian shapes — cones, cubes, spheres — are often used to make architecture, but the deep patterns come from life forms. Most of all, they come from the human body and face.

THE OLD WAY OF SEEING

Does a building really come alive? Well, does a piece of music really come alive? Music resonates in our minds and our bodies. A great building, even a good building, does not merely create an effect of power, it brings out our own power. A building is not nature and it is not an imitation of nature; it is an expression of *our* nature.

Scale

Scale in architecture is relative size. Adult humans are similar enough in size that most furniture fits most people. Dimensions based on the body can be used to establish the dimensioning system of the house. The house becomes a composition of shapes, forms, and spaces based on the size of its occupants.

The Ancient Canon of Measure

> If they exist today, if there are people or groups who have inherited the secrets of the ancient canon, their influence is not very apparent. Clearly apparent, however, is the modern need for those very qualities which the canon of proportion was supposed to impart to societies which adopted it, qualities of endurance, equilibrium and harmony under natural law.
> — JOHN MICHELL, *The Dimensions of Paradise*

Ancient dimensioning systems combined human and geodetic measure, so that a building embodied, quite literally, characteristics of its occupants and the world. We have inherited an ancient international system of measure whose numbers had geodetic, human, and spiritual meaning. The dimensions and ratios are found in the architecture of dynastic Egypt, classical Greece and Rome, medieval Europe,

and preindustrial Japan. Our twelve-inch foot is such a dimension; it is 1/360,000 of 1/360 (one degree) of the circumference of the earth, accurate to 99 percent. Did these cultures really know so precisely the size of the earth? They may well have known it even more accurately, for 360 was probably a convention for the length of a year. The real circumference of the earth is 364.6 × 360,000 feet, a figure so close to the real number of days in a year that one suspects the ancients had a reason to use the discrepancy deliberately; a multiplier of 365 makes the foot accurate to 99.9 percent. They would have reveled in that five-day gap: 5 × 6 × 12 = 360, each number endowed with sacred meaning and closely tied to human scale, the size of the earth, and the annual cycle.

The Egyptian version of the foot was 12.25 inches, and the Japanese shaku is 11.93 inches. The geodetic numbers were conventionalized to represent human dimensions, all of which fit into a duodecimal system: the twelve-inch foot; the eighteen-inch cubit (length from elbow to tip of middle finger); and the six-foot man, whose midpoint is three feet, the English yard. The tatami, the Japanese measure of area, is three feet by six feet. Our square yard is three feet by three feet. The only virtue of the meter, a geodetic measure little more accurate than the foot, is that it is divisible by ten. It associates to nothing but itself. The twelve-based foot-inch system is harder to work with. It does slow us down, but for a purpose: so that we can look at and increase, through everything we make, our part in the pattern.

Unlike the ancients, we tend not to believe we can tap into the power of gods simply by making something three feet wide or six feet high, or by using a special ratio such as the Golden Section. We have no such innocence; and yet, when we use their geodetic-human measures and ratios, our designs do link our bodies to the earth and to time.

The Golden Section

An egg, an apple blossom, a human face, a seashell — all embody Golden Section proportions. The Great Pyramid of Cheops is perhaps its most dramatic architectural expression, but the Parthenon's façade follows it as well, and Chartres Cathedral abounds in Golden Section harmonies. The Golden Section is also called the Divine Proportion, among other superlatives. In this century it has come to be designated by the Greek letter ø, phi, for Phideas, the architect of the Parthenon.

The proportion of the Golden Section is: a is to b as b is to c; and a plus b also equals c. The ratio $a : b$ is $1 : (1 + \sqrt{5})/2$, or $1 : 1.618$; so ø equals 1.618. But in ancient times it would have been expressed as a ratio of whole numbers, such as 3 : 5. In the phi proportion, length a + length b = length c; $c + d = e$, and so on. This relation is represented numerically in the Fibonacci series (1, 1, 2, 3, 5, 8, 13, 21, 34, 55, 89, 144 . . .). The series can extend to infinitely large and infinitely small numbers, but all are related to one another. Other qualities of phi are that if ø = 1.618, then 1/ø = 0.618, and $ø^2$ = 2.618.

The Golden Section is intimately related to growth; phi proportions turn up constantly in growing forms. In one mode of growth, elements of graduated sizes in phi proportion to one another are added on without changing the shape of the whole. The best-known example is the nautilus shell, whose chambers increase in size while keeping the same shape. Because of the relation of phi to the square root of 5, phi proportions are common to all pentagonal forms, such as starfish and sand dollars. Phi is contained within the icosahedron and the dodecahedron. The ratio, $1 : 1.272$ ($\sqrt{ø}$), is also common in living structures. These numbers underlie many an ancient monument — and many a tree.

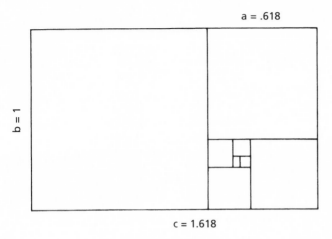

$a = .618$

$b = 1$

$c = 1.618$

The logarithmic spiral of the Golden Section. Each dimension is 1.618 times the next smaller dimension.

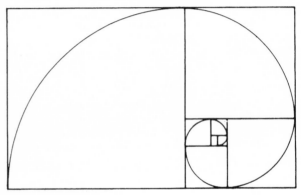

The shell of a chambered nautilus.

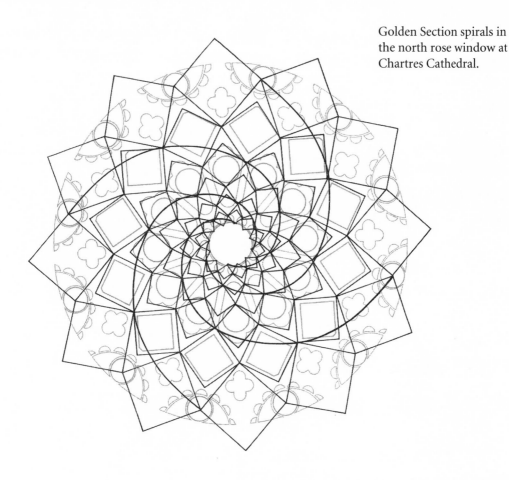

Golden Section spirals in the north rose window at Chartres Cathedral.

The oldest known rectangular space embodying phi-related proportions is the King's Chamber of the Great Pyramid of Cheops, whose proportions are width = 1, length = 2, height = 1.118 ($\sqrt{5}/2$), and base diagonal = 2.236 ($\sqrt{5}$). A rectangular volume is known as a right-angled parallelepiped (RAP). The overall volumes of many Egyptian and Greek temples as well as Romanesque and Gothic churches are RAPs of Golden Section proportions. The RAP 1, 2.618 (\varnothing^2), 4.236 (\varnothing^3) recurs in eighteenth-century furniture.

The 1 : 2 ratio, which Frank Lloyd Wright favored, also relates to the Golden Section because its diagonal is the square root of 5, from

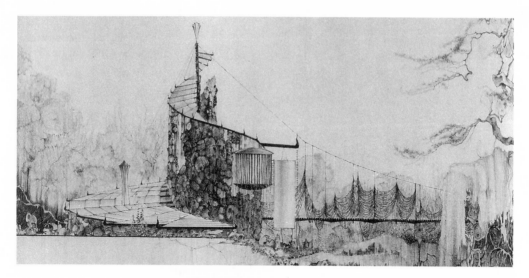

Bruce Goff was the quintessential self-expressive artist-architect, and the Bavinger House, 1950, is one of his most famous and wonderful creations. Wild though the house may appear, in plan it adheres to the logic of the Golden Section as inexorably as a conch or a Greek temple.

which phi is derived. It is also easily adaptable to current building products, such as 4-foot-by-8-foot plywood panels. Since the Golden Section proportion is 1 : 1.618 (actually an endless 1.618033989 . . .), it is more difficult to use the ratio to cut all the parts to size. A very close, even-numbered approximation, however, is the 5 : 8 rectangle (1 : 1.6).

Le Corbusier's Modulor man, showing the key dimensions of his measuring system in inches, a double series of Golden Ratios (1 : 1.618) derived from human scale.

The Modulor

While Le Corbusier waited out the Nazi occupation of Paris during the Second World War, he invented a dimensioning system that incorporated human scale and the Golden Section. The system, which he called the Modulor, is a grid of dimensions in phi proportion to one another. The dimensions form two Fibonacci series in human scale.

The Red Series starts at 72 inches, the ancient conventionalized height of a man; the Blue Series starts at 89 inches, the height of the man's upraised hand, or twice the height from floor to navel. For larger sizes, these dimensions are multiplied by 1.618; for smaller sizes, they are divided by 1.618 (or multiplied by 0.618). The system is equally adaptable to meters or feet and inches, but when the Blue Series is expressed in inches it forms the Fibonacci series in whole numbers: (. . . 3, 5, 8, 13, 21, 34, 55, 89 . . .).

Le Corbusier intended his system to be adaptable to every variety of design, from interlocking packing crates to the most elaborate buildings. A remarkably small number of Modulor dimensions can be combined to create a wide variety of compatible shapes. He designed a seventeen-story apartment house, the Marseilles Unité

d'Habitation, using only thirteen Modulor dimensions. Le Corbusier was fond of pointing out Modulor dimensions in old buildings; he discovered Modulor proportions in thirteenth-century churches, Egyptian tombs (the height of the King's Chamber in the Great Pyramid is a Modulor dimension), at Santa Sofia in Istanbul, at Pompeii.

Le Corbusier insisted that the proportioning system should not be the first step in designing a building. The Modulor was not a system for designing but for measuring. The system alone could not lead to beautiful designs, any more than a piano alone can create music. The architect and planner Jerzy Soltan, who worked with Le Corbusier to develop the Modulor, told me, "Le Corbusier forbade us to use the Modulor in all introductory stages of design. The Modulor is extremely dangerous if used to *determine* design. It should not be used as a religion."

The Modulor was invented for the rebuilding of Europe after the war. But only a few followers came forward to use the system, perhaps because Le Corbusier buried it in two almost impenetrable books. The struggle to understand the Modulor, and the extra labor involved in working with its uneven sizes, is repaid by a wealth of harmonious human-scaled forms. The Modulor awaits discovery.

Harmony, Ornament, and Symbol

> *Current arbitrary decoration lacks the initial emotional impetus, the authentic purpose, of gratifying the deep primordial urge . . . a pianist playing a Chopin nocturne is not concerned with acoustically adorning the living room.*
>
> — RICHARD NEUTRA

One purpose of pattern is to ground the building in nature and connect it to our bodies by imitating the ordering discipline of life forms, especially our own. I believe that to be recognized as a place, a building must embody the harmonic patterns of life forms. Talk of "harmony" and "embodying life forms" rubs some people the wrong way. The word "harmony" has been sentimentalized, but no other term is so apt. I mean it in the musical sense, not in the sense of "have-a-nice-day."

As for resembling life forms, it is underlying pattern, not any literal representation, that makes a building "come alive." Trees, which populate the landscape much as buildings do, are much more generally considered to be beautiful. But, as Frank Lloyd Wright said, a building should *be* like a tree, not *look* like a tree. The exception is decoration, where representation can work because it is applied, it is on or outside the main form. Trees and people contain the same kinds of patterns. Harmonious buildings that embody life forms refer to us, they are about us. That is why we are so attracted to them.

Harmony can be defined as the resonating play of shapes. It can be gentle or strong, but it is not immobility. The old way of seeing is not repose, and it is not prettiness. It might be soft or rough. It might be cheap — a diner by the side of the road — or it might be the Great

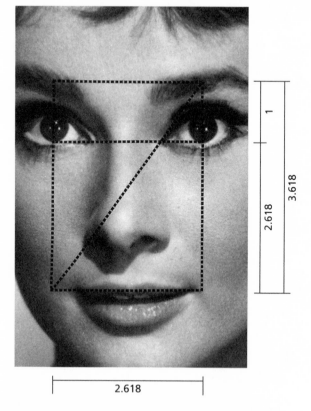

AUDREY HEPBURN: Oh, no! How can you possibly make a model out of that? You can't be serious!

FRED ASTAIRE: When I get through with you, you'll look like . . . well, what do you call beautiful? A tree. You'll look like a tree!

— from *Funny Face*

Pyramid, but the same design principles will guide it. Harmony in a building means relationships that work with other relationships. A design can have a great deal of discord. In fact, if it doesn't, if there are no mistakes or mutations, the result will be dull.

One of the purposes of ornament is to pull the eye toward the regulating lines of a building, to point out the key visual points of its geometry. Ornament strengthens the forms that are already there. The powerful governing patterns of the building are not decorative, they *are* the architecture. They are inherent in the building, just as what the building does is inherent in it: this building is a house, and it also embodies this pattern. To be a pattern is one of the building's functions. In this way a building is like music.

3.618

2.618

The sugar maple has the same proportions as Audrey Hepburn's face; she may not *look* like a tree, but she *is* like a tree. The tree's proportions are 2.618 : 3.618, both multiples of 1.618, or phi, the Golden Section. Other common tree shapes have the Golden Section proportions ø/2, ø/3, 1.5 ø, and √ø.

Another purpose of ornament is symbolic. Decoration might take the form of a series of statues that have specific meaning. But their meaning may change or be lost. During the French Revolution a great row of statues of the biblical kings was pulled off the Cathedral of Paris and smashed because the statues represented royalty. Fifty years later, replicas were put back. Unlike the originals, the new statues did not have much artistic value in themselves, but this was not noticeable from a distance. The row of kings had lost all symbolic meaning, spiritual or political. It was restored primarily in order to complete the composition.

Even routine embellishment can be attractive. The garlands and swags of Neo-Classicism are entirely remote from the traditions and myths that had meaning for their first designers. On the friezes of old banks and courthouses you will often see little protruding vertical stripes in groups of three, "triglyphs." The architect had no idea what they meant; they were part of the Classical vocabulary, and the building would not be *comme il faut* without them. The "form" dictating such decoration is social, and the sought-for result is to instill respect, to express authority, which, among other things, the Classical idiom symbolized.

But if decoration ceases to emphasize the regulating lines that make the building a pattern, then the decoration weakens the design. Weak design often shows up as confusion between ornament and deeper pattern, as happened in some Post-Modern buildings of the 1980s, where architects played with decoration tongue in cheek. I think they burlesqued embellishment because they were nervous about bringing it back after it had been forbidden for so long. Decoration had been thought to be wrong because it was so often used in the Victorian age to conceal the absence of elemental forms. The Post-Moderns welcomed superficiality itself.

Symbolic elements can be seen to fit (or not) if they are viewed as part of a composition. But all symbols are freighted with verbal meaning, while composition is nonverbal. Extremely strong symbols are almost invisible as forms because the mental noise of feeling and association is too strong. The swastika used to be common enough; in ancient times it meant prosperity and well-being. Swastikas haunt old buildings. They adorn the mosaic floor of an office building in Buffalo, one for each elevator; they lurk in the ornament of old churches and in the linoleum of old kitchen cabinets. But today the swastika is anathema.

Symbols have great power, but they do not have the same power from one generation to the next because their meaning changes. The

meaning of proportional forms always stays the same. Symbols are tied to emotions, and they are also tied to information, special knowledge. If you don't know about Nazism, a swastika will have no meaning. If you don't know about proportion — but you *do* know about proportion, because to recognize proportion is innate. The Golden Section has the same meaning now that it did two thousand years ago.

The pentagram is a symbol we have carried from the distant past right into the present. It is the five-pointed star made of intersecting triangles. We have retained it, I think, precisely because it is a Golden

Golden Section relationships in a pentagram. Each line segment multiplied by 1.618 (phi) gives the next line segment, and each line segment added to the previous one gives the next line segment.

X —— Z	0.382	\varnothing^{-2}
R —— X	0.618	\varnothing^{-1}
P ——T	1.0	
A'———— P	1.618	\varnothing
A'—————T	2.618	\varnothing^2
A'——————— D'	4.236	\varnothing^3

XZ/RX = RX/PT = PT/A' P = A' T/A' D'

XZ + RX = PT, RX + PT = A' P, A' P + A' T = A' D'

Section form; it is a remarkable collection of relationships. It is still, in a way, sacred. It is on the wings of our airplanes; it is on our flag; and many other peoples use the pentagram as well: a pentagram underlies the Canadian maple leaf, for example. The five-pointed star is a symbol of the human body but also a symbol of the heavens and an unchanging symbol of life.

A pentagram connects key points
on a maple leaf.

The primary purpose of the great ancient symbols is not to influence, not to remind, not to create a "sense" of devotion or history or community or value or place. The purpose of an ancient geometric symbol such as the pentagram is to bring to awareness the innate knowledge of innate pattern.

Mystery and the Rules of Proportion

During the age of the old way of seeing, it seems people did not understand that beautiful patterns, precise and subtle, came from a process of intuitive play. They believed that proportioning systems had to be prescribed. They believed this even as patterns flowered all around them, even in the most ordinary buildings — on the backs and sides and sheds of simple houses, not just on the public façades. So long as people saw buildings as patterns in light and shade, it didn't matter that they did not understand their own innate pattern-making ability. But when the magic was lost, there was no clear way to get it back. Those who had the old way of seeing did not know what it was they were doing. Harmony came from pattern, as anyone could see. Pattern was measurable and teachable. It was understood that a building was a form of music.

The Gothics, intentionally following the Greeks, used musical intervals to determine architectural forms. They also understood the proportions of the human body, and they put those patterns into buildings. But they did not talk about the process of play; they did not talk about the designer's frame of mind. Pattern was taught; architecture as music was taught, and every place came alive. But when the music went out of architecture, rules and systems were not enough to get it back. It had not been understood that the village square and the great church embodied the same patterns, and that their primary source was unconscious knowledge. Until the Victorian age, the magical sense of place was not discussed because it was always present.

It *was* understood that there was something magical about proportion. An air of secrecy and initiation has always attached to proportioning systems. The sign of the Pythagoreans, for example, was the

pentagram; they were forbidden to reveal that it was an extremely rich expression of phi proportions. Proportioning systems connect us to the nonverbal side of our minds, the "magic" side. The words "magic," "secret," "mystery" still tend to crop up in literature about architectural proportion. The paradox is that the "mysterious harmonies" are the source of much of the sense of reality, place, and meaning in buildings. Until our age proportioning systems were as common in human artifacts as they are in trees and flowers. Perhaps an element of fear underlay the old rules: we will *control* the unconscious pattern making, we will not acknowledge what is not conscious.

Form is a highly charged subject because it makes us aware of unknown powers inside and outside us. In our time the universality of form in nature tends to go unnoticed, and its power in ourselves is unacknowledged. People gawk at old temples and pyramids, and some chain themselves to bulldozers that would demolish old houses, but they cannot easily say why they are so passionate about it. In the past, mystical explanations were one way to put meaning onto that unknown power, making it all right to use one's intuitive power. But if we accept that intuition *does* have control, then intuition can link us to the universe without mystical explanations.

The Old Priority

The ancient Greeks are said to have had two kinds of mathematics. There was utilitarian arithmetic, the lower, less respected kind, which was for toting up their amphoras; and then there were the number systems of harmony, the patterns of geometry and music. These belonged to the higher branch, the "better" branch of mathematics.

Similarly, one can look at a house in two ways. The first looks at

comfort and utility, the other at form. The second asks, What is this place? Does the house come alive? Do *we* come alive here? Is there a "here" in this building? In our age we focus on the comfort side. And because we have been so successful at comfort compared to previous ages, because comfort is important to our health in some ways, we tend to think it is more important than form. But I hold that we have still got it backward and that the Greeks had it right. How a place embodies the sacred ratios — the patterns that define the form of our bodies — comes first. Today a builder talking about "power" means the electrical service. Comfort seems to give freedom, but you can't do much with freedom unless you have the power to express it.

5

Spirit

The Vesica Piscis

> These walls, these surfaces that you see, are imprinted
> with the life-giving flame that subordinates the world
> to primary ideas.
> — CLAUDE-NICOLAS LEDOUX, architect, c. 1790

There is a shape in architecture that symbolizes life, that represents the materialization of spirit. That shape is a place where symbol and geometry, body and spirit come together. In this way the shape is what architecture is. The shape is to be found everywhere in plants and animals. It is the shape of a flame, or a seed, or a fish. In sacred architecture it is known as the vesica piscis, vessel — literally bladder — of the fish, and it is also called the mandorla (Italian for almond). The vesica piscis is made when two circles overlap.

It may seem questionable whether we should pattern our buildings

after fish or nuts or flames. But the Gothics did just that. At Chartres, Christ sits in a vesica piscis above the West Portal. And the Gothic pointed arch is half of a vesica piscis. In every Gothic church, the shape is repeated like an incantation wherever one looks, and it may persist invisibly in the building's cross section, where it becomes an enclosing geometry of regulating arcs. The geometry of a Gothic building is an efflorescence of overlapping circles. We almost never see the complete circles, but only the places at which they join. The area where the circles overlap is the most important part of the pattern; it represents the place of harmony, awakening, grace. The vesica piscis is an emblem of unity achieved from duality. It represents the joining of the temporal and the spiritual — as architecture itself does.

The Victorians loved the Gothic shadows and spires for their quaint wild innocence. They used the pointed arch to symbolize the passion of faith — emotion as opposed to intellect. However, to a twelfth-century builder, the vesica piscis represented not opposition but the area where emotion and intellect came together.

To the Gothic architect, the vesica piscis appears to have been a living symbol that imparted its qualities in real life to the occupants and to the physical structure of the building itself. At Saint George's Chapel, Windsor, a pattern of overlapping circles determines the thicknesses of the nave walls and the locations of the buttresses. It seems a risky approach to structural physics, but the builders did not leave out common sense altogether, for the chapel has stood since 1482. Perhaps their goal was merely to align structure with sacred geometry rather than to derive structure from it; but I suspect there was some ambiguity in their minds; I suspect they believed in the physical power of spiritual shapes.

The Hôtel-Dieu of Beaune, built in 1443, nestles safely in a largely invisible pattern of vesicas. Parts of vesicas can be seen in the curve of the ceiling and the arch of the central window. A larger vesica sur-

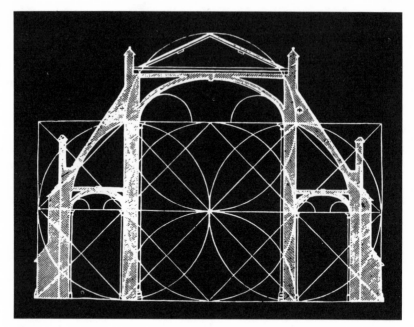

The regulating lines in the cross section of Saint George's Chapel, Windsor
(1482), were a highly deliberate pattern; their shapes, number, and relation-
ships had sacred meaning. The church structure was meant to embody the
patterns of heaven and invoke their power. It was not a matter merely of
inducing visual pleasure or reverence, for the view we see is invisible to any
visitor; the purpose was to vibrate to the music of the spheres.

rounds the whole building and locates the roof peak and the base of
the walls. The secret shape is like some giant amulet protecting the
sick, whose beds line the walls of the great room.

The force of such guiding geometry makes it easier to understand
why medieval architects felt free to take liberties with symmetry, why
they were so casual about consistency of detail. In side view, the
Hôtel-Dieu rambles; windows and moldings are misaligned, dormers
sprout as needed. But in cross section it is a finely tuned instrument.

We, in our day, cannot believe that the inscription of invisible cir-
cles around a hospital will heal the sick. Isn't it mere gesture, or delu-

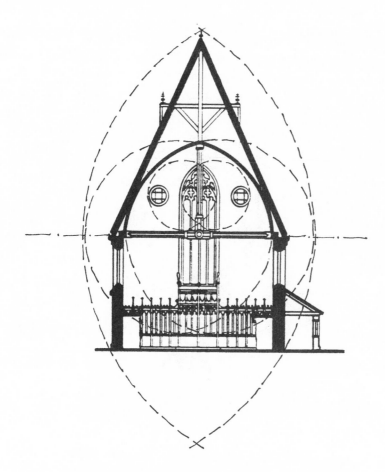

The Hôtel-Dieu (1443) in Beaune, France. The whole building nestles
safely in the invisible pattern. Circles overlap to create vesicas upon
vesicas, symbolizing Christ and wholeness. The ceiling vault is half of a
vesica; the tie-beam forms the center line of its two circles. The center
window is the top of another vesica, whose circles touch the vault and
the tie-beam. The largest vesica, centered on the tie-beam, encloses the
whole building, determining the roof peak and the base of the walls.

sion, now, for us to express the old geometry in buildings? Isn't the
poignant attraction of ancient architecture in part the ruined old be-
lief that a building can invoke heaven on earth? Isn't it just mud-

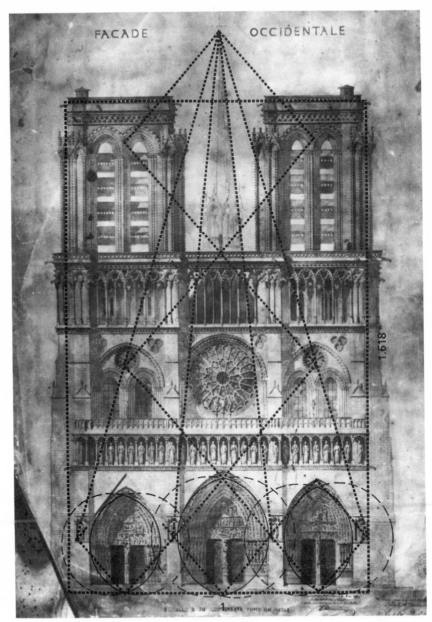

The three mandorla portals of the west façade of Notre-Dame de Paris (circa 1210). A diamond pattern of regulating lines, at an angle of 7 on 6, links the portals as well as other key points on the façade. This is only one of many systems of regulating lines that organize the cathedral. The whole façade is in a ratio of width to height of 1:1.618, ø, the Golden Section. Drawing by Viollet-le-Duc, 1843.

dled mysticism to think the ancient patterns have any power in the present?

On the west façade of the Cathedral of Notre-Dame of Paris, just over the left-hand portal (built around 1210), are two incised lines that make an angle in the shape of a gable. I used to wonder why they were there, so plain, over only one door, the Portal of the Virgin. They are a rare explicit statement of regulating lines. No tracery softens them, no roof projects from them. Here, in a most surprising place, is raw geometry. The shape is clearly there for a purpose, but the purpose is not immediately obvious.

If we extend the lines, we see that they are the beginning of a pattern of three diamonds that connect key points in the bottom tier of the façade. The sides of the diamonds point to the four statues that flank the doors. The pointed arches of the portals are segments of overlapping circles. Each area of overlap is a mandorla, and the bottom of each mandorla is also the bottom of a diamond.

The angled lines are at 49.4 degrees, an odd angle, one thinks at first. Why not the much more common square root of the Golden Section, 51.8 degrees? Why not 45 degrees? It turns out that 49.4 degrees has a slope of 7 on 6. The reason for that slope is woven into the same symbolism that locates the diamonds and the mandorlas. In the Gothic cosmology, which derived from far more ancient systems, every number had meaning. Seven was the number of the Virgin. This was her cathedral, and the left portal was her door. Six represented perfection, and it also represented time. Ratios that expressed certain spiritual qualities were built into the cathedrals. They were like numerical prayers.

We do not believe as purely as the cathedral builders in the powers of number and shape. But if a building no longer can create heaven on earth, it can still evoke what is heavenly and earthly in us. The reason a cathedral still "works," still inspires, excites, attracts, is that its patterns resonate with the shapes of our own bodies and the shapes of

the plants and animals around us. The vesica is the conventionalized shape of seeds, peach pits, many leaves and trees, the bodies of insects, fish, and birds. The controversial psychiatrist and scientist Wilhelm Reich, who studied the vesica shape in some depth, called it "the basic form of the living" and said it came from patterns of energy flow. His term for the vesica was "orgonome."

A Pacific pompano.

This form is very commonly associated with the Golden Section and its permutations. In living things the vesica/mandorla/orgonome tends to be somewhat flattened at one end, as in an egg. Reich points out that it often curls into a bean or kidney shape, more like a cashew than an almond. It then resembles the yin-yang symbol, which derives from adjacent circles inscribed in a larger circle rather than from overlapping circles. I think the orgonome relates to the process of growth, in which size increases while shape remains the same — a process related to the Golden Section, which permits such additions. There is, as yet, no consensus about the reason for the preponderance of the flame shape in nature, although the question is now more open than it has been. "You have seen leaves," writes the physicist Albert Libchaber. ". . . Now, in your kitchen, if you turn on your gas, you see that the flame is this shape again. It's very broad. It's universal. I don't

care whether it's a burning flame or a liquid in a liquid or a solid growing crystal — what I'm interested in is this shape."

D'Arcy Thompson's *On Growth and Form* is the most famous book on natural shape. Thompson discusses the shape in his studies of the energetic determinants of tissue forms, but he does not investigate why a Dover sole and a sassafras leaf should take the same form.

It is surprising that science has paid so little attention to this shape, which religion loves, because the most obvious point about the or- gonome is its ubiquity. It is everywhere — in a dandelion leaf, the egg I eat for breakfast, the oats in my Cheerios. The orgonome doesn't need to be sought out. The shape is deeply sacred and it is utterly ordinary.

I'm driving along, and I pass a yellow truck, and on it is painted a big red vesica piscis, and in the vesica are the letters *TW*. They stand for Tire Warehouse. A twentieth-century vesica, a vesica for our time. No, I don't like it that the life symbol should be used to sell tires. The vesica still has power, and it has the potential for misuse, and this is misuse. But the sign maker never heard of a vesica piscis; why should anyone care?

An ear of corn, a thigh . . . that big red vesica is very powerful, and it is a sexual shape, of course. But what is sacred about it to us? What is its value? Not just universality; that word is like "brotherhood" — awfully nice but too good. The vesica is something else. To say this shape calls to something in us, that is more like it, I think. We *have* to look at it.

Some of the attraction of the vesica piscis is its combination of wildness and logic. It is the visceral shape, the food shape: fish, wheat kernels, eggs. The meaning of the vesica piscis is more than just ab- stract goodness, the unity of all things. The vesica piscis is sex and muscle and blood and food. The vesica piscis is animal and therefore

a little smelly. The vesica piscis is spirit and therefore a little abstract. The vesica attracts and it repels.

I see the logo on a van: F-o-r-d rolling along in a blue vesica piscis. The label looks like a sort of good luck charm. I say it's fine. Use it any way you like.

Is it important that we unify our buildings and other artifacts with the shapes and patterns of nature? What does it matter that the dead fox by the side of the road curls into the same shape as my kidney or my stomach?

But the shape is fire. Van Gogh painted the burning bush, the fire of life in it; he made the black fire visible in trees. It is our fire. The flame leaps up in us when we see something we recognize. So by all means allow that sexual connotation. Sex is one aspect of it; the things and places we make are another. Our reality is a universe of ordered life forms. There it is to be seen in any bird or pinecone. We call back to those forms in the things we make.

Vesicas swarm up the terra cotta of Louis Sullivan's Guaranty Building in Buffalo. Vesicas are the stair balusters and the stained glass skylights of the lobby; vesicas surround the elevators. Sullivan's student, Wright, placed a vesica pool at the base of his Guggenheim spiral; there are two dozen more vesicas in the museum's plan. "Remember the seed-germ," said Louis Sullivan.

A building should be like a tree, said Frank Lloyd Wright. The comparison did not refer only to structural systems, such as the "taproot" foundations or "dendriform" columns he developed. The structural analogy to a tree has its meaning, its practical use, and its charm. But there is the flame of the tree to be considered. I think Wright was also saying a building should express the fire of life, the way a tree does.

Why is a feather like a fish? Why is a building like a body? The

Vesica patterns of the skylight in Louis Sullivan's Guaranty Building (1894), Buffalo, New York.

vesica piscis is a riddle and — for our time — a dilemma: in the past, there were supernatural reasons to include the sacred shapes. Now we are thrown back upon ourselves. Our culture no longer has any idea why the vesica is so important. How are we to get what ancient builders had — spirit — without their belief in spirits? In their superstition, they look childish; but we are far more ridiculous to deny spirit. The animal truth wells up, and we blurt it out on the sides of trucks.

In a dream I am canoeing on a deep, clear lake. My dark green canoe is like a giant vesica leaf. Silvery fish swim slowly twelve feet down. I

notice I am near a sandbar. On the sandbar is a gas station. I look around me. Car lots and fast food restaurants parade up and down the shores.

The formerly sacred geometry — the vesica piscis, the pentagram, the Golden Section — still comes out of us into the things we make. It is our nature. The world of architecture is still the world the ancient systems of geometry and measure describe. The architectural universe is local to us; it is the world we can see and touch. But the vesica and all of the other forms of ancient geometry are perceived mostly by the mind unconsciously, and such a mode of perception seems to be at odds with the modern way of seeing. The old fire-and-life symbol may seem more dangerous than it once did because we attempt to understand it through intellect.

The most famous vesica (or half-vesica) in American architecture is the top of the Chrysler Building, the single masterpiece of William Van Alen, who designed it in 1929. What could be more modern? What could be more ancient? Yet the form, for all its energy, is somehow superficial. Even without its frieze of giant hubcaps and its hood-ornament gargoyles, the tower would be a stunt, a pitch. But we do love it.

I believe the principles of growth and energy that underlie the vesica piscis in nature are knowable. I am not in love with the mystery for its own sake. But the way we know the vesica piscis, the way we know all pattern, will always be in darkness, because it is largely unconscious.

The Nothing

John Donne's "Negative Love or The Nothing" is a song of intuition.
Donne leaps into blackness, the unknown dark, and there he finds
a goal worthy of his love, only there in darkness, where the intellect
sees nothing.

> I never stoop'd so low, as they
> Which on an eye, cheeke, lip, can prey,
> Seldome to them, which soare no higher
> Then vertue or the mind to'admire,
> For sense, and understanding may
> Know, what gives fuell to their fire:
> My love, though silly, is more brave,
> For may I misse, when ere I crave,
> If I know yet, what I would have.
>
> If that be simply perfectest
> Which can by no way be exprest
> But *Negatives,* my love is so.
> To All, which all love, I say no.
> If any who deciphers best,
> What we know not, our selves, can know,
> Let him teach mee that nothing; This
> As yet my ease, and comfort is,
> Though I speed not, I cannot misse.

"My love, though silly, is more brave..." What moves me in
Donne's poem is that mixture of humility and courage. He risks fol-
lowing what he does not understand, walking right into the unknown.
What is most important to him cannot be understood. What seems to
be nothing contains the mystery and source of "perfectest" love.

Donne describes the primacy of intuition over intellect. What we know, study, understand, control, is lesser. The details of prettiness, the moral virtues, are a lower sort of love. But intuition and grace, its goal, are invisible and dark, "nothing" to intellect, "silly." Intuition goes where intellect cannot reach, without effort and outside of time. It is the shift to the old way of seeing.

Poetry, flat and silent on the page, often doesn't reach me. Set to music, however, it comes to life. In John Adams's setting of Donne's poem, part of the composer's "Harmonium," the words that seem abstruse in print are full of meaning. Adams builds the music to a crescendo at the lines

> If any who deciphers best,
>> What we know not, our selves, can know,
> Let him teach mee that nothing

What Donne calls the Nothing, I sometimes think of as the darkness. In architecture, the Nothing is also space. In architecture, shadow and space are real. The shadows in a building are *the* darkness, in my meaning of the word, the unknowable power behind love and life. In buildings, shadows and space do not *symbolize* the Nothing, or grace; they do not *represent*, they *are* the Nothing, there, in the present, in the building. But if one arranges shadows consciously to create the effect that one is "there," in the real darkness of intuition, such manipulations will weaken the design: "For may I misse . . ." The mystery of grace is not an effect.

The part of us that grasps the reality of the Nothing I call intuition. I do not mean feelings. Not that feelings are bad, but intuition includes judgment, and if there is one thing feelings are not about, it is judgment.

Architecture is intuitive. Intuition, as I mean it, is entirely reasonable, but only within one's own experience. Intuition tells me what is

important *for me,* "true" *for me.* Science is often counterintuitive. Science tells me the brick wall I have just built is mostly empty space. What can an architect do with such information? I must leave behind the intellectual point of view for a time if I am to design a building that is to be a place. I do not throw out the practical facts (I need to know how much weight the wall will support); but I change my point of view in order to design using the facts intellect has given me. My intellect may tell me that mixing up "love-grace-the Nothing" with buildings is childish at best; but my intellect cannot make a place.

> Unreal City . . .
> Unreal City . . .
> Unreal . . .

The words are strewn through T. S. Eliot's *The Waste Land.* While he was working on that poem of modern dissociation, Eliot gave a talk about Donne's way of seeing, the old way of seeing. "Tennyson and Browning are poets, and they think," Eliot said, "but they do not feel their thought as immediately as the odour of a rose. A thought to Donne was an experience . . ."

The split from intuition Eliot describes is also found in architecture; Donne's "Nothing" is absolutely real in architecture. But intellect, cut off from intuition, cannot perceive this Nothing; hence the slightly derogatory "Metaphysical" label critics applied to Donne, who was entirely concrete about his experience. Donne could see that the Nothing was real.

Darkness

*Little is to be expected of that day, if it can be called a day,
to which we are not awakened by our genius . . . to a higher
life than we fell asleep from; and thus the darkness bear its
fruit, and prove itself to be good, no less than the light.*

— HENRY DAVID THOREAU

I have just come out of an early-eighteenth-century house in Dennis on Cape Cod. On the outside the house has that familiar mysterious charm. It is just a little "off," a little asymmetrical, and it looks like an old temple. Not literally — it was built a hundred years before the Greek Revival facsimiles — but it has that old-young-wise feel. Inside, however, the rooms were not much more than compartments. I did not want to stay in them. They were not delightful. I wanted to get out again. The inside seemed secondary to the outside.

The average eighteenth-century American interior does not have much excitement in the daytime. The important space seems to be the outdoors. The inside is dim, the windows seem a little too small. The rooms are not interestingly shadowy, they are just inadequately lighted. The furniture seems too big, the ceilings too low. In the daytime such rooms usually became backgrounds for the tables and chairs and chests and desks and for the clothing of the occupants. At the house in Dennis the question tugs on me: why does the outside come to life and not the inside?

A year later I visit a similar house at night, and there I have my answer. The furniture fades into the dark. The shadows belong there; by candlelight they become deep rather than dreary. Little objects off in the corners sparkle. The ceilings and the windows are no longer too

low, because we are sitting down. The eighteenth-century interior lives at night. That is when it is meant to be seen. And the outside is meant to be seen by day.

There is a kind of darkness whose meaning is fecundity rather than death. A building can be like a body, and inside our bodies, it is dark. We have become unused to the intimate darkness. Even more than the old American houses, the old interiors of Japan were designed for darkness.

> At the edge of the little circle of light, the darkness seemed to fall from the ceiling, lofty, intense, monolithic, the fragile light of the candle unable to pierce its thickness, turned back as from a black wall. . . . It was a repletion, a pregnancy of tiny particles like fine ashes, each particle luminous as a rainbow. . . . The elegant aristocrat of old was immersed in this suspension of ashen particles, soaked in it, but the man of today, long used to the electric light, has forgotten that such a darkness existed.
>
> — JUNICHIRO TANIZAKI

Imperfection

Something draws us to imperfection — "that hint of ugliness without which nothing works," as Edgar Degas is supposed to have said. A ruined building has a wildness about it and, at the same time, an inherent discipline. An eighteenth-century house that has become rundown can be very alluring in its way. It keeps its rhythm, its form, but it begins to be a little more like an old tree. It still has its outlines and it still has the old power, but the civility has been stripped away.

Eighteenth-century designers seem to have been conscious of the danger of being too perfect. Many houses of that time have what

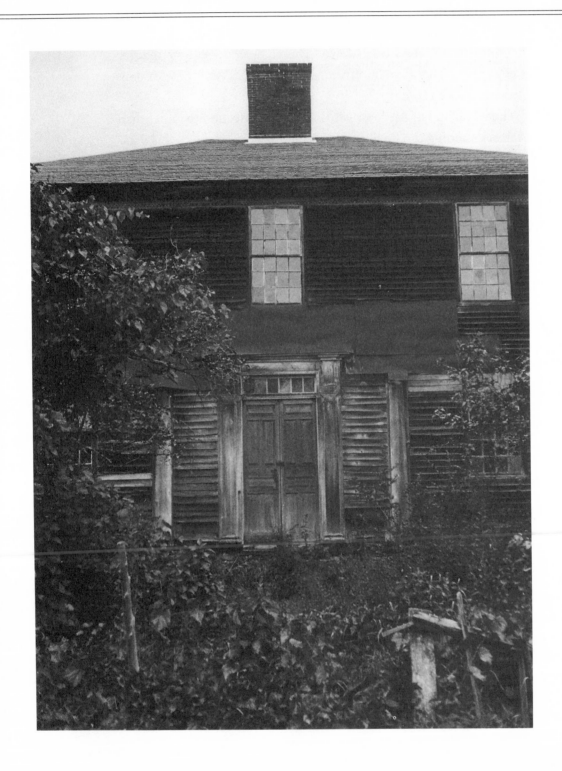

THE OLD WAY OF SEEING

Opposite page: The William Burtch House, Quechee, Vermont (1786). In decay this house is less genteel and its lines are more powerful. The same qualities of imperfection, wildness, incompleteness, cause many architects to like their buildings best before they are finished.

The Nathan Winslow House in Brewster, Massachusetts, would have been called a "three-quarter house" when it was built in 1738. Its force comes from the struggle between dignity and lopsidedness.

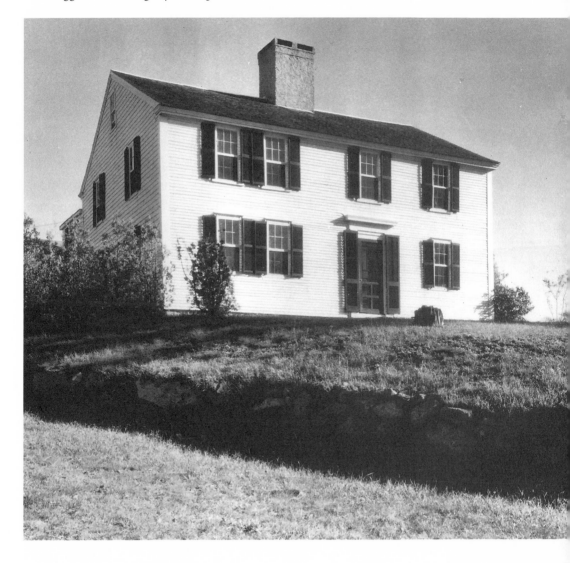

appear to be deliberate "errors." The rhythm will be thrown off by a foot, so that one of the bays is just a bit wider than the others; this can happen in quite an elegant house. Such variations are often part of the original fabric.

Gothic cathedrals are famous for such vagaries. The cathedral will be going along serenely, and with tremendous order and complexity, when suddenly it will take a little bend, or perhaps a fairly large bend. Chartres, for example, goes off center; so does Notre-Dame. It used to be thought that this happened because the walls were following old footings or for other structural reasons, or that the builders didn't have the technology to be accurate. I think there is another reason, the human sense that too much perfection is a bad thing; you don't make your building too perfect, you throw it off in some way.

But the cathedrals go far beyond the mere inclusion of an occasional flaw. I think it was the conscious and deliberate purpose of the builders to express both death and life in the great churches: inconsistency and decay amidst order and beauty. The cathedrals embrace mystery. They are meant to embody eternal radiance amidst all the aspects of being, the qualities we love and the qualities we fear and hate. There are the exuberantly perfect rose windows and the myriad harmonious patterns hidden in the plans and elevations; and there are the glaring mistakes, the arbitrary changes, the shadows, and the cabalistic secrets.

Above the arches of the aisles but beneath the highest windows in many Gothic churches is a windowless band of arches and columns, the triforium. The shadows of the triforium evoke fear. But above them is the glass, heaven. Just as death is explicit in many Gothic sculptures, death is implicit in the architecture itself. It is more visible today, now that the brilliant paint and gilding and tapestries are gone, but it was always there.

The cathedrals are shadowy, like ruins; their flying buttresses and ribbed vaults, where the skeleton is exposed, are like pieces of ruined

The Church of Saint-Severin in Paris. Gothic forms embody both sides of life, the side of decay and death and the side of growth and joy and birth. The buttress soars, but it is faintly repellent, like a bone in a carcass.

buildings. The cathedrals are unfinished. None was built as its first master intended. As successive masters took over the design, they respected not the first master's total concept but the principles the first master followed. Like a cathedral, a ruin also embodies both life and death. But a ruin is accidental; it cannot be used or replicated. A cathedral is a working building.

Taste and Tension

Some people dislike the ponderous, dark buildings of Henry Hobson Richardson (1838–1886). I think his architecture is wonderful, but that taste was acquired. In the 1950s, when I was discovering architecture, the models for good design were crystalline, clear, and light — glass boxes, like Lever House on Park Avenue. The work of Richardson was hard to look at. But Richardson used the same principles of pattern that made the moderns great. On top of that, he had wonderful textures; and shadows — there are so few shadows in modern buildings; and substance, all that rock; and color, red and brown buildings. Richardson's buildings squat like trolls. Richardson himself looked like his buildings, fat and hairy. But he knew his forms, the ancient natural shapes. Richardson's architecture shows how buildings can be tactile and physical, and at the same time keep the old grandeur, the old presence.

In Richardson's buildings, the pull is often between rich, subtle proportion and rough, heavy materials. Richardson designed the Crane Library, at Quincy, Massachusetts, in 1880. Eyebrow windows, tiny dormers, form a rippling wave across the roof. The wave is pretty, in its way. But the windows are also like the half-opened eyes of lizards — reptilian. They are called eyebrow windows, but really they are eyelid windows. There is something faintly repellent about those

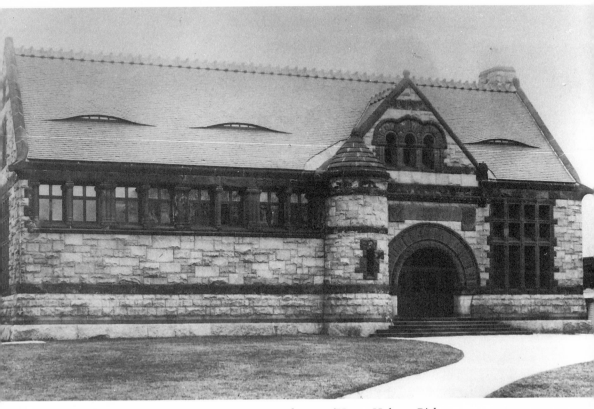

Thomas Crane Public Library, Quincy, Massachusetts (Henry Hobson Richardson, architect, 1880). What makes the roof fascinating is the beauty of those rippling waves and the repulsion of those slit eyes. Do you dare walk through that door? The black shadows and the wall of stone say "No!" The geometric composition, as delicate as a flower, says "Yes!"

half-closed lids. What makes the roof fascinating is the beauty of those rippling waves and the repulsion of those slit eyes. One doesn't want perfection in a building, one wants some discord.

Design elements that play against an underlying system of regulating lines get our emotional attention. In the Jonathan Stone House the conflict is within the pattern itself; the riddle of the "missing" window creates a special mystery. The Stone House also gives us con-

trasts to pattern in the streaked and sensuous red brick. Other buildings may create most of their tension *against* pattern rather than *within* it, as in Richardson's rough stone buildings, whose components are arranged with the delicacy of flowers.

In the International Style the conflict is between the artificial building, the machine for living, and nature, the land itself. In many International Style buildings, there is also tension between the exaggerated separation of the building from nature and the use of natural proportions. This approach comes out of the old Classical tradition of the Greeks, the Romans, and the Renaissance: the building set apart but encoding natural principles. The Classical building does not ignore its site; the Parthenon and the other buildings of the Acropolis are beautifully and subtly oriented to their surroundings, as Le Corbusier and others have pointed out. Le Corbusier also experimented with the idea of discord by making very rough-textured buildings of board-formed concrete. To describe such designs, he used the term *brut,* "rough"; this became "Brutalism" in English, but in French it has a less ferocious sound; it relates more to our animal quality, beyond intellect.

American landscapes often have a kind of scruffy messiness that has its own appeal. You see it on secondary highways — the billboards, the motels, the truck stops. We all know those roads; there is something tacky but comfortable about them, something a little tough, a little raw. Such a landscape violates every principle of design — except, perhaps, one: do something wrong. I do not refer to the strip. The strip is its own world; it has a very different character from the occasional garage or billboard or roadhouse. The strip is urgent and hostile; it no longer says it's okay to relax, it's okay to be casual.

I come upon a picture of a shiny old diner that is very attractive as a form. I run a straightedge across the photograph. I find that the building is a strong, symmetrical, tightly ordered composition. Glitz

The tension between glitz and geometry makes the Midway Diner, in Rutland, Vermont, interesting. If you carry the regulating lines up to the left and right, you will see that the photographer has tied in the street lamp and the telephone pole.

and nostalgia give an interesting edge to its form. The old elemental rules determine its shape; it sings the old song in its carnival way; it gives more than it takes. What is pleasing about the building is the tension, the tug between its strong lines and its cheesy effects. Newer fast food restaurants leave out this tension. Their jingles and bright colors are not play; they are all business.

Neatness can be just as deadening as the strip. In New England, neatness takes the form of signage control, spotless shopping districts, tidy sidewalks, neat little Neo-Nothing houses. At the scale of a street, the whole world can seem to go dead. Suburban propriety is really the

flip side of the strip, which may be a block away. It is all emblems. Each neighborhood slams the door on the life principle.

I think there is room for mess and room for harmony. There is no room for deadness, which is to be alive but cut off from life. Deadness is not the same as death. A ruin is an expression of real death, and we find this moving. Some of the most passionate architecture in the world is ruins, where real death has come.

A great deal of snobbery went along with the former idea that taste could be good or bad ("vulgar," after all, meant "common"). But while our society has accepted the common, it has also continued to assume that what is common is trash. We have decided to choose egalitarianism *instead of* beauty, as if we had to make a choice. And we have thrown out responsibility along with snobbery. We have ignored the social pattern, as we have ignored geometric pattern. When we look at our cities we see right away that irresponsibility doesn't work, and we tend to ask the government for more regulation. But the discipline that brings a city alive must be spontaneous.

Why There Are Angels at the Top of the Bayard Building

The buildings of old Broadway are of the end of the nineteenth century, the time Lewis Mumford called "the Brown Decades." They are caked with decoration: corbels, crockets, pediments, brackets, pilasters. They are too somber, too narrow, too high. But some of them are fine in their way. This was the center of New York a hundred years ago, and now it is coming into its own again.

As I turn onto Bleecker, there suddenly rises up something quite different, the Bayard Building, by Louis Sullivan. The building is so much finer than its neighbors, it is like stumbling across some Gothic masterpiece off on a side street. But it is just another 1890s office building, not brown but white-glazed terra cotta. More than color

sets it apart. The building is sensual, and it is a bit magical in the evening light; but most of all, unlike its neighbors, it is sure-handed. That is what is so pleasing. "Lieber Meister," Frank Lloyd Wright called Sullivan; and that is the character of the building, love and mastery.

Six giant angels spread their wings under the cornice. Years ago I used to walk downtown and admire the Bayard Building, but I saw it in the context of Modernism. Those angels above those frilly arches were a disappointment, they raveled the clean white proto-skyscraper lines. It is much easier to appreciate Sullivan now that I don't require him to be a precursor of the International Style. I see, for example, that removing the extraneous does not have to lead to plainness, as Modernism believed. It may reveal, or make possible, richness. Compared to its neighbors, the Bayard Building, though heavily decorated, does look simple because its patterns are very clear. Looking straight up, you can almost see the regulating lines running diagonally through the spandrels to the leaf-clump capitals that are the springing points of double arches, and on up to the faces of the angels.

Sullivan's simplicity is not spartan. The streamlining that came later to tall buildings made the eye move faster; but the top of the

Overleaf: The Bayard Building, New York (Louis Sullivan, 1897). Sullivan wrote:

> In such times came the white-winged angel of sanity.
> And the great styles arose in greeting.
> Then soon the clear eye dimmed.
> The sense of reality was lost.
> Then followed architectures, to all intents and
> purposes quite like American architecture of today . . .
>
> That she awaits,
> That she has so long awaited . . .
> I can prove to you beyond a gossamer of doubt.

Bayard Building is slow. Embellishment can be annoying to an eye not accustomed to lingering, but the Bayard Building slows you down because it is already *there.* Sullivan's building is "the thing itself," as Montgomery Schuyler said of it when the building was new. Simplicity, for Sullivan, was not ascetic purity or virtue. Simplicity was to be, as much as possible, there, in the present moment. As the eye becomes involved in the pattern of a building, the viewer is taken out of time. The viewer's experience is a parallel, a match, to the eternal moment in which the architect made the design. In such moments, spirit comes into, and can be recognized in, a building. Sullivan's angels are a sort of Eureka! They proclaim the building's spirit.

The *presence* of the Bayard Building is an expression of Sullivan's mastery, which is the ability to organize material, function, structure, symbol — and still be in the dark.

Towers

I stand at the foot of a skyscraper from 1929, on Wall Street, looking straight up at this great, black tower. Close up, in among the shadows that it casts, I feel exhilaration and excitement, but I also feel fear. Almost any building that is sixty stories high will have an element of cruelty to it, a sense of danger. I am not sure that is altogether a bad quality in a building.

From a distance, skyscrapers sparkle and are romantic. From a distance, we look at the spires and imagine ourselves up in them. What we love about the spires is the way they evoke the sky. In our minds, when we look at tall buildings we go to the top. But down on the street, the architect had better provide something small, because people are not very big. So you bring the tower down to the street at a more human scale. And then you let that power, that unbelievable power, rise up.

Skyscrapers are anthropomorphic. If, in a drawing, you represent a person with a small head and a big body, that person will be read as tall because tall people's heads are small in proportion to their bodies. If you make a gigantic tower loom up to a tiny dome or a little spire, the building will seem even bigger, even more immense, and more exciting, more soaring, but sometimes more frightening.

The Modern movement pretended not to be cruel in its gigantic buildings. In Boston, the Federal Reserve Building, for example, is one of the city's more elegant skyscrapers. It is a light building. The walls are of glass and aluminum. Inside is a big sunny lobby and big plants. But armed guards patrol the lobby, and at the base of the tower are gun slits and bulletproof windows.

Some of the more recent towers seem to be deliberately forbidding, with their harshly detailed embellishments, those cold steel shields. Why do these buildings set out to look hostile?

For some skyscrapers winning is the only thing. A tower may be the biggest building in Cleveland or Cincinnati or Detroit. But there is something "off" about a building like that, something wrong, because it takes over the town, while it participates in only a narrow aspect of its life. Only in cities like New York or Chicago, which have so many towers that they form a landscape, and only at a distance, do the towers cease to threaten.

I acquired some of the thrill I feel about architecture from growing up in Manhattan in the fifties, when it was still the 1930 city of magical towers. Each one was a special adventure that everyone shared. That was the city Le Corbusier called the "fairy catastrophe," an architecture of frivolity and power.

Shortly before 1900, New York took the leap into the time of the great towers, when it began to put up buildings that were twenty and thirty stories high. Once they had built a few of those, the scale of the city jumped; there was no going back. There is a note of fear in some of the early commentary: What have we done? Where are we going?

Do we really want them there, all looming so high? Djuna Barnes wrote, in 1917, "New York rose out of the water like a great wave that found it impossible to return again and so remained there in horror, peering out of the million windows men had caged it with."

There are many very good skyscrapers, but almost no great ones. There is the Seagram Tower in New York and, maybe, Wright's Price Tower, in Bartlesville, Oklahoma — but that is a skyscraper only because its city has no very tall buildings. Like Sullivan's thirteen-story Bayard Building, the Price Tower is marginally a skyscraper.

There are, of course, great skyscrapers; but they are eight hundred years old. The cathedrals are great because they are full of grace. But isn't it possible for any kind of building to embody grace? I think we could have a kind of greatness in our towers, something beyond power, even in their cruelty. Contemporaries of the cathedrals remarked approvingly on their fearsomeness.

There may be a limit to how great a skyscraper can be, because the primary purpose of the skyscraper is to express corporate power. That purpose is too narrow to admit much of the larger power that comes from play, and that leads to grace. The metaphysical cathedrals were much more down to earth than the skyscrapers of our time. It may be that the only buildings that should be as big as skyscrapers are buildings that reach out to everyone, buildings that embody the aspirations, the greatest dreams, of the whole community.

Gothic Cathedrals

We go into a cathedral, and we know that we are in a space that has a pattern of the sort that we have. We know it fundamentally; we don't think about it. To enter the darkness of the cathedral is almost like going into the darkness inside a body.

Whatever weaknesses the cathedral builders had, or perhaps because of them, perhaps because they didn't know too much, they were able to tap into a source of great power. I won't say it was energy, because the energy we feel may be something which we bring to the building, something brought alive in us by our experience there. But that isn't how they sensed it; they thought the energy was there, created by the building itself.

We walk through a community that has been designed the way the Gothic cathedrals were designed, by many different designers all using the same strong principles that come from life patterns and geodetic measurements, which do have a spiritual meaning even if that meaning is lost to conscious memory, even if it was not known consciously by the designer. When we walk through such a place we get some of the same feeling we can get in a Gothic cathedral. What we find in the old towns of Europe, what we find along the streets of Newburyport, is also to be found at Chartres. We are made aware of the unity of underlying principle in the forms we see and the forms we are.

The Gothic cathedrals involved the contributions of various masters, but each designer could trust the next to continue the work in a way that would be constant and beautiful. The changes introduced from one master to the next might be radical or as small as a different way of carving a molding; but the inconsistencies we see do not come from any lack of skill or vision. It was not that people were too primitive to notice the differences; the subtleties of the great cathedrals are unsurpassed. The variations expressed respect for the other designers and for the principles within which they all worked. The work shows a profound spiritual belief in proportioning systems, a belief that goes beyond what is expressed by any structures built since. They were not attempting to produce beauty alone. Their purpose, like that of the builders of any temple, was to embody the aspects of universal spirit.

The Gothic carried on a way of seeing that had existed for centuries, but the style itself came into existence rapidly around 1130. Its development was not reassuringly slow. Tradition of style or structure was not what guided the Gothic; ratio was its ancient authority. The numbers the Gothic builders used were the dimensions and proportions found across all cultures and across all times. Every church held multiple layers of number, pattern, and form, each with its own meaning. The Gothic builders also apparently believed that structural lines of force followed the lines of harmonious proportion, and here they were flagrantly wrong. We smile at their naiveté, but when we enter a cathedral we know its power is, somehow, absolutely real.

Now extend this way of seeing out from the cathedral into the community. Assume that each designer has a different way of designing and a different way of building, but that each uses the same underlying principles. These principles are not arbitrary; they are *the* underlying universal principles of living form, expressed in dimensions that are both geodetic and human. There is no reason we cannot build communities this way today. I build a building, you add something to it. I build this part of the building, you build that part. We build a building on one side of the street. Thirty years later someone else puts up a building, of a new material, on the other side of the street. And they work together.

6

Context

What attracts me most about old buildings is not their quaintness or the knowledge of what happened in them, not age or history. I am attracted to what I call their smile, their slightly mysterious *presence*. I get exactly the same feeling in front of a new building that embodies the old harmonies. When it comes to spirit, I draw no fundamental distinction between old and new. But the quality I value is much more common among buildings of the past than among the buildings of our time.

Something *is* the matter with many new buildings. In an old city like Boston, committees are set up and regulations written to make sure new buildings do not destroy the feeling their old neighbors still give. In the past, builders were able as a matter of course to design buildings that other people would like. It was assumed that new buildings would be right, as it is now assumed they will be wrong.

"Contextualism" has been the design profession's recent answer to the problem. Contextualism makes older buildings the basis for new

design. Style, material, and size are the main criteria. Proportion gets less attention. Contextualism — the dryness of the word! — is a form of political correctness. You can't very well be against its intent to save the beauty of old neighborhoods, but its method is too narrow. It puts new buildings at risk of becoming dead replicas or meaningless "background." In the absence of any higher standard, contextualism may drag a design down to the level of whatever happens to adjoin a particular building lot. That may be pretty good or it may not.

Unreal City . . . Even when we want to make the city real again, we make buildings that are *about* other places. Even if the place a building is "about" is right next door, the new building risks unreality. Its references to its neighbors will be unconvincing if it does not have enough relationships within itself.

Many buildings that try to be contextual ignore the patterns of their neighbors altogether. Any building is as real as the next, but it is play of pattern that makes a building *feel* "real." Style, color, scale, historical accuracy, craftsmanship, all must be part of the music of pattern. If there is no song, all the rest counts for nothing. Every building must make its own music in order to contribute any sense of place to its city.

> To come and go where East Eleventh Street, where West Tenth, opened their kind short arms. . . . There I repeat, was the delicacy, there the mystery, there the wonder, in especial, of the unquenchable intensity of the impressions received in childhood. They are made then once for all, be their intrinsic beauty, interest, importance, small or great; the stamp is indelible and never wholly fades.

Henry James and I grew up, a hundred years apart, in the same neighborhood of Manhattan. I know the place he describes; I know exactly what he means. We often wish we could return to the place of our childhood because we were so fully *there*. However, authenticity

— what we want — is not a matter of permanence, of immutable historic districts. Those who built West Tenth Street so that it came alive were not trying to stop time. But they were not lost, as we are.

I still see myself reflected in New York as I see myself reflected in the woods. New York does come alive in that way. But places do lose their vitality; the tomatoes really don't taste as good as they used to. New York, like our wild forests, is broken. And this injury did not happen in 1830 or 1907, when James wrote, but in our day. Most of the new buildings that have gone up since I played on West Tenth Street are a form of damage worse than any neglect. When you build new, you want to believe you are offering something better, but it is as if New York City had become doomed to build itself out of existence.

In Boston, Suffolk University has built a new facility adjoining its old red-brick neighborhood of row houses. The new structure is encased in what look like several smaller buildings of the early nineteenth century. There are breaks in the roofline, changes in the brick; it is all quite convincing as you drive by, but one close look tells you it is a ruse.

The building faces a commercial street of mixed architecture that ranges from a two-hundred-year-old mansion by Charles Bulfinch to a cold 1960s International Style skyscraper. The new building is even colder, but in a different way. The best word to describe it would be "realistic." It is like a city scene on a studio lot. The building is reasonably well proportioned, but what draws one's attention is the elaborate trick. Was that building always there? Is it one building or two or three? I suspect this accuracy was not meant to amaze, but to make the building as unobtrusive as a good toupee, so that it could fade into the crowd of "real" buildings.

After 1945, the obliterated center of Warsaw was reconstructed to look just as it had before the war. Old Warsaw is now a lifesize replica of its former self. I can understand why the Poles felt they had to do

this. Warsaw had lost everything, and the old streets were beloved. Perhaps it was also a gesture to the Nazis: you can't destroy us! But the Nazis were gone, along with the old streets. I think some similar anger hides in the Boston reproduction. Such a design is as much against the new — anything new — as it is for the old, or some memory of it. I don't know how the people of Warsaw feel today about their reconstruction; but here in Boston, I don't think people love the pretend façade, as we do love our surviving old buildings. Nor are we are supposed to love it; the façade is meant only to defer to its old neighbors. The designers of such structures forget they are not just building within some previous context, that every new building creates a new context. The context they have created is a movie set of the past.

A monograph on a well-known architectural firm discusses one of the firm's designs. The building looks different from every angle. It is explained that this side addresses a vista, that side responds to a neighbor; a large sign relates to a planning board policy; an oddly shaped spire on the top is meant to evoke sails, which have to do with the history of the city. Materials and colors change from one side of the building to another. The design resulting from all this information is not riotous but slightly surreal. The architect talks about harmonizing with the neighborhood and with the history of the city, but his building is so contextual it forgets to harmonize with itself. It is a series of answers to other people's questions. The building is such a strange conflation, it requires a running commentary by the architect to explain what it "addresses" or what it "speaks to." I do not think a building needs to speak. I think a building should sing, but no, it should never just speak.

Pattern is the quality that tells us most deeply that a new building relates to the old buildings around it as well as to people and to the world. Perhaps the most contextual thing a designer can do for a community of old buildings is to graft an old proportioning system

right onto the new building. But where the design goes from there should remain much more open to choice than our committees now like to permit. Such a combination of freedom and discipline is the reason an old town like Newburyport works so well. There a 1740 building and an 1840 building have similar underlying proportioning systems, although their styles, and even scales, may be very different. A Victorian bay window enhances its eighteenth-century gambrel house because the new addition continues the old regulating lines. What is actually a very different style — more glass, less wall, more trim — aligns with the old proportioning system. We don't notice any anomaly. The contrast of styles is stimulating.

A worthy contextual goal would be a return to the universal criterion of proportion, which goes with the territory of being a person, not just with the territory next door. If we designed that way, we would have the beginning of unity among buildings with very different styles, uses, materials. And then we would not have to worry so whether the next new building might be wrong for its location.

How tempting it would be to make a rule book of proportions. It was done often enough in the Renaissance. But I do not think we should rigidly specify the use of ratios or systems, except, perhaps, in such cases as additions to important buildings that are already strongly proportioned. Good proportion is not the final end of design. The primary purpose of external rules should be to strengthen the designer's ability to play. In that context, more information about proportion would be very useful to designers.

A new building will not fill a gap if it does not come alive, but how do you make such a requirement? Guidelines often get entangled in this problem. Some places do deserve careful contextual regulation, but even in those cases, I would rather err on the side of originality than on the side of deadness. It is not the past we want back but the life the buildings of the past embody.

When Planning Is Not Enough

The job is not to "plan" but to reveal.
— BENTON MACKAYE

The planners Andres Duany and Elizabeth Plater-Zyberk have rein-troduced concepts of town design from the time of the old way of see-ing. They have brought to awareness ways of planning that were taken for granted in an earlier day. For example, in a plan by DPZ (as the team is known), buildings are often close together, as they were in old towns such as Newburyport, and vistas lead to significant buildings. There are many guidelines and restrictions on design and materials. The planners have put together valuable and positive ideas for a num-ber of communities. They have created a structure for design that is potentially more beneficent than the usual suburban approach — those houses dotted on two-acre lots, office buildings isolated in a sea of pavement, gigantic shopping centers.

In Gaithersburg, Maryland, outside Baltimore, DPZ has planned a three-hundred-fifty-acre development called the Kentlands. The site plan shows groupings, views, destinations, interesting variations in street pattern; there are green clusters of trees, red roofs, enticing blue ponds. The sense of community, the sense of place, leaps off the plan. But the finished buildings themselves undo that sense. The Kentlands looks like Belmont.

The house styles are based on the architecture of the eighteenth and early nineteenth centuries — the time when everyday design still came alive. As in Belmont, the houses have a bit of variety; the idea is to make the street look as if it had been built over time. The buildings are not harsh to look at. But something in us knows we are looking at an imitation.

The Kentlands, Gaithersburg, Maryland (1990). All the codes in the world cannot turn this street into a place.

The buildings of the Kentlands do not concern themselves with historical accuracy. A big gable faces the street in the Greek Revival manner of 1830, but the detail on it is 1780s Georgian. The model for such design is the familiar fantasy of the Colonial past. The design source of the Kentlands, like that of much Post-Modern design, is not 1720 or 1820 but 1920. Not that Colonial correctness would have brought the street to life. The Neo-Classicism of eighteenth-century American buildings was never historically correct. Those buildings

used some Classical detail, but they had little else in common with Roman architecture — except proportion. They carried on the ancient patterns, and this the modern imitations fail to do. Unlike the designers of the Kentlands in 1990, the designers of 1790 aimed to delight the eye and the mind and the heart through pattern. The designers of 1790 aimed for grace, and that is how they achieved the sense of place that eludes Kentlands.

Andres Duany seems to acknowledge this failure when he complains, "We have taken on an agenda to actually reform American urbanism, and what people notice instead is the style of the buildings, blaming us for the fact that many architects are trained to be subnormal designers." The solution to this "subnormality," Duany argues, is intensive design regulation through codes. But such rules can make the designer's job too simple: just meet the code, don't design. The training of architects has its flaws, but there are many architects today who can bring a building to life. If planning is to reform American urbanism, then the planner must provide a framework in which buildings can come alive. "If we succeed where others have failed it will be because we are obsessed with codes," says Duany. The buildings of Kentlands only *appear* to be logical because they fit those codes. Architecture has a different logic. If, for all the careful regulations, Kentlands fails to become a place, then its planners, as much as its architects, have failed. A town plan is a structure whose purpose is to make room for life to happen.

A design *can* come alive within the limits of strict rules, but only if the designer has a larger goal, which is to imbue the design with grace. The code maker must share that goal and must recognize that the code itself is subservient to it. There were restrictions of many kinds in the days when buildings came alive. But no code required the old way of seeing. If we could devise such a code it might say something like this:

The process of design shall be play. The designer shall experience great pleasure in the work, or the design shall be deemed to have failed. A rich geometric pattern shall underlie the design. The designer shall not be aware of how this pattern was arrived at.

We feel welcome among real buildings of the old styles — among Georgian houses, for example. We see their old beauty, simplicity, and charm, and we want that for our own buildings. But we can only hold on to the elements of the past that are still alive, and what lives or dies is not up to us. Victorian buildings looked ghoulish to the designers of 1920. Those designers wondered, how could the Victorians have abandoned the sweet simplicity, dignity, power of the eighteenth century? We will have it back! But the Victorians were braver and more honest than our Neo-Colonialists; they were off on their own journey, trying out new things — or old things in new ways.

I believe places like the Kentlands arise from a belief in weakness. Their planners leave no room for designers to play because they think (Duany says it explicitly) that most designers are incompetent. The hollowness of the Neo-Nothing suburb reinforces society's sense of design failure.

No amount of zoning, increased or decreased density, structural expression or concealment, energy efficiency, traffic control, vistas, open space, regulation of style-height-material-use, will bring back the sense of place. Our towns make us feel lost and insecure, but the enduring sense of place does not come from friendly circulation patterns, festive signage, or sweet memories. It comes from the gut recognition of form and pattern. If you want to feel you are in a *place*, go to the Yucatán, to Chichen Itza, which hasn't been occupied for a thousand years. Only one memory is awakened in such a place, the memory of who we are.

The Elihu Coleman homestead, Nantucket, Massachusetts (1722), rear view. The inventors of the Shingle Style recognized the harmonies among the casual addings-on and began to imitate them.

The Shingle Style

Style is a series of cues, not a language so much as a *gestalt*, a cluster of meanings and methods. When you force the designer to turn back the clock of style two hundred years, you make it hard for intuition to play. But it is fine to borrow from the past. That is what the Shingle

This Shingle Style house, built in 1882, borrows what it pleases from the eighteenth century, turning all its elements into a free but highly ordered composition of textures and shapes.

Style does (Vincent Scully coined the term in the 1950s). The Shingle Style was brought into being in the 1880s by a number of well-known architects, most notably H. H. Richardson; but it quickly became a vernacular way of building, perhaps the most visually successful we have had. The Shingle Style takes a little from this and a little from that and puts it together. The style is selective, however; it is careful to borrow elements that work well within a composition.

The unwritten code of the Shingle Style refers primarily to elements that define edges and surfaces, and those elements may remind us pleasantly of Colonial houses or other styles we enjoy — there are hints of Tudor and medieval styles, for example. The Shingle Style

works because it is relaxed about correctness and precedent, but always strongly organized into pattern. The code is unspoken, so it does not impede the visual process.

The Shingle Style took inspiration from the old wooden Colonial houses, but it added a slightly sentimental poetry that the Victorians liked. The inventors of the Shingle Style took the old, crusty, dilapidated houses and looked at them from the back or the side instead of the front. They were interested in the sheds and additions and in the implications of history and romance; and they designed rambling, free compositions.

The compositions were free, but they were also imbued with proportion, and they were often quite beautiful. They used Colonial elements — scrolls, dentils, multipaned windows at a time when large-paned windows were relatively new. But the small panes were there for texture, not as devices to make people believe they were actually in a Colonial house; there was not the slightest pretense of historical replication. The eighteenth century had been superb at finding the right touch, the right detail, so the Shingle Style designers took the Colonial elements and used them freely; they spread them around on houses wherever they pleased, but in ways that were not disordered.

In its point of view and use of historical reference the Shingle Style differs from the Neo-Colonial, which was an attempt to create a Colonial effect rather than to create patterns. Somewhere in the ethos of the Shingle Style was the message, the house is a composition.

One element the Shingle Style doesn't know, doesn't address, is space. You don't look *through* a Shingle Style house; it isn't exactly heavy-looking, but it is opaque. The interior space feels carved out; the space itself is inert, it doesn't flow, even though the plans are pleasantly loose. In that sense the Shingle Style is entirely Victorian. But the rooms have what you expect but seldom find in an eigh-

teenth-century house: play of light and shade, interesting nooks and crannies. Inside and out, the shingle cottages of the 1880s are designs of delicious textures, strange blanknesses, shadowy intricacies.

Façades

Sometimes a building has an exterior but no real interior. One such building I designed contained a garage and some offices. After I had planned how to get from one room to another, made sure the storage spaces worked, designed a legal egress, and arranged the elements in a reasonably pleasant way, there was really no chance for architecture on the inside. In such a building, if you merely express on the outside what is going on inside, you will have nothing more than a box. The client for the garage sent my floor plans to a builder, who drew up an exterior that expressed just what was inside and no more.

When the client saw the result, he asked me to design a real façade for the building. So I played with the pattern of windows and wall elements. The result of my playing was an exterior that could be taken seriously. Does that sound artificial? Was it wallpaper? But the façade had a purpose, which was to make the building a place. Instead of being the honest expression of an interior that was architecturally nothing, it was the honest expression of a relation to place and people.

Many buildings are like that. Speculative office buildings are just empty floors, stacks of them, which somebody other than the architect is going to finish. The chance to turn those spaces into something special is limited: there will not be cathedral ceilings or fascinating vistas in every file room. These buildings are all around us. Inside they may be nothing much, but outside they are quite able to relate to the world as patterns in light and shade. The most important space in

such architecture is between and around the buildings. One can perceive the city and its streets to be *rooms,* of which the buildings are the walls, as Louis Kahn said.

On the outside, I think buildings have a moral obligation to reach out to the world. Ideally, the insides ought to be wonderful and magical as well. But when you design a thousand-unit apartment house, you must leave much of the magic to the occupants. Only in special cases or in special parts of ordinary buildings — lobbies, restaurants — does the inside become the opportunity for design.

With a curl of the lip, some architects call designing façades "wrapping." I agree that the practice has an element of compromise; the inside doesn't live up to the outside. But a façade is diplomacy, really. It is the way a utilitarian building takes its place in the world.

An eighteenth-century façade acknowledged other houses across the street, around the corner. It was a family's gesture of welcome, but also their screen from the world. To reach out with a harmonious façade was part of the social contract, and it was also a boundary.

The strong composition connected the house to its community. The serene and lively form was a contribution to its neighborhood. But the elemental patterns, the imperfection and the inspiration, also brought the house into contact with the living world of growing forms. Through its natural proportions and geodetic-human dimensions, the house was connected to the wide universe as well as to its local community.

The Victorian house shifted the emphasis from grace to social gesture. The goal began to be to influence the observer through symbols. As the significance of its symbols changed over the years, a house might lose the power to influence; to later generations the emblems, now meaningless, often appeared hideous or foolish.

Just after World War I, the suburban house became a representation of domestic security and national honor. Patriotism was associ-

ated with the Age of Reason, so the house often became an emblem of that age. But it did not embody the ideals of that age. To do that would have required intuitive play with pattern. Neo-Colonial suburban architecture relied almost entirely upon symbols: red brick and white trim, eagles and weathervanes, shutters, dentils, six-over-six sash. It was dress-up; it was the opposite of reason.

The twentieth-century house, like the Victorian, continues to emphasize effect, but the primary effect sought is normalcy. The twentieth-century house does not reach out in the eighteenth-century way, nor does it grab the viewer by the lapels in the Victorian way. The house of our day does not *wear* a mask, it *is* a mask: "home." The old way of seeing is openness to one's own experience. A mask used in the old way protects that inner openness.

Haute Architecture

> It is a building that is self-referential, it's about itself, and it is very difficult to engage, and I guess that is what draws me to it.
>
> — DESIGN AWARDS JUROR

An architecture magazine features two houses by architectural theoreticians. The first house is a pleasant little building; it has some nice spaces and a few charming details; it also has some flaws. And I can see nothing more to look at. But the article goes on for eight pages; evidently I am supposed to appreciate aspects of this house that set it apart from and above other houses. I keep thinking I must be missing something. I begin to suspect I was meant to feel this way, not quite smart enough to understand.

The second house is more interesting; it has nice lines; I find it

attractive. But again I am not getting the point, for the text says the architect "hoped to avoid 'the suppression of the actual' that comes from excessive reliance on visual expression at the expense of other senses." The suppression of the actual. Hmmm. If one understands the passwords, it is implied, one may enter an architectural world of special secrets. Well, *any* good house is full of special secrets. Words are a favorite mask of haute architects.

It is expected that an architect's masterpiece, like his words, will be weird, incomprehensible, outside the mainstream. That has been the role of the artist for at least a hundred and fifty years, and architects play it to the hilt. They don't have a lot of choice. If they don't stand out, they may end up designing "background buildings." To design a serene building — this is not a goal we hear about. "Serene" is not a word used by architects.

Other designers go beyond the arcane to the deliberately hostile: chain-link in the living room. They want to be exciting. Any designer wants to imbue his building with spirit; but we tend to define spirit only as excitement, and spirit means more than that. The synonym for spirit is soul. Buildings that don't have real spirit leave us ill at ease. Being ill at ease, however, can be a form of excitement, so discomfort is often sought for its own sake.

To design a hideous building on purpose shows a confusion between excitement and the feeling of being alive. The smack in the face we get from such a building is meant to awaken us from our presumed sleep. It has been typical of the art of our age that it affronts us. I think we have become overly accustomed to the idea that if art is to have any value, it should have that quality of murder. You must kill the routine, kill the expectation. You must kill the normal. This point of view assumes there can be no magic in life as it is normally lived.

Perhaps the greatest creative pressure on the architect is not so much to be different; perhaps the worst pressure now is to come to

Offices, Los Angeles (Eric Owen Moss, architect, 1990). The little office building is a bristling bunker, fending off those who are not in the know. Under its mask lies a strong composition of regulating lines.

terms with normality. It may be that these architectural screams, these outbursts, these intellectual effusions, express a fear that if the art of architecture became normal it would cease to exist.

The haute designers, many of whom have substantial ability, are not providing any model that can be used in buildings not destined for celebrity. There is nothing a designer of suburban houses or utility company garages or schools can take from their example other than an occasional modish device. Haute design offers no leadership. It is an entirely introverted exercise of talent. Each building stands alone,

each architect stands alone. There is no connection between these buildings and less expensive buildings — except the connection to the strip mall, where every building becomes a sign; and there they are all the same.

The Function of Structure

Louis Sullivan's 1891 Wainwright Building in St. Louis is a famous early expression of the steel frame. Sullivan grouped the windows in vertical strips, carrying them straight up. Between each strip of windows was what appeared to be a column. But only half the "columns" contained steel; every other one was empty. The deception made sense, because the purpose of the building was not to reveal its structure but to make a composition out of structural shapes.

The only function of structure is to support the building. The architect reveals structure when it suits the purposes of pattern making, and conceals structure when it doesn't. An I-beam or an open-web joist is an elegant solution to a physical problem, but a ceiling full of open-web joists is unlikely to inspire someone who doesn't understand structural engineering. Two-by-four frame construction is also a brilliant system, but the system is not architecture.

Aesthetics

I spoke to a group of architects about intuition one morning. I talked about vision and about how buildings connect people to the world. I talked about how the magic and the sense of place come from ourselves. I had worried that they might say all this talk about vision and intuition was "soft." I hadn't expected the reaction I got: they looked

sad. They were way beyond worrying about softness. They were wondering whether there was any reason for architecture at all. "Maybe what we do just isn't that important," said one. How glum they looked.

"Aesthetic" is a word that puts their problem in a nutshell. Architecture has lost the root meaning of the word, as many architects have lost faith in their art. Aesthetic: "of perception." To me the word connotes being in touch with where you are. If you are in touch, you will naturally concern yourself with how a place looks and feels and whether it pleases you. The inner judgment of each individual knows whether a place pleases sufficiently. But we no longer make it our first requirement to please the spirit. We have put what we have thought to be practicality first, and everywhere we have the results.

To please the spirit is not a frill. To play is not a diversion. Architecture uses decoration, but architecture is not decoration.

"Aesthetics" was first used to mean "the criticism of taste" in 1830. The nineteenth century, like our own time, excelled at the brilliant invention, not at seeing the brilliance all around. It was the age of science, but design could not become scientific, so it was pushed into academia and the salon, where cognoscenti admired it. And there it remains. But there is no reason that we must have one or the other, science or architecture.

Before the machine age, no one had to make the choice to be conscious of pattern, to *be* aesthetic. Now, to be in visual touch requires taking a deliberate step. Numbness is today offered all around. We fall into it easily. We do have to choose to be awake, as people in the past did not.

7

The Life and Death of Modernism

The Vision of Walter Gropius:
Why There Could Be No International Style

> *Since my early youth I have been acutely aware of the*
> *chaotic ugliness of our modern man-made environment*
> *when compared to the unity and beauty of old, pre-*
> *industrial towns.*
> — WALTER GROPIUS, creator of the Bauhaus

Walter Gropius (1883–1969) wanted to show how to make the built world beautiful again, and he knew it must come through a way of seeing, not through a style. "A 'Bauhaus Style,' " he wrote, "would have been a confession of failure and a return to that devitalizing inertia, that stagnating academism which I had called it into being to combat. . . . There is no such thing as an 'International Style.' "

There was, indeed, an International Style. But that is only one of

the proofs that the dream of Walter Gropius failed. The movement he led did not achieve its promise to make the world beautiful. The Bauhaus did not give us harmonious cities, and today it is easy and fashionable to make fun of the Bauhaus and its acolytes. But the Bauhaus was a valiant, audacious attempt to bring back the old way of seeing and make it part of the industrial world. Reading Gropius's *Scope of Total Architecture,* and knowing of his failure, one is struck not only by his brilliant grasp of the issues of style, form, and industrial culture but also by his generosity, his depth of feeling.

At the Bauhaus, which he directed from 1919 to 1928, Gropius set out to mold the kind of person who could design harmonious buildings. The designer of the future was not to be a narrow specialist but a thoroughly rounded creator, the product of years of training. Whole towns would have to be built in the new harmonious way in order to reawaken their inhabitants to the old awareness of form. "There is no other way toward progress but to start courageously and without prejudice new practical tests by building model communities in one stroke and then systematically examining their living value." The Bauhaus was to be the beginning of an immense endeavor. Gropius assumed that mountains would have to be moved, and he set out to move them.

Like his contemporary Le Corbusier, Gropius believed that the old way of seeing sprang from character. Le Corbusier thought such character was a rare sensibility; he believed in an aristocracy of talent. Gropius believed that most people had the necessary ability but that its development required intensive nurturance, a profound education in life and form. The designer, not just the way of designing, had to change. Style represented the superficiality Gropius was trying to undo. There could not be a Bauhaus Style because the whole purpose of the Bauhaus was not to come up with some new fashion — "buildings will be daringly simple this season" — but to go beyond style to

first principles. But once the new design language was accepted, there was no controlling it. It was a race horse, it required expert handling.

As part of Modernism, which was a philosophy of life and culture, the International Style reached for great goals. When it was new, its simplicity was refreshingly shocking; severity itself was considered a virtue. The Moderns' purpose was to cut away meaningless fuss and manner in order to get back in touch with fundamental truth. The machine and its products were expressed. Use was expressed. And elemental form was expressed.

The terrible simplicity of Modernism was sensational in the hands of a Mies van der Rohe. His Farnsworth House in Illinois — a box of plate glass and white-painted steel — was famous the minute it was completed in 1951. "The house is above all a work of art of supreme integrity, unity and perfection," said *Architectural Forum*. "What remains after Mies' subtraction is a concentration of pure beauty, a distillation of pure spirit." But there was not one operable window. Dr. Farnsworth sued her architect on the grounds that the house was un-inhabitable. The Moderns could be sublime, but they could not be normal.

In the hands of masters, the International Style did achieve the old spirit; but these designers were specialists in seeing buildings as compositions in light and shade. The Victorian masters, amidst their upholstery, had done the same. Despite all the talk of functionalism and honesty, Modernism was an elite style. Only artists could make it work, and this affirmed the belief, which had arisen in Victorian times, that only artists could design. The artists encouraged this opinion. Le Corbusier wrote, "The art of our period is performing its proper functions when it addresses itself to the chosen few."

The simplicity of the International Style made it much easier to express elemental form. But the designer who used it walked a knife edge. The style offered true greatness to those who could stay on that edge, but on each side was an ice-cold abyss. Even the best designers

took an occasional tumble. The International Style was merciless to the less talented.

When it came to city planning, the Moderns made more than a misstep. In 1920 Le Corbusier proposed what he called the Radiant City: huge, sheer, flat-topped towers set in parks among superhighways. He suggested that this would be the perfect solution to the gnarled street patterns of old Paris. During the three decades after World War II, the heyday of the International Style, Radiant Cities were built all over the world, from Moscow to Chicago to Brasília, and within sight of the old streets of Paris itself. Radiant City was the Modernist apotheosis of the machine — dramatic size, the speed of highways and elevators, efficiency, order, healthy greenery. Le Corbusier's own designs for huge apartment dwellings, the series of Unités d'Habitation, were strikingly beautiful in their monastic way — even if no one shopped in their "streets in the sky"; so were Mies's glass apartment towers in Chicago and Detroit — even if the occupants had to keep the curtains drawn against the sun. But the overwhelming drabness of New York's Co-op City, built in the 1960s, was more typical of what the Radiant model produced, and that model was a disaster for public housing, as at Chicago's Cabrini Green and St. Louis's Pruitt-Igoe project, which was deliberately blown up twenty years after it was built, to the unending delight of Post-Modernists.

Yet the International Style is the great style of our time, even though it promised more than it could give. It promised a new way of life and a way to come to terms with the machines that seemed to be sapping the old vitality. It promised contact with the eternal grand principles of form. The Moderns were right to say that design had a moral aspect, but Modernism got mired in conflict between the utilitarian way of seeing, functionalism, and the intuitive way of seeing, composition.

In Le Corbusier's *Towards a New Architecture* (1923), the photos of

cars and airplanes express the honesty of the machine. They are aesthetic models, moral models — functionally pure — for buildings. But something is wrong. Le Corbusier's buildings, on the same pages, look fresh, but the cars and the planes are as antique as morning-glory phonograph horns. For us today there is no high virtue in a building's resemblance to a Caproni Triplane or the *Aquitania,* as there was for Le Corbusier, although we do still relate to the machine aesthetic — after all, we are surrounded by machines. It is not a resemblance to cars and planes that makes Le Corbusier's buildings fresh after seventy years, it is the dance of pattern.

Le Corbusier described the need to return to first principles of form; Gropius saw that a lost way of seeing must be recovered. But another priority interfered: the need to be "honest" about structure, use, materials. Like the Victorians before them, the Moderns saw that the machine had jarred the world loose from the old way of seeing, but they tended not to see that the machine was not the fundamental issue. You could no more solve the problem by embracing the machine than by rejecting it.

On a hill in Lincoln, Massachusetts, the house Walter Gropius built when he came to America in 1937 still gleams fresh and bright. But over the years the house has come to seem more and more isolated in time and place. It belongs, now, to the Society for the Preservation of New England Antiquities. The house is beautiful and subtle and delicate, but in a way it stands for the failure of Modernism to reintroduce the old way of seeing.

In his writings and teachings, Gropius seemed to advocate an egalitarian simplicity. But the house in Lincoln cannot help being suave, sophisticated, complex. A little extension of the roof will slide out and stand on a pole, just because it was necessary, visually necessary, or seemed that way to Gropius and Breuer — Marcel Breuer collaborated on the design. The house is all small subtleties because all the

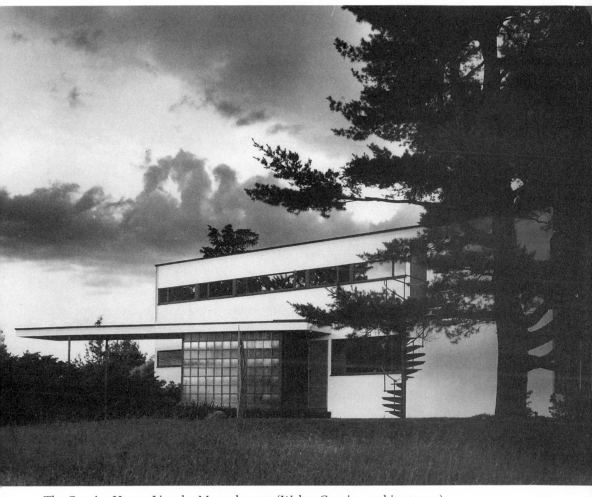

The Gropius House, Lincoln, Massachusetts (Walter Gropius, architect, 1937).

large things, all the usual equipment of architecture that makes it possible to blur the perceptions, are gone. We are left with only the shape of this window, the indentation of that wall. Whether to have the roof overhang six inches or twelve inches becomes a major decision because there are no other decisions to be made. The house is stripped to the barest elegance. The house fails as an example to any but the

most talented designers; if you do not have access to that underlying elegance, such a design strips down to nothing.

But the Gropius House does come alive. You expect the house to be a sort of reliquary of sacred Bauhaus objects because it is full of the ancient Bauhaus furnishings. But it feels neither old nor new. It does not feel like a museum or a house that someone has left. There is nothing of death in it. Gropius the man is present in the house, surprisingly and gratifyingly strong.

The interiors are multiple shades of gray, black, tan, and white. There are no other colors, yet the house feels very rich. Outside there is one exception to the color scheme: the inside of one wall of the deck is pink, the color of reflected light. The story is the pink was not coming out right so Gropius asked Lionel Feininger to mix it. It is that kind of house and that kind of pink.

The exterior, conspicuous on its hill, is such a Pronouncement that it is easy to assume that the outside of the house is the main point, that the primary reason for its placement is to be seen. But the inside is more important than the exterior; it has more to teach, and what a pleasure to be taught by Gropius. The perceptions and patterns pile up. One comes away with a heightened sense of all colors, patterns, and shadows. One is reminded of the Japanese sensibility for subtle shades and shadows, but here *things,* as well as light and darkness, make the patterns.

The Gropius House is not a humorless exposition of theories. The house is alive and subtle and complicated and fun to be in. It is fun. It is not witty. Its mysteries are in the relationships among the parts, the unexpected connections, the surprising views from every room.

There is a particularly fine framed view from the upper deck, looking out at a big tree, beyond which are meadows. From the outside the artificiality of that unglazed frame looks arty, but from the deck itself the view is a little experience in how one's eyes see.

The house may be self-conscious and didactic, but it also plays. It says, "Look! How do you like the way that gray relates to that brown? You didn't expect that view over there!" It is not afraid to wear its happiness on its sleeve. Under its sophisticated shell, the Gropius House is innocent.

Gropius came to America to take over the design program at Harvard, but he found, somewhat to his surprise, that he had also come to take over the direction of architecture in the United States. He and the other ex-Bauhaus luminaries, notably Mies and Breuer, went from one great success to another. It began to seem as if all the steps before had led inevitably to that moment in which Modernism was to triumph. Not since Abbé Suger introduced the Gothic in 1130 had a new style become so overwhelmingly successful. And Walter Gropius was the International Style's Suger. His protestations of denial must have looked like modesty: "Every so often I feel a strong urge to shake off this growing crust so that the man behind the tag and the label may become visible again." Gropius did enjoy his celebrity, but it was urgently important to him that he not be famous for the wrong thing.

The International Style did solve the problem of how to express the machine in architecture, at least as machines were in 1925. But, as Gropius said, to express the machine was not the central problem. The problem was, and still is, how to express life in buildings and cities in an age of machines.

Now that we are no longer dazzled by the International Style, it is easier to recognize that Gropius's worst fear was borne out: he had set out to teach a vision, but he gave the world a style. What remains fresh is the vision he offered. He wrote, "I believe that every healthy human being is capable of conceiving form. The problem seems to me not at all one of existence of creative ability but more one of finding the key to release it."

Robert Venturi and the End of Modernism

The closest thing Modernism had to an official voice was Siegfried Giedion. In the 1960s every student of architecture read his *Space, Time and Architecture.* But by 1967, Giedion admitted, Modernism was tired — not dying, he hastened to say — but unsure. "In the sixties a certain confusion exists in contemporary architecture . . . a kind of pause, even a kind of exhaustion. . . . Fatigue is the mother of indecision, opening the door to escapism, to superficialities of all kinds."

The architects who created Modernism had continued to produce one masterpiece after another, but Modernism had not been able to create an average street that came alive. And the Modern masters themselves were at the end of their lives. Modernism was meant to be an eternal approach to design, but Giedion saw that it would have to redefine itself. Instead, Modernism came to an end.

Two books by a Philadelphia architect, Robert Venturi, created a theoretical basis for the end of Modernism in America and helped bring about what came to be called Post-Modernism. They were *Complexity and Contradiction in Architecture* (1966) and *Learning from Las Vegas* (1972, with Denise Scott Brown and Steven Izenour).

You may say that Modernism still exists. It does, in its outer form, but not — with a few exceptions — in its purpose. Modern has become just another style in the grab bag. It is said that the style known as Post-Modern — with its false fronts and cut-out Neo-Classical columns — is already passé, but we are still in the Post-Modern period. During the 1970s, leadership passed to a group that did not aspire to express the principles that underlay Modernism. The Moderns, far from throwing out the past, had been the last upholders of the old way of seeing. In contrast to the age-old model of light and

shade, walls and space, Venturi wrote, "The Flamingo sign will be the model to shock our sensibilities towards a new architecture."

Modern architecture was an attempt to eliminate style in order to get to what was essential and alive, at the center. Giedion explained, "The contemporary movement is not a 'style' in the nineteenth-century meaning of form characterization. It is an approach to the life that slumbers unconsciously within all of us."

Venturi welcomed the symbolism of style, its historical, nonvisual content. And, he wrote, Modernism was rigid and narrow: "Architects can no longer afford to be intimidated by the puritanically moral language of orthodox Modern architecture." Modernism often *was* prudish and cold; Giedion, for example, could write, "To become a constituent element of a volume, the wall had first to be cleansed of all decorative eruptions of the nineteenth century." A previous age might have applied a "blind" arcade to the wall to say "Good afternoon," but the Modern wall was too honest for social convention. The downside of pre-Modernist conventions had been whole streets of "Please" and "Thank you" and "Nice weather we're having." The downside of Modernism was blankness. Venturi called for a balance: "control *and* spontaneity . . . correctness *and* ease."

Venturi's message was a relief to many architects. It *would* be nice to relax among inconsistencies, surprises, "whimsy," as Venturi called it — using as his illustration Antonio da Sangallo's delightful sixteenth-century Palazzo Tarugi. Many of the embellishments Modernism rejected were the architectural equivalents of "How do you do?" — archaic, unoriginal usages but still socially serviceable. Some of Venturi's suggestions had the potential to introduce an exciting tension between intellect and intuition: symbol, history, and effect pulling against eternal pattern. Venturi broke rules that needed breaking; he opened some new design possibilities and reopened some old ones. But when he said that most design in our time was

inevitably banal, he revealed an underlying contempt for the designer. For this reason Venturi's two books took more from architecture than they gave to it.

In arguing against an architecture of inspired form, and in accepting as essential the mediocrity of our age, Venturi was reviving beliefs of the Victorian theorist John Ruskin. "It is now time to reevaluate the once-horrifying statement of John Ruskin that architecture is the decoration of construction," wrote Venturi. John Ruskin's *Seven Lamps of Architecture* was published in England in 1848, some twenty years after American architecture first began to lose touch with intuitive design. The book was an immediate success in the United States. Ruskin described clearly the loss of the old way of seeing, which he called "the dissolution of . . . ancient authority in our judgment." He saw that medieval architecture had the spirit that was missing from his own age. His solution was dramatically simple: "But there is a chance for us . . . and that chance rests on the bare possibility of obtaining the consent, both of architects and of the public, to choose a style, and to use it universally." All buildings were to be Gothic; one English and three Italian versions were to be permitted. Neo-Gothic, in various forms, had been in vogue for years; Ruskinian Gothic turned out to be as awkward and scary, and as occasionally charming, as any other variety.

Ruskin made the loss of the old way of seeing respectable — or almost respectable; for it was to be understood that the designers of his day were in no way equal to those of the past. What had been lost could only be imitated, not reclaimed: "The forms of architecture already known are good enough for us, and for far better than any of us." If inner authority had been lost, then outer authority must be followed. Ruskin saw Victorian eclecticism to be a sort of visual panic. Any amount of Sacrifice and Obedience — two of the Seven Lamps — was preferable to chaos. "There is no such thing as liberty," he said.

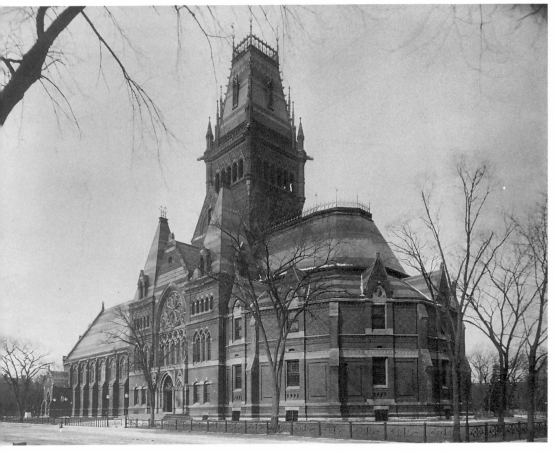

Harvard's Memorial Hall (Ware and Van Brunt, architects, 1868) deliberately followed John Ruskin's "Lamp of Sacrifice," which said to spare no expense. It is charming (in places) on the inside but scary on the outside.

If the architect would submit to the rule of style, his work would flourish, "freed from the agitation and embarrassment of that liberty of choice which is the cause of half the discomforts of the world . . . his imagination playful and vigorous, as a child's would be within a walled garden, who would sit down and shudder if he were left free in a fenceless plain."

By the time Ruskin died in 1900, Ruskinian Gothic was out, and it stayed out for seventy years. But today style and story are back. Both Ruskin and the old Ruskinian buildings — they do have their charm — are being rehabilitated. Ruskin's belief in consistency of style survived his version of Gothic. Planning boards and historical commissions insist upon mono-style architecture to this day. But Venturi now revived a Ruskinian tenet of far greater implication: that a building is primarily an emblem.

"Finally we shall argue . . . for architecture as shelter with symbols on it," Venturi wrote. *Learning from Las Vegas* categorized buildings into two types, the "decorated shed," which was shelter with symbols on it, and the "duck," the building itself as symbol — Venturi's example was a building literally in the shape of a duck. Most buildings Venturi considered decorated sheds. The term sounds, at first, like wrapping, but there is an essential difference. The façade on the empty box is not shelter with symbols on it but shelter made into pattern. In *Learning from Las Vegas,* the Cathedral of Amiens and the Golden Nugget Casino face each other from opposite pages to illustrate that "Amiens Cathedral is a billboard with a building behind it."

In Modernism all literary meaning was stripped away; embellishment, even to reinforce pattern, was eliminated. Modernism was out of balance, as Venturi showed. He demonstrated that effect, symbol, message, and history had their place, as did ordinariness. But, just as the Moderns had thrown out symbol, Post-Modernism threw out form. Architecture now slid past the balance point.

Giedion had already pointed out that Modernism had become weak. What made it easy to finish it off was the death of the Masters, as the Post-Moderns now began to call them, with just an edge of irony. By 1970 the inventors of Modernism, the old figures, the great old monuments of twentieth-century architecture, were dead: Wright in 1959, Le Corbusier in 1965, Mies and Gropius in 1969. Most of the

remaining leaders, such as Marcel Breuer, Richard Neutra, Alvar Aalto, and Louis Kahn, died soon afterward.

Modernism had looked at the gigantic social and environmental problems of the age and set about doing something about them, trying to put civilization on a new course. It was in the Modernist spirit that Neutra had called his 1954 book *Survival Through Design*. But Post-Modernism said it was idle for architects to presume they could affect the state of the world. Venturi wrote, "Architects should accept their modest role." If the world underrated architecture, irony was the way for architects to express "a true concern for society's inverted scale of values."

The Moderns were both moral and moralistic, but Venturi was amoral: "[In Rome,] the pilgrim, religious or architectural, can walk from church to church. The gambler or architect in Las Vegas can similarly take in a variety of casinos along the Strip." Sheds or ducks . . . symbol is the main thing. And in the nonintuitive world all symbols are equal, and "decoration is cheaper."

Venturi singled out the "Heroic and Original" for special derision. Having cut all architecture down to the level of Las Vegas — whose casinos really are decorated sheds — he advised against trying to make any other kind of architecture: "Why do we uphold the symbolism of the ordinary via the decorated shed over the symbolism of the heroic via the sculptural duck? Because this is not the time and ours is not the environment for heroic communication through pure architecture." Venturi argued that original buildings were beyond the perceptions of people used to the highway view of the world: "Articulated architecture today is like a minuet in a discotheque, because even off the highway our sensibilities remain attuned to its bold scale and detail."

But driving a car brings out visual intuition, as Betty Edwards describes in *Drawing on the Right Side of the Brain*:

Driving on the freeway probably induces a slightly different subject state that is similar to the drawing state. After all, in freeway driving we deal with visual images, keeping track of relational, spatial information, sensing complex components of the overall traffic configuration. Many people find that they do a lot of creative thinking while driving, often losing track of time and experiencing a pleasurable sense of freedom from anxiety. . . . Of course, if driving conditions are difficult . . . or if someone sharing the ride talks with us, the shift to the alternative state doesn't occur.

The Jonathan Stone House is an ordinary building. It is not a duck, because it is not a sign; but it is not a shed, because its patterns are not applied, they *are* the house. It would have to be called a building "as a building."

As the deliberately "hybrid," "distorted," "vestigial" products of the Post-Modern age began to show up on city streets, it began to be clear that there would be no more Ronchamps, no Seagram Towers, no Guggenheim Museums. Such grandeur was out. But also there would be no building so charming as the whimsical Palazzo Tarugi. The new architecture was too acidly witty to be friendly. And everyday architecture did not spring to life; Post-Modernism was even more erudite than Modernism.

Is the heroic gesture the only way to express nature and life in a building? Le Corbusier and Mies took that view. But what Modernism needed was not more inspiration but more normality. Post-Modernism, however, did not try to restore the sparkle to ordinary architecture. Instead, it brought the drabness that had increasingly blighted ordinary architecture since 1830 to what it called "high design." Modernism had kept contact with the ancient principles of form; it was not a break with but a continuation of this spirit. "Good architecture should be a projection of life itself," Gropius had said.

The masters of Modernism did make contact with what Giedion

The chapel at Ronchamp, France (Le Corbusier, 1950), was Modernism at its most Heroic and Original. But there was no room in the Post-Modern vision for such a building.

called their inner "organic forces." The language sounds inflated, but Modernism — Le Corbusier's chapel at Ronchamp, in France, for example — had the capacity to live up to it. In the past, lesser talents had expressed "organic forces," as well. The results in such cases were not Ronchamp, not the Seagram Tower, but cities such as Urbino and Charleston.

The Modern masters were Romantic *grands seigneurs* in the mold of Wagner, with their capes, their mysteries, and their epigrams. But their vision was sound at its source. That vision was to express the intuitive inner self, and through its expression to evoke the truths of nature. Their error was to believe that they alone had the key.

Venturi's error was to believe that no one had the key. Venturi

punctured Modernist grandiosity: it was elite, it was cold . . . it was ridiculous. And then he stumbled right into a Modernist mistake: he assumed normality to be dull. The Moderns, making the same assumption, had at least sought life where they could find it, even if they thought that meant rejecting the everyday. Venturi welcomed dullness.

"I like boring things," Venturi quoted Andy Warhol. Intentional ugliness and banality were common enough in twentieth-century art, and the Warhol deadpan was one form of the sought-for affront. "Indeed, is not the commercial strip of Route 66 almost all right?" wrote Venturi. "Almost all right?" question mark and all, delivered the haute-design smack in the face with such perfect, diffident irony that the phrase became a favorite term of the Post-Moderns. Venturi apparently thought the vacant stare of the Ugly and Ordinary building would shock and amuse, like pop art. But unlike a painting, a building is stuck in normality, as real as a mountain or a meadow. A boring building is just a hole in the landscape.

Ordinariness. Every time Post-Modern architecture tried to get closer to normality, it got farther away from life. There was more life in Mies's evanescent little Barcelona Pavilion of 1929 (it lasted only a matter of months and was reconstructed in 1986) than in all the "of-the-people" façadism that followed from Venturi's *Las Vegas*. There was more dark fire in Mies's 1957 Seagram Tower than in any of the decorated skyscrapers of the 1980s. No wonder the Post-Moderns tried to cut Mies down to size.

One evening in 1992, I watched Venturi and Scott Brown present their design for the new Sainsbury Wing of England's National Gallery of Art to a packed hall at Harvard. The rooms of the new wing copy John Soane's Dulwich Gallery of 1811, which still stands, a few miles away. Sainsbury uses the same system of monitor windows above inward-sloping ceilings; nearly identical archways connect the

rooms. But Dulwich is ebullient, a building one loves at first sight, while Sainsbury is static.

At Dulwich, Soane takes big chances. The arches are too wide, they come too close to the break between wall and ceiling, and the break is not defined by the expected molding. The little arches in the sloped ceiling are too small, and the monitor windows cantilever too far in, making the structure look unstable. And it all works, the whole room dances. Soane's rooms play at the edge of discord and disintegration.

Below, left: Dulwich Picture Gallery, London (Sir John Soane, architect, 1811). *Below, right:* Sainsbury Wing, National Gallery of Art, London (Venturi, Rauch, and Scott Brown, architects, 1987–91). Venturi eliminates Soane's imbalances, and the dance grinds to a halt. The four-paned windows are an affectation — "I like boring things" — that makes the room look like a big toy. However, the same type of window can work in a rustic building such as the O'Herlihy House (page 47).

 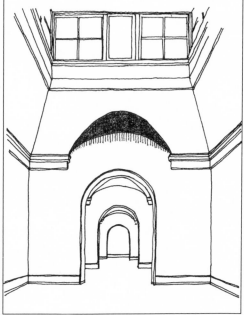

In a dance you almost fly, and you almost fall. At Sainsbury, all of Soane's "mistakes" have been smoothed away: a molding is where Soane "should" have put it; Soane's pinched upper arches, suitably enlarged, relate appropriately to the lower arches, which are sensibly narrowed. And now these elements just stand around. At Dulwich your eye can feel the texture and pattern of the windows. Venturi's windows, in the same relative locations, are too plain; in this context they read like the symbol for "window" on a child's drawing of a house.

Venturi teaches that there is nothing wrong with borrowing. No doubt Soane himself borrowed from other architects. Venturi acknowledges that Dulwich was his source, and he has made a career of putting down Originality. But the Sainsbury galleries still belong to Soane, if they belong to anyone, because Venturi — who *is* a talented designer — has not put his spirit into them. To copy shamelessly — and from a 180-year-old building, at that — was absolutely forbidden in Modernism. But in 1992 Modernism was no longer a force, and the point — that it was all right (almost) to borrow — had long since been made. In 1992, architecture needed to relearn that it was all right to make a form.

We can now see from the results of Post-Modernism that something was seriously wrong with its theoretical underpinnings. Venturi's writings were strongly worded; they seemed an honest attack on the coldness and pseudo-logic of Modernism, but the main target turned out to be intuition. Venturi, like Ruskin, was in rebellion against the machine age; but he did not rebel against machine *thought,* which includes intellectualism.

Post-Moderns like to talk about semiotics, which has to do with signs and symbols. The word is one of their shibboleths, like "praxis" and "hermeneutic," but semiotics is what the new way of seeing is all about. Las Vegas became the model of the Post-Modern age because it

was the city of signs; it was a city of calculation and sensation, not of intuition.

Modernism had followed a different model. In 1961, Giedion wrote:

> The question which at present comes everywhere to the fore, and which cuts increasingly deeper into the marrow of this century, is the relation between constancy and change. In other words — as a result of bitter experiences — we are concerned to know what can be changed and what can not be changed in human nature without disturbing its equipoise. . . . Contemporary art was born out of an urge to go back to elemental expression. The artist plunges into the depths of human experience, just like the psychologist. The artist shows that an inner affinity exists between the expressions of primeval man and contemporary man with his longing to become aware of his buried depths.

The game of architecture is not a matter of being great or being ordinary. It is a matter of playing. Technology and society will give the designer whatever happens to be at hand: the program with its symbols, the devices, the materials. I do not mean to say you just accept passively anything you get. But the process of architectural play is to use the ingredients you have, including style — just playing, making your sandcastle out of whatever seashells and rocks and sand may be around. If you must make an Ordinary sandcastle, maybe you will stick a bottle cap on it.

In 1990 Richard Sennett wrote, in *The Conscience of the Eye,* "A city ought to be a school for learning how to lead a centered life." I think that is a good model for a building.

8

Paradigms

Marlene Dietrich walks into a room, and John Halliday says, "You're looking more beautiful than ever." The year is 1936, and the movie is *Desire,* and those clothes, on Dietrich, are still as beautiful as ever. A woman would look up to date in those clothes today — the costume is a dark blazer and a white skirt — but we are as far from that time as they were from the 1870s, the time of bustles! It was Coco Chanel who came up with the new archetype for women's clothing; she was not alone, of course, but she was the greatest personal force. Chanel is the name we attach to the discovery of that paradigm for clothing, as we attach the names of Raymond Loewy and Norman Bel Geddes to the streamlined look we still expect of industrial products. What Chanel "got" was a style, but it was more, it was a new way of looking at what clothing was, at who a woman was.

A paradigm is a mental model. Thomas Kuhn's *Structure of Scientific Revolutions* brought the term into common usage in the 1960s. After reading some of Kuhn's case histories, one tends to imagine that

changing a paradigm must be a lonely, wrenching effort. "They all laughed . . ." might seem to be the paradigm for changing a paradigm. But the striking change one makes upon shifting one's point of view may be personal, easy, immediate. The change may be brought about deliberately, or it may occur without much thought or comment. A new paradigm may be a relatively little thing; it need not rest upon a vast theory.

Paradigm makers like Chanel answer questions that are already in the air, using resources that are already floating around. As Chanel describes it, "One world was ending, and another was coming into being. I was there; I saw an opportunity, and I took it. I was a contemporary of this new century: and so it was to me that it turned for its expression in clothes."

The world may accept a design paradigm quite rapidly, once somebody "gets" it. In the early 1930s a few car designers "got" the automobile. It took a little more than forty years from the time of the first gasoline-powered carriage for the very different image of the automobile as we know it to be discovered. In Raymond Loewy's 1933 illustration of car evolution, it seems almost as if the previous concepts had been peeled away to reveal the obvious fact of the modern car, his 1934 prediction.

But there had been nothing obvious about the shape of the modern car to Modernist architects. The Bellanger saloon that Le Corbusier used to illustrate his radical *Towards a New Architecture* in 1923 resembles Loewy's 1918 model. To Le Corbusier, its pure sheen and the subtle camber of its roof and doors represented the cutting edge. But to our eyes it is a hansom cab without the horse. By the late twenties, "machine for driving" had largely supplanted "horseless carriage" as the paradigm for car. When Le Corbusier designed a prototype car in 1928, he came up with a box with a rounded back, a true machine for driving. It was strictly utilitarian, unlike his machines for sitting,

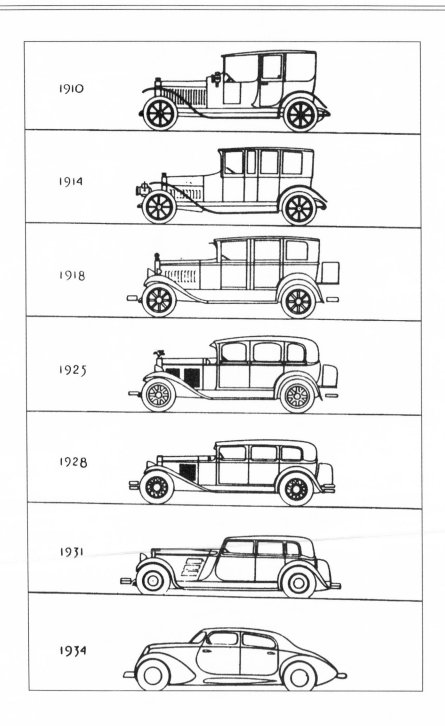

1910

1914

1918

1925

1928

1931

1934

which, despite his description, were art works. But Le Corbusier's design was not the new paradigm for car. Gropius designed a far more elegant machine for driving, an Alder Cabriolet, in 1930. The car was as angularly Modern as Mies van der Rohe's famous Tugendhat House of the same year. Even its detachable trunk had style. The Gropius Cabriolet looked like a two-door version of Loewy's 1931 model. It was of another age than ours; it was still the "before" picture.

Loewy's 1934 model is a car as we expect a car to look. It was not only Loewy who had the idea. Pierce-Arrow built the first one, in 1933; then Cord (using a design by Gordon Buehrig), and Chrysler, with its Airflow, put the new paradigm for car into production in 1934. By the late thirties, every car embodied the new paradigm. Our cars embody it still.

The new car paradigm included "machine," but that wasn't all. The design looked truly aerodynamic, ready to slice through the air like the DC-3 airplane (also of 1934, and also still modern to our eyes). In the thirties everything got streamlined, from locomotives to desk lamps. In cars, elements that had formerly been discrete — headlights, fenders, grilles — were absorbed into the overall shape. Function was not the motive; the newly integrated body panels and fenders and headlights were actually more difficult to repair. Nor was fuel efficiency a motivation; gas was cheap, and there were few roads on which one could drive fast enough to stir up much wind. Looks were the point.

Speed was part of the image, but that was not the element that made Loewy's drawing *the* image of a car for the next sixty years. The teardrop shape of the fenders connoted speed, but the teardrop was

Opposite page: Raymond Loewy's illustration of the evolution of the automobile. In 1934, the paradigm shifted suddenly to the car as it has been ever since.

also the mandorla, the life shape, the elemental animal form. The new paradigm for car was not "fast machine," it was "fast animal." Jaguar, Cougar, Impala, Mustang, Sable, Lynx, Barracuda, Sting-Ray are the names of some of them. Or think of a Greyhound: Loewy designed the "Silversides" bus in 1940, and that is the way buses look. He "got" the paradigm for bus as surely as he had "gotten" the car.

The fast-animal model for cars became irresistible, because it resonated with something in people. Its logic was the logic of the body and the spirit and only secondarily of use.

Designing on the Right Side of the Brain

Towards a New Architecture was famous for the line "A house is a machine for living"; but what excited me when I first read Le Corbusier's book were the patterns of regulating lines that determined harmonious proportions in great buildings, such as Notre-Dame in Paris and the Capitol at Rome.

I had always loved the old houses of New England. Most new houses made me angry: why weren't they as beautiful as the old ones? Several years after I read Le Corbusier's book, it occurred to me that ordinary old American buildings might also have regulating lines. And indeed, I found the same kinds of rich patterns Le Corbusier had shown in the masterpieces of Europe. I concluded that our early builders must have handed down the ancient principles from master to apprentice and through pattern books that imitated the proportions of famous buildings.

But proportion alone did not explain why old buildings came alive. It was not just that people found those buildings appropriate or pleasing or comfortable. People *loved* them. Why had designers all over the United States lost the ability to make harmonious buildings? I wrote at the time, "Victorian architecture changed the emphasis from form

to structure, symbolism." That came close to the answer, but I did not yet recognize that the new paradigm underlying the change was not just a different point of view, in the sense of an opinion; it was a literal alteration in the physical process of seeing.

In 1979, Betty Edwards, a professor of art, showed that by changing the way you look at things, you can release the innate ability to draw them. In *Drawing on the Right Side of the Brain,* Edwards demonstrated that anyone could draw anything. The key was to see that the subject of a drawing was not an apple or a chair; the subject was a pattern in light and shade. The drawings by Edwards's students were not merely accurate, they were alive and full of spirit. When they learned to see this way, all her students, not just a chosen few, "got it."

Edwards showed how to change the paradigm of what a drawing and its subject were. She also changed the paradigm of visual talent; it was not a rare gift but a normal ability. And she changed the paradigm of how the artist's mind worked; she showed that the artist drew what the eye saw, not a memorized series of symbols.

Before I read *Drawing on the Right Side of the Brain,* the only thing I could draw was a house. A tree, a hand, or a face was beyond me. One day I picked up Edwards's book. After perhaps two hours, I could draw everything I looked at. What made the transformation possible was being told: a hand is a pattern in light and shade; a drawing is a pattern in light and shade. All you have to do is look at the pattern and draw. "Drawing is not really very difficult," Edwards wrote. "*Seeing* is the problem, or, to be more specific, shifting to a *particular way of seeing.*"

What struck me at first was the simplicity, the *ease,* of the process. There was no painful unlearning of bad habits, no laborious practice to acquire new ones. I didn't learn how to draw, I gained access to my ability to draw. But I had to be told.

Drawing on the Right Side of the Brain teaches that to draw a picture that looks like the thing you are drawing, you don't draw what you

The paradigm is "hand." The mind struggles
to represent not what it sees but what it
knows to be there. The drawing is blurry
and tentative. The main idea is to
not make a mistake.

"know" the thing to be, you don't think about the object as what it is,
what it means, at all. You simply allow yourself to see the shadows and
the light.

As I drew this way, instead of thinking harder and harder about
what an ear or what a foot "really" looked like, I became aware of
those curves, this shadow, that line. I drew the shades and the shad-
ows and the lights and the darks. And in the process of doing that I
found that I was able to put into the design the quality of spirit, which
is the quality that comes into the design of a building when we see it
as light and shade, walls and space.

A drawing made this way tends to become more realistic as it
comes alive. This seems to go against the modern belief that truth in
art is outside the ordinary. A drawing can be as weird as you like, but
it does not have to be. Like a drawing, a house that comes alive need

The paradigm is "pattern" — lines, shapes, relationships — not "hand." Following this paradigm releases the innate ability to draw. In the same way, the inborn ability to design can come out when we look at buildings as patterns in light and shade, solid and void. Two drawings of a hand by Jonathan Hale, February 1986.

not be odd. In fact, an old house that plays with pattern tends to look more "real," more like what we think of as "house," than most of what we build today.

A hand is very hard to draw until you think about the pattern, and not the hand. And then what you get is something that looks real. That is because, as Edwards points out, visual reality is not symbolic. The labels we use to get around in the world are shortcuts. Much of the time it is infinitely quicker not to think about the lights and the shades. But there are appropriate parts of ourselves to do particular tasks, and the task of pattern making is not within the capacity of our symbolic side.

Until Edwards proved the opposite, it was entirely respectable to say that schemata — little formulas for trees or eyes or hands — were the primary way representational art was made. E. H. Gombrich took

that view in his well-known *Art and Illusion* (1960). He quoted the psychologist C. F. Ayer: "The trained drawer acquires a mass of schemata by which he can produce a schema of an animal, a flower, or a house quickly upon paper. This serves as a support for the representation of his memory images, and he gradually modifies the schema until it corresponds to that which he would express."

Schemata can work when they become part of the play of pattern, as in ritual art. This can also happen in traditional architecture and in children's art. A child does not draw primarily what he sees on his retina but what he knows to be in front of him. But he makes a pattern of those elements, much as the ritual artist makes a pattern of the received forms of an icon, and so the drawing comes alive. Play and ritual and pattern are often closely linked. It is not schemata that are the problem — there are "w" birds in Van Gogh's skies, and Leonardo used schemata — the problem is failure to make patterns. However, the world as it is seen on the retina is not schematic, it is pattern.

Most buildings today are perfunctory arrangements of schemata. "Buildings influence behavior by embodying images," an interior designer announces to a conference on office planning. It is a succinct statement of the way our time sees buildings. But it is the same thinking that sees "hand," not the line and shadow of a hand; it can be useful, but not when you want to make a place.

> *Quickly we stick labels on all that is, labels that stick once and for all. by these labels we recognize everything but no longer SEE anything. We know the labels on all the bottles, but never taste the wine.*
> — FREDERICK FRANCK, *The Zen of Seeing*

In *On Photography*, Susan Sontag notes that photographs tend to enhance their subjects. I think that is because a photographer, like any

designer, automatically wants to make a pattern, no matter how utilitarian or harrowing the subject. But if, as you design, you are told not to make a pattern but to pile up the schemata, the eagles and weathervanes and shutters that say "house," then your intuition doesn't get a chance to play, and the pattern — there is almost always *some* pattern — is weak.

I found that regulating lines organized my drawings just as they organized my buildings, although I was equally unaware of them as I drew. Books on visual composition showed regulating lines in pictures by Seurat or Dürer, but I had imagined that their patterns were the result of high technique; now I saw that they did not have to be. It seemed pattern was the way anyone's mind worked when one set about to play with light and shade.

I knew how to design a building, but I did not know how to draw a picture. I needed to be told very specifically that a drawing was a pattern. Conversely, knowing how to look at a drawing does not lead inevitably to seeing a building as light and shade, although it can make the shift easier.

Here was an explanation for the loss of pattern in American design — for that abrupt change from ubiquitous beauty, liveliness, and grace to disharmony and the apparent general weakening of ability. People had *not* lost their ability, they had changed what they thought they were looking at. They had stopped looking at buildings as patterns in light and shade and had started seeing them primarily as devices to be used — for effect, comfort, commerce. The results were readily measurable: the patterns of regulating lines disintegrated.

The loss of the old way of seeing buildings was the reverse of the transformation Betty Edwards's students made: it was a *closing* of access to visual competence, brought about by a shift in paradigm. The old paradigm for design had been pattern; the new paradigm was use. When the paradigm changed, *seeing* itself changed. Seeing buildings

became a different process. Around 1830, designers of buildings made what seemed to be a small change in paradigm, but the results were not small. The new design process was like the "left-mode," or symbolic, drawing of a hand: it was *about* its subject. Such a drawing tries to get "handness" onto paper, whereas the "right-mode" drawing derives from the pattern of light and shade on the hand; the pattern an artist sees is not on the hand at all but in the artist's eye. The right-mode drawing process explores and plays with the pattern the artist sees. In intuitive design, one does not think about the object perceived, one does not think about perception. One just plays with the light and the shadows.

A drawing is one thing, a building is another. A drawing is an abstraction, separate from its subject, but a building is both pattern and subject: it is easier for architecture than for drawing to lose track of pattern.

A building is an agglomeration of windows and doors and cost estimates and program requirements. Can you get thirty people into this space and still meet code? Can you get them out? Do you need handicapped access? Do the light fixtures work? But when you have taken care of all these matters, you still haven't got a design. So you find out what requirements must be met, you gather the information together, and then, to make a design of it, you turn those elements over to your intuition. When you do that, you imbue the design with a system of proportions.

There come moments of inspiration when, having worked out all the elements of the design, I suddenly "get it," and then I put a design down on paper. The idea is already there, and all I am doing is recording it on the page. I don't think inspiration means that you come up with a masterpiece or even, necessarily, with something that works; but it is the only way I know to make designs that come alive. As the result of my work comes fully into consciousness, it sometimes feels like magic, but it is just something that I have been making.

Thinking should be done beforehand and afterwards,
never while actually taking a photograph.

— HENRI CARTIER-BRESSON

You do play-by-play with your eyes. When you're doing
play-by-play and you're conscious, you can't do it, you
break down.

— RED BARBER

Beginning in the early 1950s, Roger Sperry, working at the California Institute of Technology, studied the way the cerebral hemispheres work — how they share information, how differently they process it. Edwards quotes Sperry: "The main theme to emerge . . . is that there appear to be two modes of thinking, verbal and nonverbal, represented rather separately in left and right hemispheres, respectively, and that our educational system, as well as science in general, tends to neglect the nonverbal form of intellect."

Even as far back as the 1830s, research showed differences in hemisphere function, notably that the left side tends to control speech. In part because the left side is verbal and the right side is not (the pattern typical of right-handed people), the left hemisphere came to be known as "dominant," while the right was called "minor."

Edwards was aware that she made a shift of consciousness when she drew. Sperry's description of right-hemisphere function matched her experience of that shift. But, she realized, the nonverbal form of intellect must be going untapped: "That work provided me with a sudden illumination that an individual's ability to draw was perhaps mainly controlled by the ability to shift . . . from the verbal, analytic processing . . . to spatial, global processing."

The reason, Edwards proposes, that most people do not know they can draw is that they are using the wrong part of their brains to do it. The process, the state of mind, and the results of Edwards's method

are not disputable: you merely have to look at the drawings — or, better yet, *do* the drawings. Sperry, who received a Nobel Prize for his work in 1981, endorses Edwards's work. However, as Edwards acknowledges, her approach does not require, or prove, a right-brain location for drawing ability.

Since Sperry's work, many investigators have researched the right and left hemispheres, and I think it can be said that his general findings, as Edwards described them in 1979, have been corroborated. But science is only just beginning to understand perceptual and intuitive processes. We have outlines, highly educated anecdotal guesses, detailed replicable fragments. The right- and left-brain model does show in a very concrete way that we are each capable of thinking, at will, in entirely different modes, of seeing in two profoundly different ways.

The right-brain drawing is more disciplined and looks more real than the methodical left-brain drawing because the right brain sees form and pattern as they are, not as schematic labels. The neurologist Oliver Sacks writes, "It is the right hemisphere which controls the crucial powers of recognizing reality which every living creature must have in order to survive. The left hemisphere, like a computer tacked on to the basic creatural brain, is designed for programs and schematics."

"All thinking is sorting, classifying," Gombrich wrote in *Art and Illusion.* That is what Edwards would call the left mode. She describes the right-mode frame of mind: "In that different subjective state, artists speak of feeling . . . 'at one with the work,' able to grasp relationships that they ordinarily cannot grasp. . . . They feel alert and aware yet are relaxed and free of anxiety."

I use "intuition" where Edwards uses "right mode." Intuitive drawing is right-mode drawing, but intuition is a broader term; it means unconscious judgment that uses the appropriate innate resources and

attunes to external resources as well. I use the more inclusive term because architecture is a more general discipline than drawing.

The intuitive way of seeing is intense but relaxed sensory contact with one's surroundings. Intuition is not all nonverbal, as the right-brain drawing state tends to be. But intuition calls upon resources we associate with the right brain. The link between right-brain perception and intuitive judgment seems to be the ability to think in terms of pattern.

Intuitive seeing is to see, and seem almost to be seen by, one's surroundings. It is like silent visual listening, an awareness in which the listening goes both ways. The Nothing in the walls, the windows, the shadows, and the light, listens. One is master of knowing where one is.

Betty Edwards admires the paintings of Jean-Baptiste Chardin (1699–1779), of whom Wylie Sypher writes, "Chardin's pitchers, fruits, plates . . . are private meditations upon objects. This is what endows these things with their poetry. . . . For Chardin is bringing to bear upon them his own generous awareness; he is not canceling out the *way* he sees them. . . . Do not the things almost seem to know they are being looked at?"

"Notice that no parts are named," writes Edwards of the intuitive drawing process. "No statements are made, no conclusions drawn, such as, 'The chin must come out as far as the nose,' or 'Noses are curved.'" "I never stoop'd so low, as they / Which on an eye, cheeke, lip, can prey," wrote Donne. "If care and attention are lavished on the negative spaces," writes Edwards, "the forms will take care of themselves." And she quotes Samuel Beckett, "Nothing is more real than nothing."

The psychologist Julian Jaynes uses the term "voices of the gods" to describe the feeling of magic that often accompanies intuitive judgment. In *The Origins of Consciousness in the Breakdown of the Bicam-*

eral Mind, he suggests that the ever-present gods of the ancient past were the wisdom of the right hemisphere, which the left hemisphere perceived as external. Jaynes writes that the task today is to reintegrate that inner authority without personifying it.

One of Roger Sperry's associates, Colwyn Trevarthen, writes of the "extraordinary superiority of the right hemisphere for knowing a face, especially when it lacks bold distinctive features, such as glasses, moustache, hat, or birthmark." For the left hemisphere, by contrast, "face recognition is poor and identification is achieved by a laborious check-list of distinctive semantic elements to be memorized and searched for."

A two-year-old is a master morphologist; he knows all about faces; and he is a linguist, who understands the concepts of word and sentence. These things come first because they are the important things. They go along with play. No one is more playful than a two-year-old. I think the reason we attune so easily to pattern making, in buildings and in drawings, despite the failure of our culture to teach, or even to acknowledge, such patterns, is that pattern recognition uses the skill of face recognition.

"Just as we recognize a face in a crowd instantly, the right brain can recognize a trademark or logo in a crowd of products — without even reading it," writes Thomas Blakeslee in *The Right Brain.* The ornate letters that say "New York Times" are not read but explored and enjoyed and, the next time they are seen, recognized. Often, on a magazine cover, a photograph will obscure part of a name. This is another way to engage intuitive vision; it is like looking at a ruin; the mind likes to put in the missing pieces of the pattern. Many of the most enduring logos — GE, Ford, Coca-Cola — make no great effort at legibility; they let the eye rove among their curlicues. A signature is a logo. I think this is also why handwritten notes are more esteemed, even if harder to read, than typed ones.

Before Edwards's work, it was generally assumed that most people were born without visual skill and were incompetent to draw. Similarly in architecture, Ugly and Ordinary continues to be so general that it is accepted as inevitable. Some in our century have thought the problem was not innate but cultural. Walter Gropius recognized that we have two kinds of seeing, and he observed that the intuitive way could lead rapidly to increased ability: "When intuition has found food, skill develops most rapidly while routine alone can never supersede creative vision." But Edwards showed that most people already have a high level of visual skill. I do not say that there is no need for visual training but that we start out much farther ahead than we have thought.

Pleasure is at the core of intuitive seeing, as Edwards notes and as the psychiatrist Klaus Hoppe also points out:

Endoceptual phenomena are "global" experiences, like the "oceanic" feeling, occur in dreams, and are the basis for empathy. The nonverbal, quasi musical character of endoceptual cognition seems to be closely linked to right hemispheric functions. . . . Recently Paul Horton (1988) connects positive emotions, like joy, love, gratitude, bliss, ecstasy, and happiness with these zones of the right parietal cortex. Here the close connection between cortical functions and emotions are shown as a basis for creativity.

Or, as Louis Kahn said:

You cannot make a building
unless you are joyously engaged.

9

Reason

I am walking in the country, thinking about lunch and the bad thing someone said, or the good thing I will do, tramping along, when I stop for a moment . . . and suddenly it all comes in: yellow trees, fields, shadows — the country is full of shadows. The sensation is a kind of visual listening. In this state, perception is more vivid, colors are deeper, the world looks at once more real and more magical.

The woods and meadows often bring out this way of seeing. But built places may evoke it as well:

> This City now doth, like a garment, wear
> The beauty of the morning; silent, bare,
> Ships, towers, domes, theatres, and temples lie
> Open unto the fields, and to the sky;
> All bright and glittering in the smokeless air.
> Never did sun more beautifully steep

In his first splendour, valley, rock, or hill;
Ne'er saw I, never felt, a calm so deep!

> — William Wordsworth, "Composed upon
> Westminster Bridge, September 3, 1802"

It can come about in the middle of Grand Central Station, as Tony Hiss describes in *The Experience of Place*: ". . . a change that lets us start to see all the things around us at once and yet also look calmly and steadily at each one of them. . . . The experience . . . is of being overtaken by a sense that in the midst of a crowded and confining city you can be present in and a part of a serene and endless world."

"But what is this openness . . . ? It strikes me as something like a *region,* an enchanted region where everything belonging there returns to that in which it rests." Martin Heidegger's word for this state of perception is *Gelassenheit,* "letting-go-ness toward things." *Gelassenheit,* Heidegger points out, is "an old word." But Heidegger, writing in 1955, warns that another mode of perception, "calculative thinking," is taking over and taking us away from ourselves: "calculative thinking may someday come to be accepted and practiced *as the only* way of thinking. . . . Then man would have denied and thrown away his own special nature. Therefore, the issue is the saving of man's essential nature."

After a certain age, a child tends to stop seeing just what is in front of him — the shadows, the colors — and starts instead to see what they *signify.* It is no longer a lovely blue-and-white shape with white speckles on it, it is Rest Area This Way. But it *is* a lovely blue, isn't it? Must we have one or the other, practical information or intuitive vision? Must the intuitive experience be childish? The old way of seeing is a child's way of seeing. It is my memory of how I saw when I was five years old. But it is not childhood I want, it is the visual experience I remember from childhood.

The term "old way of seeing" refers as well to a time before the dominance of mechanistic thought, a time that welcomed and acknowledged for adults the kind of vision we now relegate to childhood. If you think our way of seeing was never like that, just look at how old buildings dance and play. Not that I want to turn the clock back. Not that we could go back. We cannot just catch the former vision like a bug in a net. To regain the old way of seeing is not to return to the styles or superstitions of the former world any more than it is to return to childhood.

"The coming period . . . has to bridge the gap that, since the onset of mechanization, has split our modes of thinking from our modes of feeling," Siegfried Giedion wrote in 1948. But it is more than feeling that has been split from thinking; it is also what Buckminster Fuller called Mind, what Ralph Waldo Emerson called Intuition, what Thomas Jefferson called Reason. "You have to distinguish between reason and thinking," writes Joseph Campbell. "Reason has to do with finding the ground of being and the fundamental structuring of order of the universe. . . . All men are capable of reason. That is the fundamental principle of democracy."

Architecture and democracy both come from reason, the intuitive judgment that goes beyond calculation. The words "reason" and "ratio" share the same Latin root. Reason is seeing in proportion. It is the nature of architecture to join intellect and intuition; but intuition must govern, or the building will feel dead. Architecture is always in tension between intellectual use and intuitive pattern. The rain has to stay out and the building has to sing.

A building is play. Play, mystery, opportunity, mastery. Jefferson gave play its proper place when he made happiness one of the three highest principles of democracy. He was, after all, an architect. Jefferson derived the famous rights of the Declaration from "life, liberty, and property," John Locke's formulation of many years before 1776.

But property, Jefferson saw, has nothing to do with fundamental principle; property is merely in the service of life, which must play. Our Declaration at its simple deepest makes the national goal the protection, not of our livelihood but of our liveliness.

"Man only plays when he is in the fullest sense of the word a human being, and he is only fully a human being when he plays." *Sincerity and Authenticity,* in which these lines of Schiller are quoted, is Lionel Trilling's remarkable investigation into paradigms of self. Trilling describes a parallel in the models of Schiller, Wordsworth, and Rousseau:

> There is one point of connection between the two men [Wordsworth and Rousseau] that requires to be kept in mind — the passionate emphasis each of them put upon the individual's experience of his existence. [They called this] the "sentiment of being." . . . The sentiment of being is the sentiment of being strong. Which is not to say powerful: Rousseau, Schiller, and Wordsworth are not concerned with energy directed outward upon the world in aggression and dominance, but, rather, with such energy as contrives that the centre shall hold.

It is the model of Jefferson, who was the contemporary of all three. In such a model, the person is complete. The playful process of design expresses that complete self. It is an old-fashioned model. We have learned a thing or two since those days. But one look at our buildings compared to theirs tells us that we have learned some things that are not true.

The Enlightenment claimed reason must be dominant in the individual mind because science seemed to show it to be so in all natural processes. Ben Franklin wrote, "All the heavenly bodies, the Stars and Planets, are regulated with the utmost Wisdom! And can we suppose less care to be taken in the Order of the Moral than in the natural System?"

The United States was established to put that belief in personal wisdom into practice. It was Thomas Paine who named the era the Age of Reason, but his use of the word "age" contained a premonition of its impermanence. The Age of Reason in America lasted about one lifetime. The years correspond so closely to Jefferson's dates (1743–1826) that one wonders what sort of Age of Reason there could have been without him. Jefferson wrote, "Reason and free inquiry are the only effectual agents against error. Give a loose to them, they will support the true religion by bringing every false one to their tribunal, to the test of their investigation. They are the natural enemies of error, and of error only."

The words are as quaint to us as the houses of Newburyport. But we go back to Franklin and Jefferson again and again, as we go back to the old houses. To follow reason required trust in the unknown, both inside and outside the individual. The decision to put power ahead of reason, as the modern age does, may come from fear of what cannot be known consciously. The motive is to control events, to know, through force or manipulation, what is going to happen, instead of trusting what the Enlightenment called Nature — including one's own and others'.

> *Humans grope for* absolute *understanding,*
> *unmindful of the a priori mystery*
> *which inherently precludes*
> absolute *understanding.*
> *unaware that the groping*
> *does not signify personal deficiency,*
> *and ignorant of the scientific disclosure*
> *of fundamentally inherent mystery,*
> *they try to "cover up" their ignorance*
> *by asserting that no fundamental mystery exists.*
> — BUCKMINSTER FULLER, *Intuition*

The old way of seeing thrived in the now-dead culture of an agrarian age. During most of that age, mysticism was the paradigm that explained how inspiration came out of the unknown. In the mystical world, the unknown darkness was granted its due magnificence. There was magic everywhere, but the unknown could be influenced. Buildings were subject to supernatural ills and remedies. The corner might be sliced off a cottage if it blocked the path of the fairies.

Mysticism projects values and meanings upon the unknown in order to explain and control it: it sees intuition to be outside the individual. Dreams, for example, are signs rather than expressions. Reason, on the other hand, trusts the darkness of intuition, and sees it as the center of the individual. Jefferson could look into the darkness — his darkness — and see what he called light.

In Enlightenment democracy, the wisdom of nature was thought to be available to everyone. In the paradigm of the Age of Reason, the magic — the sense of life, play, the unknown — is still there. Reason trusts the Nothing. This part of the Jeffersonian philosophy is ancient: "What-is sprang ... from What-is-not," said Lao-tzu, around 500 B.C. "It is in the spaces where there is nothing / That the usefulness of the room lies." But Lao-tzu was no democrat: "The more the folk know what is going on / The harder it becomes to govern them." He was saying most people are not centered enough most of the time to make positive use of information; only a few can be trusted to act from deepest intuition. The same concern caused Walt Whitman to write, after the Civil War, "I will not gloss over the appalling dangers of universal suffrage in the United States. . . . For know you not, dear, earnest reader, that the people of our land may all read and write, and may all possess the right to vote — and yet the main things may be entirely lacking?"

The founders of our democracy restricted the vote to those who could not be financially coerced. But it was a plutocratic stopgap, not

a solution, and the Age of Jackson began its overthrow. However, the new approach shifted the focus of democracy away from the expression of inner wisdom to fairness. The Age of Jackson did not attempt to solve the problem by broadening access to inner wisdom or by encouraging its expression but by balancing power among haves and have-nots, so that coercion of votes would be less possible. Surely it was right to try to balance that power, but if Jackson — or such a Jacksonian as Roosevelt, Truman, or Clinton — had read Lao-tzu, he would have been warned never to sacrifice intuition:

> The mighty Way declined among the folk
> And then came kindness and morality . . .
> So codes were made to regulate our homes.
> The fatherland grew dark, confused by strife:
> Official loyalty became the style.

Jefferson's (and Washington's, Madison's, and Jackson's) lifelong possession of slaves cast doubt upon all the principles of the Declaration. The underlying model of individual wisdom was at risk so long as the anomaly of slavery was accepted. But by the time abolition came, the machine age had already pushed intuitive wisdom into the background. The Age of Reason has been over now for a hundred and sixty years, but reason has always remained an article of our faith. America did not so much turn away from reason as allow the vision of trust in inner wisdom to become more distant.

The age that has followed is again superstitious, in a sense. The break the founding fathers initiated — the break from mysticism, with its need for exterior authority — was not completed. Underlying the superstition of both the mystical time and our mechanistic time is fear of the unknown.

Mysticism respected the power of the unknown in nature, interpreting it through the authority of dogma. Jeffersonian democracy

accepted nature through personal wisdom. There was room in both for intuition, the old way of seeing. A third alternative was to impose power upon nature, and that became the form of rule after the Age of Reason.

Emerson's Answer

Ralph Waldo Emerson's "Self-Reliance" is an answer to a question that is at the root of American democracy and architecture: is there a self we can trust? During the Age of Reason the answer might have seemed as self-evident as the truths of the Declaration. But Emerson lived in a different age, the beginning of our own, which mistrusts human nature and so relies on power.

"Self-Reliance" is a passionate and cogent response to that mistrust. Emerson wrote his essay in 1841, when America's view of both democracy and architecture had just changed profoundly. In architecture the old way of seeing had faded, while in politics the paradigm for democracy shifted from inner wisdom to relative power. Ratio and reason, the inner play of pattern, were pushed aside. The model for both politics and architecture became manipulation from the outside in rather than expression outward from an inner center.

Reason needed an advocate. Emerson made it his life work to fill the gap the Age of Jefferson had left and the Age of Jackson had revealed, to provide an American mental model, a paradigm, for trust in the innate judgment of the self:

> The magnetism which all original action exerts is explained when we inquire the reason of self-trust. Who is the Trustee? What is the aboriginal Self, on which a universal reliance may be grounded? What is the nature and power of that science-baffling star, without parallax, without calculable elements, which shoots a ray of beauty even into

trivial and impure actions, if the least mark of independence appear? The inquiry leads us to that source, at once the essence of genius, the essence of virtue, and the essence of life, which we call Spontaneity or Instinct. We denote this primary wisdom as Intuition, whilst all later teachings are tuitions. In that deep force, the last fact behind which analysis cannot go, all things find their common origin. For the sense of being which in calm hours rises, we know not how, in their soul, is not diverse from things, from space, from light, from time, from man, but one with them.

If one could trust intuition in all things, then one need not turn to ancient architectural styles:

The soul created the arts wherever they have flourished. It was in his own mind that the artist sought his model. . . . And why need we copy the Doric or the Gothic model? Beauty, convenience, grandeur of thought and quaint expression are as near to us as to any.

At the time Emerson wrote "Self-Reliance," he had already met Horatio Greenough, an American sculptor and thinker-about-art who lived in Rome. Greenough later wrote two books on architecture that were influential in their own right; but it was Emerson who first brought his writings to the world's attention and who continued to promote them after Greenough's early death in 1852. Greenough wrote to Emerson: "Here is my theory of structure: A scientific arrangement of spaces and forms to functions . . . color and ornament to be decided and arranged and varied by strictly organic laws . . . the entire and immediate banishment of all make-shift and make-believe."

Form to function, organic. The words and ideals became the core of a new architecture in the twentieth century. It was to be a new way of building, but it was also very much an embodiment of the old principles of the American Enlightenment, the expression of nature through reason: "Let us encourage experiment at the risk of license,

rather than submit to an iron rule that begins by sacrificing reason, dignity, and comfort. Let us consult nature, and in the assurance that she will disclose a mine richer than was ever dreamed of by the Greeks, in art as well as in philosophy."

This was in the vein of the Jeffersonian vision, but Greenough believed it came closer to the heart of the matter than Jefferson's own buildings. There was harmony and play of pattern in Jefferson's architecture, but Greenough criticized its imitation of past styles. He made fun of Jefferson's appropriation of the Roman Maison Carrée at Nîmes to be the model of the Virginia state capitol at Richmond, and he opposed resuscitating any ancient style: "The monuments of Egypt and of Greece are sublime as expressions of their power and their feeling. The modern nation that appropriates them displays only wealth in so doing."

Unlike Emerson's philosophy, Greenough's thought contains weaknesses, as well as strengths, of twentieth-century design. There is a tinge of mechanistic purism to his "scientific arrangement," his "strict laws," his "banishment of make-believe." Ships were his highest architectural model (Ruskin, his contemporary, also greatly admired ships). The way a ship expresses its function can be very beautiful, but a building's function, to be a place, must be expressed in its own way. Emerson took a broader view of architecture; he did not say a building should be like a boat.

Self-reliance! When I was in high school, I took the words to be an admonition to be responsible, and I read no more of Emerson. But Emerson stated the American vision of reason as few have since.

"Nothing can bring you peace but yourself," wrote Emerson in the radiant summation of "Self-Reliance." "Nothing can bring you peace but the triumph of principles." The Emersonian self *is* the triumph of principles. But what does Emerson mean by "peace"? I think he means peace as D. H. Lawrence defines it: "Peace is when I accept life."

Frank Lloyd Wright: The Freedom to Become Uncommon

All man-made things are worthy of life.
— FRANK LLOYD WRIGHT

Frank Lloyd Wright set out to create the Emersonian architecture. Emerson had said buildings must express democracy in a concrete way, not through symbolic eagles or Greek columns; there was to be no *telling* about democracy; architecture must be *visually* democratic. In the eclecticism of Emerson's day, the building was made to influence the occupant's sensibilities through stylistic references. The goal of an Emersonian architecture would be connection, not influence. Such an architecture would be of the self: not selfish, not self-centered, but centered in the self. Wright called it the architecture of democracy.

Louis Sullivan, in the 1880s, had coined the Greenoughesque dictum that form follows function. But Wright rejected that view. Form does not follow function, he said; form and function are one. Wright took his search — the search for a way to build Emerson's ideal, a way to embody democracy in light and shade, walls and space — beyond his mentor.

Wright's Emersonian leap of faith was that by expressing *his* true self, he would express the true selves of people who occupied his buildings. His talent would not be an imposition, a tyranny. It would be a connection, just like the connection one feels when one hears a piece of music — a connection not *to* the composer but *through* the composer to Nature, or Nature's God.

The famous precedent was Whitman, who had taken the Emersonian plunge forty years earlier; the result was a new poetry of de-

mocracy. In the preface to *Leaves of Grass*, Whitman wrote of architecture:

> To put anywhere before the human eye indoors or out, that which distorts honest shapes . . . is a nuisance and revolt . . . but those ornaments can be allowed that conform to the perfect facts of the open air and that flow out of the nature of the work and come irrepressibly from it and are necessary to the completion of the work.

"Power ceases in the instant of repose," Emerson had written; "it resides in the moment of transition from a past to a new state, in the shooting of the gulf, in the darting to an aim." One thinks of the Guggenheim Museum rotunda, which is the Emersonian definition of beauty, "the moment of transition, as if the form were just ready to flow into other forms." Or of Unity Temple in Oak Park, Illinois, which Wright designed in 1904; it is all space and movement and, at the same time, calm at the center. No architecture has ever been more self-reliant than Wright's.

In his *Autobiography*, Wright tells of the process of discovering the architecture of democracy, around 1900:

> Proceeding, then, step by step from generals to particulars, plasticity . . . began to grip me and to work its own will. Fascinated I would watch its sequences, seeing other sequences in those consequences already in evidence. . . . Vistas of inevitable simplicity and ineffable harmonies would open, so beautiful to me that I was not only delighted, but often startled. Yes, sometimes amazed.

"Plasticity" — what does he mean? He says, "In my work the idea of plasticity may now be seen as the element of continuity." Wright's words might lead you to expect his buildings to be sinuous, blobby, amorphous. Not at all; they are always highly ordered geometric patterns. Everything is defined. Continuity means that every element contributes.

Emerson had written, "The pleasure a palace or a temple gives the eye, is, that an order and method has been communicated to stones, so that they speak and geometrize, become tender or sublime with expression." In a Wright house, a four-by-four-foot grid will be inscribed right into the floor, the roof will slope at exactly 30 degrees, the walls will form clean right angles. And then the shadow of a branch will flicker against such a wall — the wall is red, the sunlight glinty gold — amidst those sharp lines and edges. You see that he has done it; you are in the hands of a master. But what has he done?

Sullivan's decoration had aimed for continuity in that it was meant to have no background or foreground. But Wright took Sullivan's concept outside of embellishment and into the whole building. The liquid decoration of Sullivan and the contemporaneous Art Nouveau *represented* continuity. Art Nouveau was not the breakthrough its name implied, because it was still an architecture of separate elements *on* one another, although it sometimes tried to dissolve joints in order to create unity.

Wright played with such decoration, but he abandoned it around 1900. Wright's continuity meant that each element and aspect — shape, color, texture — participates, not as one thing *on* another but as one thing *with* another. This is why Wright came to understand that materials required expression for what they were. The purpose was not to be morally honest, but to let each element be seen and experienced individually. In the unity of a Wright building, every component is active.

The essence of each material stands out. Wood is not painted, because paint would conceal its "woodness" — its color, grain, odor. Paint would muddy the experience of continuity, which accords value to everything. So the wood is unpainted. The blocky rectangularity of brick is revealed so that each brick reads as a clear element. Wright would never paint brick, as Gropius does, because the idea is to em-

phasize "brickness." The Wright building does not *use* brick, it *is* brick. But geometry comes ahead of material in a Wright building. Richardson's brick is more sensuous — you feel the clay with your eyes; Le Corbusier's concrete is more "poured" — the board lines of the form work make you imagine that the forms were pulled off an hour ago. Wright's materials are cut, stacked, shaped into patterns. The materials are various, but the discipline of shape is continuous, in the same way that pattern is the visual continuity from one form of life to another. But even pattern is not dominant. Wright uses pattern to bring out space. Space, the Nothing, is dominant. Wright said, "I think [Unity Temple] was about the first time when the interior space began to come through as the reality of the building. . . . You'll notice that features were arranged against that interior space, allowing a sense of it to come to the beholder wherever he happened to be."

Unity Temple does not express material, nor does the Guggenheim Museum. In these buildings of poured concrete, space, not material, is the focus. Wright sets the space humming . . . or does he bring out a hum that is already there?

Gropius admired Wright, and he used some Wrightian language; he wrote of "our conception of the basic unity of all design in relation to life"; but Gropius's work, superb though it can be, is still one thing *on* another. The paintings are *on* the wall, the furniture is *on* the rug, which is *on* the floor. Everything is next to, on, or refers to something else. An architect acquaintance said to me, "Gropius was a gentleman; he would have agreed Wright was more talented." But is Wright's continuity the result only of talent? Isn't it also the product of a different way of seeing? And Wright always said architecture was no profession for a gentleman. Inspiration goes naked — although it can be far more gentle than intellect. Wright subordinates intellect to intuition, while Gropius never quite relinquishes control: there is a fatal moment of thoughtful deliberation while the perfect tone of gray is cho-

sen to paint the door. Wright does not paint the door at all. When Wright does use colors they sometimes look like mistakes — but *such* mistakes, as one great pianist said of another's playing. Wright demands a leap into the unknown far greater than any Gropius suggests, but he makes it seem like the most natural thing in the world — which, indeed, it is.

Vincent Scully probably had more influence on architectural education than any other individual between 1950 and 1990. At Yale he was mentor to such Post-Modernists as Duany and Plater-Zyberk, and he wrote the introduction to Venturi's *Complexity and Contradiction*. In 1960 he wrote a monograph on Wright. Like Lewis Mumford, Henry-Russell Hitchcock, and Philip Johnson before him, Scully buried Wright in the past, even though at the time Scully wrote, more than thirty Wright buildings were under construction:

> Wright's "time, his day, his age" was that of late nineteenth-century America. . . . Wright was the heir, in architecture — and regarded himself as being so — of a tradition, in part Jeffersonian, which had previously found its best expression in the works of Melville, Whitman, and Mark Twain. As they, in their writing, had celebrated at once the flux and flow which characterize modern times and the compulsion toward unity which is the democratic will, so he, in his architecture, sought to make the images of flow a fact, to celebrate continuous space, and to bring all together into shapes which were unified by his will.

Wright's architecture took off when he learned how *not* to assert his will but to let the design come *through* him. In his own description of the process, Wright "watches" his work, "fascinated," as "vistas . . . open." His amazement at these creations is not egotism but is typical of the intuitive experience of work. It has a parallel in Zen, as Eugen Herrigel writes in *Zen in the Art of Archery*: "Sunk without purpose in

what he is doing, he is brought face to face with that moment when the work, hovering before him in ideal lines, realizes itself as if of its own accord."

Scully speaks of the "compulsive and mesmeric" quality of Wright's space. Scully seems to see Wright's architecture as some form of hypnotic manipulation. But I do not find Wright's continuity, his space, in any way "mesmeric." I would describe the sensation of a Wright space as awake, centered, exhilarated. Nor do I agree that the ideal of Jefferson is "compulsion toward unity which is the democratic will." The Jeffersonian ideal is *expression* of unity, not compulsion. I believe democracy fails to just the extent that it is willed. Scully misses Wright's purpose when he says a Wright building has no center: "The Wright plan is an image of modern man, caught up in constant change and flow, holding on, if he feels he must, to whatever seems solid . . . like Huck and Jim on the Mississippi, where they find comfort only while floating onward together through the mists and where all turns to nightmare whenever they touch the shore."

In Wright's architecture of democracy, *you* are the center; you are *always* at the center. It is the essence of democracy that everyone is at the center. Scully's "modern man" is disconnected from intuitive experience. The nightmare of Scully's river-of-life metaphor comes from trying to control life by intellectual will; one knows it cannot be done, but the thought of letting go becomes terrifying. Wright's buildings are on and of the real river of space that flows through them. D. H. Lawrence writes of such a river: "It will seem to us we are nothing when we are no longer actuated by the stress of self-will. It will seem we have no progression, nothing progressive happens. Yet if we look, we shall see the banks of the old slipping noiselessly by; we shall see a new world unfolding round us. It is pure adventure, most beautiful."

Scully's writing describes the dissociation from such experience,

the industrial-age split, which John Dewey, in *Art as Experience* (1934), characterizes as:

> . . . a separation of that mode of activity commonly called "practice" from insight, of imagination from executive doing, of significant purpose from work. . . . We see without feeling; we hear, but only a second-hand report, second hand because not reenforced by vision. We touch, but the contact remains tangential because it does not fuse with qualities of senses that go below the surface. . . . Prestige goes to those who use their minds without participation of the body.

The critics are right, Wright is not of their age, the age of machine thought.

In *Redesigning the American Dream* (1984), Dolores Hayden attacks Wright in a way that reveals how two different ways of seeing — intellectual and intuitive — can give opposite meanings to architecture. Hayden accuses Wright of sexism:

> Wright's Affleck House of 1938 returns to the forms of the German peasant's cottage of 1750. . . . The householder sits as head, with his sons and male servants on the high-backed bench next to the wall, and his wife, daughters, and female servants on the backless bench next to the kitchen. . . . The pre-industrial religious orientation helped the businessman preside at home.

The Affleck House soars out from a hillside, all plate glass and cantilevered decks, but to Hayden's way of seeing, it "returns to the forms of the German peasant's cottage of 1750." To Hayden, "form" means social symbol — in this case, a built-in L-shaped seat that faces movable seating. To Wright, "form" is visual pattern. Tables and chairs are rhythmic and spatial devices. Wright does not care who sits where, because every seat is "there." To make it so is his overriding goal.

Wright's democracy means everyone is always at the center. The visual expression of this democracy, "continuity," gives presence to

every aspect of a building. Hayden's democracy is limited to fairness. But fairness is not a visual concept. It is like Ruskin's "Lamp of Obedience," literary. Knowing that L-shaped built-in seats once represented domestic tyranny, Hayden sees Wright's dining area as an attack on women. If historical evidence had shown that L-shaped seats were a sign of reverence for women, she might have praised his design. There is no inherent standard, no timeless criterion, no trust in innate judgment in this approach to architecture. (How *do* you design a fair dining room? Are all banquettes taboo, or just L-shaped ones? Must all seats be equidistant from the kitchen?) This is intellectual architecture, groping its way from one label to the next. The designer cannot be trusted; the right thing to do must be figured out from received ideas, whose meanings and values shift, depending upon interpretation.

Wright's architecture is profoundly democratic in that it brings out the true selves of its occupants. Alexander Woollcott wrote to him in 1941,

> I told Lloyd [Lewis, for whom Wright designed a house in 1939] that this one makes even a group of his friends look distinguished. . . . Just to be in the house uplifts the heart and refreshes the spirit. Most houses confine their occupants. Now I understand, where before I only dimly apprehended, that such a house as this can liberate the person who lives in it.

Wright made it possible for his clients to live in a continual experience of intuitive seeing, a gift which many of them appreciated very deeply, as several have told me. Dr. and Mrs. Zimmerman, for whom Wright designed a house in 1950, had only one complaint: they loved being in the place so much they seldom went anywhere else. Wright's most famous house was Fallingwater, built at Bear Run, Pennsylvania, in 1936. Engineers regularly informed the Kaufmanns, who built the house, that it had structural problems, but Mrs. Kaufmann was not

being ironic when she wrote to Wright, "Living in a house built by you has been my one education." Wright's buildings do not bully or overwhelm so long as you are open to them. It is true, however, that Wright chose to work with strong clients; weak ones might have struggled.

Wright believed the modern city made its inhabitants close down. He wrote, in *The Living City*, "Why, then, should we try so hard to make life and buildings look hard, like machines? Why breed a tough mechanized citizenry, merchants commercialized by machinery?" Unlike the Moderns, Wright rejected the industrial model of the city. But he was far from believing all cities had always been bad: "Urban life, originally, was a festival of wit, a show of pomp, and a revel of occasion while all was still in *human scale*. . . . The ancient city was not opposed to the course of normal human life in relation to natural beauty of environment."

Wright argued, in effect, that the modern American city undermined urbanity itself. But, while Wright's architecture did return to the old patterns, his solution to the problem of the city did not revive the ancient "revel of occasion." It, too, was antiurban. The houses of Wright's ideal "Broadacre City" are dispersed through a civilized countryside, each one self-sufficient: one acre per occupant. Wright made beautiful models and drawings of Broadacre City, and the mini-Broadacre clusters he designed in various parts of the country are a delight to visit. But Broadacre's lots isolate each little nuclear family into its separate garden, safe from the world. Broadacre is not the "city of democracy."

Space in architecture, the space that was Wright's preoccupation, can be likened to the silence Mozart said was the most beautiful aspect of music. This is not the deadness of an anechoic chamber; it is a stillness of the moment. "My father taught me that a symphony was an

edifice of sound, and I learned pretty soon that it was built by the same kind of mind in much the same way that a building was built," said Wright.

Wright often called attention to the similarity between architecture and music, but he disliked the term "composition," which he associated with picturesque artificiality. Goethe — via Greenough and Sullivan — seems to have been the source of this opinion. Goethe had said that a work of art must be like a work of nature and that "organs do not compose themselves as if already previously finished, they develop themselves together and out of one another, to an existence which necessarily takes part in the whole." Wright called his architecture "organic," and in defining the term, he emphasized wholeness, rather than formal imitation of nature: "Even the very word 'organic' means that nothing is of value except as it is naturally related to the whole in the direction of some living purpose, a true part of entity."

While he denigrated composition, Wright also liked to say that the greatest architects were Beethoven and Bach. The inconsistency is a philosophical wrinkle Wright did not work out. It was Goethe, after all, who had called architecture "frozen music" — although he might have made a warmer analogy had he seen the work of Wright. Wright knew perfectly well, and all but said, that architecture was composed. It is an important point, because the process of composition, in the musical sense, is the way we make architecture. A design may seem to grow like some seed planted in the intuitive darkness, but the building itself is strictly an artifact. Buildings do express life; and they resonate with the life in us. But it is no worse that a building should be a composition than that a song should be. The architect of a piece of music is a composer. The composer of a building is an architect. I do not like Goethe's "frozen"; architecture involves movement just as music does. The difference is that in the building it is the person who moves. You can always sit down and look at a place from a certain angle, but even then your eye continues to move.

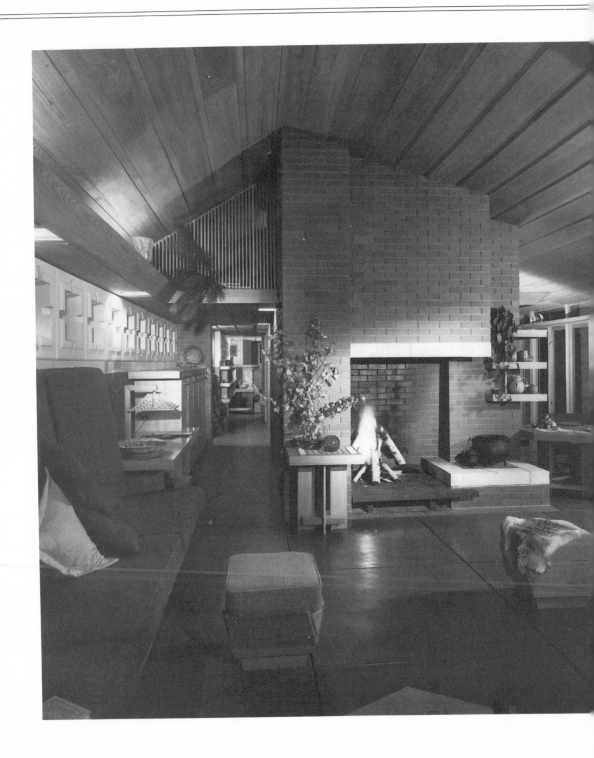

Now, the house is an idea.

— FRANK LLOYD WRIGHT, 1956

At the turn of the century, Wright called his new buildings Prairie Houses. But the name was too narrow; it referred only to the land. Wright always emphasized that a building should be *of* its site rather than *on* it; but he called his later houses "Usonian," to denote an ideal — the democratic United States, "Usonia" — rather than a location. Wright credited the invention of the word to Samuel Butler, author of the utopian novel *Erewhon.* The similarity of "Usonia" to "Utopia" was surely part of its attraction for Wright. I think he believed, like his friend Buckminster Fuller, in the necessity of Utopia. And, if "Usonian" sounded a bit Emersonian, then so much the better.

In 1950 Wright designed the Usonian Zimmerman House in Manchester, New Hampshire. The Zimmermans bequeathed the house to the Currier Gallery of Art, which restored it in 1990. The Zimmerman House is not contextual. It makes not the slightest reference to traditional New England — no clapboard, no white paint, no six-over-six windows — and it "turns its back on the street," to use Wright's words.

A Wright house is in a different world from its neighbors; therefore it keeps something back. It may look daring, but it also holds something in reserve. This is one reason (of several) why the door is usually hidden at the rear or the side, why there is no welcoming veranda on the public side. The house lacks the usual polite mask of routine. So it stands back or turns away; its secrets are not for every passerby. The roundabout path, the low, dark passage leading to a wide, bright space, is a transition from one way of seeing to another. That other way of seeing requires a barrier, some protection. In the early Prairie

Opposite page: Interior of the Zimmerman House.

Houses, the windows are of small leaded panes, which make a screen to the outside world. The plate-glass windows of the later Usonians turn away from the street. The public side of a Wright house is by no means blank or ugly; it reveals the spirit of the house, but it protects the occupants in the mental and physical openness the interior space evokes.

The Zimmerman House presents to the street, not a blank wall but a slightly forbidding row of tiny, elegant, stony white cast-concrete window frames. The door is small, the entry hall is small, the roof comes down low in shadows on the front of the house, the north side. But on the south side the house is wide open to an expansive garden; the living room is called the garden room.

Wright makes you aware of the space all around you. L-shaped walls of red brick hold you safe as you look out the open glass, through the space. You are not lulled or comforted; but you are protected so that you may experience the Nothing. The garden room windows are squares of plate glass framed within slightly larger rectangles: Wright shows you something you can see through or around so you will know the space is there. This is also the primary purpose of Wright's cantilevers — the roofs, parapets, and trellises that jut so far out from his buildings. The function of Wright's cantilevers is to reveal space.

The house uses its elements the way music uses instruments to make rhythm, color, texture, proportion, harmony. The floor plan is like a musical score. In plan, the little concrete mullions on the north side look like rows of sixteenth notes; the big columns on the south side look like quarter notes; the long walls are like sustained tones. In the plan, you can see the rhythms and the patterns — the contraction of the entry hall, the expansion of the garden room, which contracts again at the west end. The space also expands and contracts vertically, as ceiling heights rise and fall, and built-in elements, such as seats, ta-

Frank Lloyd Wright's plan of the Zimmerman House (1950), Manchester, New Hampshire. "I think a plan is always beautiful, perhaps more beautiful than anything that ever comes afterward. . . . The plan is the thing!"

bles, and shelves, advance and recede. The idea isn't heroism or originality; that was Wright's artist's mask. The idea is the dance.

Right in the middle is the fireplace; it is a reassuring hearth, but it is also fire at the center of the house.

> *This is the country that . . . declares it, the only one that has made it official, the only one that has made it constitutional, to be — yourself!*
>
> — FRANK LLOYD WRIGHT

Wright held out a vision. He wanted the Usonian House to be a model for American design and for a way of living. But he also knew

his houses were very special. The Usonians remain set apart. Not that the Zimmerman House seems disturbing among its Neo-Colonial neighbors, even though it is way outside the New England tradition; the house has a strong personality, but it is also sweet. But the Zimmerman House is great art. It is outside the normal range of talent.

Was Wright hopelessly above and beyond the ordinary? Wright wanted to be the best, but he did not want to be alone. He preached his beliefs relentlessly from the beginning to the end of his career. He said that everything could sparkle — and when he designed, everything did. Was he a magician? Was he beyond everyone else? Everything sparkles in an eighteenth-century house in the evening. A Vermont village comes alive.

A Wright house is as complex as a whole town. It is a little cathedral. But the simpler old houses are also rich. It takes, perhaps, a group of ordinary buildings designed with the old vision to equal one of Wright's houses. "In architecture, plasticity is only the modern expression of an ancient thought," he wrote. In its patterns, Wright's work was qualitatively different from the work of most of the builders of his time and our time. But it was not qualitatively different from the work of the old builders. Wright wrote:

> See all the records of all the great civilizations that have risen and fallen in the course of Time and you may see this evidence of love as joy in the making of their things. Creative artists — that is, workmen in love with what they were making for love of it — made them live. And they remain living. . . . We study them longingly and admire them lovingly.

Even Wright's mastery of space in architecture was not new. You can see the same kind of mastery in cathedrals and in Renaissance churches; and there is no more wonderful play of space than in the

church of San Vitale, in Ravenna, Italy, which was completed in the year 547. Wright wrote, "The space *within* as the reality of building is not a new concept; it is ancient essential principle not only necessarily implied by the ideal of democracy itself but inherent first in the philosophy of Lao-tze and then in the nature studies of Jesus."

Wright's architecture was the old way of seeing. But he opened new territory; he brought the play of space and geometry into the everyday house. He designed hundreds. In those houses he put the ordinary in touch with the old magic. Unlike the International Style masters, Wright joined the sublime to the everyday.

The next step for architecture is to rediscover ways for the ordinary designer to express that magic, for the average talent to take up Wright's insights, especially the expression of space. "We are capable of a world now in three dimensions," Wright wrote; "the third, as I have said before, interpreted as a spiritual matter that makes all integral — 'at one.' "

We can see from past history that the average designer can play beautifully with geometry and pattern. I think we can find a way for average designers to learn to play, as Wright does, with space. I believe that if the old way of seeing returns, a new play of space will also become part of everyday architecture.

Because Wright was a great master, his contribution seems less accessible to others. We start to compare ourselves to him, and then we are lost. But we need masters to teach us. Wright teaches, through his buildings, that space is an element of form to be played with like any other.

The nonintuitive paradigm says that "it" — power, magic — comes from outside; the only alternative to dull routine is anarchic "self-expression." Wright breaks that paradigm and says "it" comes from inside. You turn to your self for knowledge of form. You turn to your self for the sense of place. There, as Emerson says, you find the

timeless quality. Wright discovered how to do it, but he did it so well that people who did not understand his paradigm said he was one of a kind. Many would say that Wright, of all architects, least represents the ordinary — lovely or ugly. Many would say that Wright's architecture is not democratic. Whether you agree depends on how you see democracy; it depends on how you look at architecture.

Why should it matter if architecture is democratic, or if there is a true self? And, if Frank Lloyd Wright is the Emersonian architect, what is one to do with that? "Architecture as a social art cannot depend upon the existence of men of genius," wrote Mumford. But Emerson was asking, what would the world look like if we each expressed our own genius?

Other architects often feel overwhelmed in Wright's presence: the talent is too superior, the style too personal. And it makes no compromises. Many architects want to come to terms with their society's lack of vision. But you do not come to terms with the architecture of Las Vegas or Belmont. If you want such places to come alive, you must rebuild them. You must put your own life into them. Wright said, "We see ourselves all drifting back again, drifting toward the commonplace, drifting toward the common man. And you hear it asserted that is what our country meant: that the common man was free to be common. Well, he wasn't. He was free to become *uncommon*. And that's the freedom that we ought to talk about."

I do not suggest we must make our buildings *look* like Wright's. I suggest our buildings can *be* like Wright's — alive, in the ancient way — if we rely upon the paradigm of intuition, the "aboriginal Self." In a Wright building I am the purpose and the meaning. The key is me. Not *in* me, not *about* me. Me. The completeness of a Wright design does not dominate; it resonates — to me and for me. The self is the bottom line in the work of Wright, not ego, but the self exalted, in the sense of Whitman, in the sense of Emerson: "I will so trust that which

is deep is holy, that I will do strongly before the sun and moon whatever inly rejoices me and the heart appoints."

In the intuitive world, we are immersed in unknown space, and we know where we are. This is why Wright wrote, at the end of his *Autobiography,* "I wish to build a city for Democracy: the Usonian city that is nowhere yet everywhere."

10

Can It Happen?

*Can we ring the bells backwards? Can we unlearn the arts that
pretend to civilise, and then burn the world?*
— CHARLES LAMB, December 1830

No, we cannot undo the damage — not the "we" who see ourselves in
the modern way. The most dangerous creation of the "arts that pre-
tend to civilise" has been a paradigm of the self for whom life is a se-
ries of problems to be solved. When that self tries to make a place, it
becomes quickly bored, lost, and angry; and the place becomes
nowhere. The "common man," who makes the unreal city, is a fig-
ment of the modern age, which is cut off from intuition.

It requires quite a different self to see in the old way: it takes the
"aboriginal Self," which is intuition. In 1830 Charles Lamb worried
that it was already too late to undo the deadly arts, too late to go
back to the old way. But it was not a matter of unlearning, or going
backward, as he thought. We can revise our paradigm of ourselves in
the present.

Intuition is right here. When we set aside the belief that closes off intuition, the world of perception comes flooding in. If we had somehow completely blinded ourselves to intuition, the shift to the old way of seeing might feel overwhelming. But we do not really shut out intuition altogether — how easily we recognize a face — we devalue it, set it aside, forget it.

But Lamb's question nags: can we hope, in our extreme version of the machine age, to regain what was lost? Will there be a price to pay if we return to the old way of seeing, an unacceptable price?

Democracy won't tolerate superior talent, says Tocqueville; give the masses power and you can *expect* a second-rate culture. But it is not talent that has fled this democracy. It is the old magic, the voices of the gods. Dull normality becomes the standard, the balanced expression of the average mind. Emerson calls it degradation. But America resigns itself to Tocqueville's view: the price of freedom is not eternal vigilance, but mediocrity.

Aristocracy or no more voices of the gods. The American choice has been to deny the voices. Every moment the emptiness must be filled, and the sacrifice must be justified. And yet, if I listen, with my eyes and my body as well as my ears, I can still hear them. The shadows take life. This is not madness or hallucination. It is the old subtle mystery.

A new process of control replaces the old process of listening. In the new way of seeing, you look past the thing at hand, toward what you can *do* with it. Society ceases to listen and begins to struggle. You don't make it happy, you make it happen. And they who are still laughing must be wrong. In the new paradigm, the individual is incompetent and alone.

The house begins to turn into a mask. At first it is a mask of purity. The pillared mansion does not *become* a temple, it *uses* a temple, hides under the skirts of a temple. After 1830 the house becomes a letter, a banner, a flag, an ad. The man unking'd, therefore a palace

instead of a place. The gods are silent, their temple is a shell; use it as you wish.

"The great issue, about which hangs a true sublimity, and the terror of overhanging fate, is what are you going to do with all these things?" says Thomas Henry Huxley. "To what end, pray, is so much stone hammered?" asks Thoreau. World without end takes on a new meaning in the modern time: to what purpose? The invisible hand replaces the gods. Greed yields abundance. Abundance of what? But even if Huxley and Thoreau are right, what can we do about it?

Does it all come to economics? Does the mechanistic mind come *from* commerce? Or is turning life into business just what you do in that particular mental mode? To get back the old way of seeing, do we need to return to a barter economy of subsistence farms? Easy for Thoreau to say! But for now we will have to scrounge our simplicity where we are, use the elements at hand — which are not necessarily meadows — which may be a drive on the freeway — which should not have been built.

A designer is a master of playing; master, most of all, of listening. There can be a moment of fear just as you let go, when first you become afraid of the modern silence. The silence is daunting, if you don't try to fill it up. But such a moment passes. The silence is unreal. It is the voices — of shadow and light and pattern — that are real.

In the sense of knowing my inborn patterns, I know much more than I have learned. In listening — visually — I listen with the force of that self-knowledge. That is the force I see expressed in the ancient awesome buildings.

Are the solemn temples, in which the Divinity was once visibly revealed among us, crumbling away? We can repair them, we can rebuild them. The wisdom, the heroic worth of our forefathers, which we have lost, we can recover. That admiration of old nobleness, which now so often shows itself as a faint *dilettanteism,* will one day become

a generous emulation, and man may again be all that he has been, and more than he has been.

But, ah, Carlyle, it has been a hundred and sixty years. You and Emerson saw fifty of those years, and you were not smiling at the end. It is only two lifetimes; there were people alive in 1990 who once knew those who trundled their hoops in 1830. I believe it is as simple as you say: "One bold stroke . . . and thou art delivered!" But can it happen?

One has wandered into a field of gigantic problems. Better to side-step, narrow the question, at least; observe; stick only to architecture. But the architectural problem is the American problem.

Isn't there some very good reason why we have done this, why we have made this sacrifice? Why did people acquiesce? It must have been the force of events — the wave of commerce and industry that knocked over everything in its path, leaving a few remnants of the former way bobbing on the surface. They did not know; it had never happened before.

There is the urge to rescue the situation, cobble together a theory. Stories and interpretations and explanations rush in to fill the imagined vacuum. But intuition says, play; there is no gain without pleasure. The difficulty is our incredulity that play could be the method and the end-goal.

What if there were no price to pay for going back to the old way of seeing? The American secret, then, would not be avarice or smallness but needless acquiescence to the loss of our intuitive selves. Mediocrity was never our truth. Betrayal of our spirit was our secret. The goals of democracy became balance of power, equality, fairness, self-esteem . . . but esteem of *what* self? The bigger problem was not greed or inequality but inaccuracy. Loss of self? No such thing: "The doors of the temple stand open, night and day, before every man." It was loss of *belief*.

Our self-sacrifice is not generosity but submission. But our history provides an alternative model: that society exists not at the expense of self but to secure self. The architecture of such a society, what Wright calls the architecture of democracy, is "simply the human spirit given appropriate architectural form."

Does it have to be hard? Will a new paradigm of inspiration require individual struggle and social upheaval? Do all the reasons we have strip malls have to disappear before beautiful buildings can become the norm? I am not sure. I hope not. At the end of a Roman drama, as everything seemed to be turning into disaster and disorder, it was common for a god to be lowered from the sky to put things right. We say *deus ex machina* to mean a cheap solution. But I think it may have been entirely reasonable for the gods to show up and set things right. The *deus ex machina* means not every solution is complex but not every problem is within our conscious power to solve. When you make the shift to intuitive design, you get a *deus ex machina;* you get immediate gratification. Suddenly, what had seemed arid and uninspired becomes not necessarily "great" but rich with possibility. The change is not shocking, not unpleasant; you could say it feels like a gift.

Our architecture appears to be a failing in ourselves. The smashed and thwarted and denatured patterns look like a sickness. It *is* a kind of affliction to be locked into a false belief that creates again and again something we hate. However, it need not take much for us to learn to use our personal resources very differently.

The grammar of shape is innately understood. Unlike speech, it is visible in plants and animals everywhere. The intuitive design process gives access to that knowledge. You do not work at design, you play at it.

The question becomes clearer: now that you know there was an old way of seeing, do you want it back? And if you want it back, what

needs to happen? Was there a good reason it was lost? Not necessarily. Was there a big reason? Not necessarily. I propose we apply to architecture a simple device: the shift of perception. Simplicity is what I suggest. We sidestep the problem. We change our point of view, and now we see what to do. Problem and solution is not the way this pattern works.

The shift to intuition takes a small act of faith, a moment of letting go, not a reorganization of the individual. It is a quick change, a transformation of perception, not of personality. We have thought we had no choice. Now we can see a new possibility.

"A correspondent revolution in things will attend the influx of the spirit," writes Emerson. Imagine the release of all that talent. Imagine how our towns and cities and houses would come alive. Wright imagines "buildings public, private, or industrial, a tall shaft or a streak of light . . . enmeshed in metal strands and glass as music is made of notes." Music it will certainly be.

Must society change? To recapture the old way of seeing will be a great change. The implications are big because buildings are big. Of course, you can have the old way of seeing at any moment. And, knowing what it is, can you go back to your modern habit? Once you have heard the voices, that are all around, why wait, why sacrifice?

"Shall we continue to destroy?" asks Louis Sullivan. "What is our *Choice? . . .* What shall *our* dream be?" In the flat world of the new way of seeing, there is no answer.

I do answer, says intuition. We have to make a choice. We have only to make a choice. Choose me. What is inevitable is ME.

The rug is blue. The floor is brown. A plane is humming outside. This is where I start . . .

NOTES

page

 1. *Light and Shade, Walls and Space*

9 "For although ... without thinking." James Agee, Introduction to Helen Levitt, *A Way of Seeing* (1946; reprint, New York: Horizon Press, 1981), p. xv.

 2. *Ordinary Places*

14 "Never was there ... brick meeting house." Emily D. Wright, *First Church Jaffrey 1780–1980* (First Church Jaffrey Congregational, 1980), p. 10.

20 "For the first time ... meaningless places." Eugene Victor Walter, *Place-ways: A Theory of the Human Environment* (Chapel Hill: University of North Carolina Press, 1988), p. 2.

 3. *1830: The Loss of the Old Way of Seeing*

28 "The two great truths ... Grecian architecture." Nicholas Biddle, quoted in Wayne Andrews, *Architecture, Ambition and Americans* (New York: Free Press, 1964), p. 140.

30 "The uses of Geometry . . . utmost extent." Peter Nicholson, *The Carpenter's New Guide* (London, 1793).

"If the builder . . . to complete his design." Chester Hills, *The Builder's Guide* (Hartford, Conn., 1834).

32 "It is the Age of Machinery . . . understood at all." Thomas Carlyle, "Signs of the Times," in *Essays* (New York: Hurd and Houghton, 1867), vol. 2, p. 138.

"What we cannot read we cannot see." Lewis Mumford, *The Brown Decades* (New York: Harcourt, Brace and Company, 1931), p. 22.

"Might we not . . . present day?" Richard Upjohn, "The Colonial Architecture of New York and the New England States" (1869), quoted in Everard M. Upjohn, *Richard Upjohn, Architect and Churchman* (New York: Columbia University Press, 1939), p. 171.

"The children trundling . . . objects' chimnies." James Fenimore Cooper, quoted in Andrews, p. 105.

35 "Irate landlords . . . distressful methods." Moses King, *King's Handbook of New York City* (Boston: Moses King, 1893), p. 36.

36 "The old reliance . . . national imagination." John R. Stilgoe, *The Common Landscape of America 1580 to 1845* (New Haven: Yale University Press, 1982), pp. 101, 104.

"The source of beauty . . . fitness." Jean-Nicolas-Louis Durand, *Précis et Leçons d'Architecture* (1802–1805), quoted in Anthony Vidler, *Claude-Nicolas Ledoux* (Cambridge: MIT Press, 1990), p. 392.

"Architects should . . . nothing else." Jean-Nicolas-Louis Durand, quoted in John Fleming, Hugh Honour, and Nikolaus Pevsner, *The Penguin Dictionary of Architecture* (London: Penguin Books, 1980), p. 99.

"Architecture may be . . . of art." William Ware, *An Outline of a Course of Architectural Instruction* (Boston, 1866).

37 "The history of architecture is the history of the world." Augustus Welby Pugin, *Contrasts* (1835), quoted in Raymond Williams, *Culture and Society 1780–1950* (New York: Doubleday and Company, 1960), p. 141.

38 "A large number . . . less socially." Jack Larkin, *The Reshaping of Everyday Life 1790–1840* (New York: Harper and Row, 1988), p. 60.

"I now find . . . establishment." Amos Lawrence, quoted in Tamara Plakins Thornton, *Cultivating Gentlemen: The Meaning of Country Life among the Boston Elite 1785–1860* (New Haven: Yale University Press, 1989), p. 137.

39 "The nobles shall . . . eat them up as before." Ralph Waldo Emerson, *Historic Notes of Life and Letters in New England* (1876), quoted in *The American Transcendentalists,* ed. Perry Miller (New York: Doubleday/Anchor, 1957) p. 6.

Tocqueville and Emerson saw . . . expression of spirit. Tocqueville wrote, "When all the members of a community are independent of or indifferent to each other, the co-operation of each of them can be obtained only by paying for it: this infinitely multiplies the purposes to which wealth may be applied, and increases its value. . . . Amongst aristocratic nations, money reaches only to a few points on the vast circle of man's desires: in democracies, it seems to lead to all." Alexis de Tocqueville, *Democracy in America* (vol. 1, 1835; vol. 2, 1840; reprint, Cambridge, Mass.: Sever and Francis, 1863), vol. 2, p. 179.

" 'T is the day . . . the man unking." Ralph Waldo Emerson, "Ode," *The Complete Essays and Other Writings of Ralph Waldo Emerson* (New York: Random House, 1940), p. 769.

Tocqueville argued . . . was inevitable. Tocqueville wrote, "It is impossible, after even the most strenuous exertions to raise the intelligence of the people above a certain level." Tocqueville, vol. 1, p. 254.

40 "The fears of Jefferson . . . adjustment." Arthur Schlesinger, *The Age of Jackson* (New York: Mentor Books, 1949), pp. 128–29. Of the rise of corporate power Schlesinger writes (p. 130):

> From the start of the century, first in banking and insurance, then in transportation, canals, bridges, turnpikes, then in manufacturing, the corporation was gradually becoming the dominant form of economic organization. The generation of Jackson was the first to face large-scale adjustment to this new economic mechanism. For owners and large investors, the adjustment presented no particular problem. But those on the outside had a feeling of deep misgiving which was less an economic or political than a moral protest: it was basically a sense of shock. . . .
>
> The history of government intervention is thus a history of the growing ineffectiveness of private conscience as a means of social control. With private conscience powerless, the only alternative to tyranny or anarchy was the growth of the public conscience, and the natural expression of the public conscience was the democratic government.
>
> In spite of Jeffersonian inhibitions, then, the Jacksonians were forced to intervene in the affairs of business. Their ultimate aim was

to safeguard the equitable distribution of property which they felt alone could sustain democracy, but this effort inevitably required a battle against the concentration of wealth and power in a single class.

The fate of the Jacksonian economic legislation was that common historical irony: it on the whole promoted the very ends it was intended to defeat. The general laws sprinkled holy water on corporations, cleansing them of the legal status of monopoly and sending them forth as the benevolent agencies of free competition.

"Wealth has more . . . rich and the poor." Thomas Carlyle, quoted in Williams, p. 78.

"[By the 1830s] it had already . . . grown immeasurably." Betsy Blackmar, "Rewalking the 'Walking City': Housing and Property Relations in New York City, 1780–1840." In *Material Life in America 1600–1860*, ed. Robert Blair Saint George (Boston: Northeastern University Press, 1988), pp. 379–82.

41 "gave architectural form . . . countryside." Larkin, p. 120. Larkin's book is a trove of contemporary images of change. Here is one: " 'What magic it seemed to me,' recalled Lucy Larcom, 'when I was first allowed to strike that wonderful spark, and light the kitchen fire.' And when Susan Blunt's mother, a village blacksmith's wife, got a stove in 1828, 'we children missed the bright fire in the evenings with the big back log and fore stick and pine knots between; it made our great kitchen look very bright and cheerful.' " Larkin, p. 141.

Perhaps their denial . . . power. The social historian Karen Halttunen comments on the American denial of stratification: "Despite widespread signs of growing stratification in Jacksonian society, despite the reality of severe limitations on upward social mobility, there were few expressions of class-consciousness in antebellum America: in stark contrast to Old World society, Americans believed, theirs was a uniquely open social system." Karen Halttunen, *Confidence Men and Painted Ladies: A Study of Middle-Class Culture in America, 1830–1870* (New Haven: Yale University Press, 1982), p. 195.

And the historian Gordon Wood notes, " 'The market house, like the grave, is a place of perfect equality,' said Philip Freneau in bitter derision. But he was right. All this commercial activity did promote equality, yet not, of course, equality of wealth. Quite the contrary: wealth was far more unequally distributed in the decades following the Revo-

lution than it had been before. Nonetheless, early-nineteenth-century Americans felt more equal, and for many of them that was what mattered." Gordon S. Wood, *The Radicalism of the American Revolution* (New York: Alfred A. Knopf, 1992), p. 340.

"more humor . . . plodding age." Horace Greeley, quoted in Larkin, p. 259.

42 "The usual working hours . . . vicious amusements." Stilgoe, p. 331.

The factory was the change . . . workplaces. In *The Coming of Industrial Order: Town and Rural Life in Rural Massachusetts, 1810–1860* (Cambridge: Cambridge University Press, 1983), pp. 15, 57, 10, the historian Jonathan Prude presents a case history of the transformation as it affected two New England towns. He notes the changed meaning of time and money:

> By the 1790s, local storekeepers accepted as "payments" labor by the day. . . . By the early 1800s they accepted "payments" of a third or even a quarter of a day's work time; and by 1810 both Dudley and Oxford were paying for some road work by the hour. . . .
>
> Linked as they were to extra-local customers and the sweep of impersonal regional market pressures, textile mills in Dudley and Oxford were significantly insulated — detached — from the influence and logic of community custom. As a result, these institutions — and the proprietors most directly concerned in their management — were free to stress profits. . . . But profit, although scarcely unknown among colonial and postrevolutionary Yankees, was not the polestar most Dudley and Oxford residents were accustomed to follow.

America was still . . . increase during 1820s. Population sources: United States Department of Commerce, *Historical Statistics of the United States,* pp. 8, 106; and *A Century of Population Growth* (Baltimore: Genealogical Publishing Company, 1989), pp. 14, 15.

New words . . . "normal." All dates are from *Oxford Universal Dictionary on Historical Principles,* ed. William Little and C. T. Onions (Oxford: Clarendon Press, 1955).

"The key to the period . . . aware of itself." Emerson, *Historic Notes,* quoted in Miller, p. 5.

43 Lewis Mumford . . . out of business. Lewis Mumford, *Technics and Civilization* (New York: Harcourt, Brace and Company, 1934), pp. 212–14.

In 1832, Babbage's automatic calculator was built. Doron D. Swade, "Redeeming Charles Babbage's Mechanical Computer," *Scientific American,* February 1993, pp. 87–88.

"The idea produced . . . past and over." Helmut and Alison Gernsheim, *L. J. M. Daguerre, 1787–1851*: *The World's First Photographer* (New York: World Publishing Company, 1956), p. 16.

"The camera-eye . . . self-exposure." Mumford, *Technics,* pp. 243–44.

"The age of arithmetic and of criticism has set in." Emerson, *Historic Notes,* quoted in Miller, p. 6.

"We see nothing . . . mode of *viewing* Nature." Carlyle, p. 160.

44 "I was myself . . . who I am!" Rip Van Winkle is a powerful evocation of the changed consciousness: "His mind now misgave him; he began to doubt whether both he and the world around him were not bewitched. Surely this was his native village, which he had left but the day before. . . . The very character of the people seemed changed. There was a busy, bustling, disputatious tone about it, instead of the accustomed phlegm and drowsy tranquillity." Washington Irving, *Rip Van Winkle and Other Sketches* (1820; reprint, New York: Ginn and Company, 1923), pp. 17–19, 21.

"I happen to have lived . . . *modern* man." John Lowell, quoted in Thornton, p. 137.

"The question 'Who am I?' . . . bereavement." Halttunen, p. xv.

"One cannot both be sincere and seem so." André Gide, quoted in Lionel Trilling, *Sincerity and Authenticity* (Cambridge: Harvard University Press, 1972), p 70.

4. *The Principles of Pattern*

45 "Nature . . . contains all styles." Auguste Rodin, quoted in Theodore Andrea Cook, *The Curves of Life* (1914; reprint, New York: Dover Publications, 1979), frontispiece.

59 "If they exist . . . natural law." John Michell, *The Dimensions of Paradise* (San Francisco: Harper and Row, 1988), p. 119.

66 "Le Corbusier forbade . . . liturgical way." Author's interview with Jerzy Soltan, 1976.

67 "Current arbitrary decoration . . . adorning the living room." Richard Neutra, *Survival Through Design* (1954; reprint, London: Oxford University Press, 1969), pp. 102, 104.

A building . . . like a tree. Wright, *Autobiography,* p. 147.
But as Frank Lloyd Wright said . . . like a tree. Wright wrote, "I now propose an ideal for the architecture of the machine age, for the ideal American building. Let it grow up in that image. The tree.

 "But I do not mean to suggest the imitation of the tree." Frank Lloyd Wright, *An Autobiography* (New York: Duell, Sloan and Pearce, 1943), p. 147.
68 "Oh no! . . . a tree!" Leonard Gershe, screenplay for *Funny Face* (Paramount Pictures, 1957).

5. *Spirit*

76 "These walls . . . primary ideas." Claude-Nicolas Ledoux, quoted in Vidler, *Ledoux,* p. 73.
82 "the basic form of the living," Wilhelm Reich, *Selected Writings* (New York: Noonday Press, 1961), pp. 327–28.
 "You have seen . . . this shape." Albert Libchaber, in James Gleick, *Chaos: Making a New Science* (New York: Viking Press, 1990), p. 195.
83 D'Arcy Thompson's . . . the same form. D'Arcy Wentworth Thompson, *On Growth and Form* (Cambridge: Cambridge University Press, 1971), pp. 89–92.
84 "Remember the seed-germ." Louis Sullivan, *A System of Architectural Ornament, According with a Philosophy of Man's Powers* (New York: Eakins Press, 1967), plate 5.
87 "I never stoop'd . . . I cannot misse." John Donne, in *The Poems of John Donne,* ed. H. J. C. Grierson (Oxford: Oxford University Press, 1933), p. 59.
89 "Unreal City." T. S. Eliot, *The Waste Land and Other Poems* (New York: Harcourt, Brace and World, 1934), pp. 31, 37, 44.
 "Tennyson and Browning . . . his sensibility." T. S. Eliot, "The Metaphysical Poets" (1921), in *Selected Essays of T. S. Eliot* (New York: Harcourt, Brace and World, 1964), p. 247.
90 "Little is to be . . . than the light." Henry David Thoreau, *Walden* (1854; reprint, Boston: Houghton Mifflin Company, 1960), p. 61.
91 "At the edge . . . darkness existed." Junichiro Tanizaki, *In Praise of Shadows* (1933), trans. Thomas J. Harper and Edward G. Seidensticker (New Haven: Leete's Island Books, 1977), p. 34.
101 "In such times . . . of doubt." Louis H. Sullivan, "The Tall Office Build-

ing Artistically Considered," *Lippincott's* (March 1896), reprinted in *Kindergarten Chats and Other Writings*, ed. Isabella Athey (1947; reprint, New York: Dover Publications, 1979), p. 215.

106 "New York rose . . . caged it with." Djuna Barnes, "The Hem of Manhattan," in *New York* (1917; reprint, Los Angeles: Sun and Moon Press, 1989), p. 289.

There may be a limit . . . corporate power. Henry James wrote in 1907, "One story is good only till another is told, and sky-scrapers are the last word of economic ingenuity only till another word be written. This shall be possibly a word of still uglier meaning, but the vocabulary of thrift at any price shows boundless resources, and the consciousness of that truth, the consciousness of the finite, the menaced, the essentially *invented* state, twinkles ever, to my perception, in the thousand glassy eyes of these giants of the mere market." Henry James, *The American Scene* (New York: Harper and Brothers, 1907), p. 75.

6. Context

110 "To come and go . . . never wholly fades." Henry James, *The American Scene* (New York: Harper and Brothers, 1907), p. 86.

114 "The job is not to 'plan' but to *reveal*." Benton MacKaye, quoted in Tony Hiss, *The Experience of Place* (New York: Alfred A. Knopf, 1990), p. 205.

116 "We have taken on . . . subnormal designers." Andres Duany, quoted in Andrea Oppenheimer Dean, "Their Town," *Historic Preservation* (May/June 1992), p. 61.

123 "It is a building . . . draws me to it." Juror quoted in John Morris Dixon, ed., "Thirty-seventh Annual *Progressive Architecture* Design Awards," *Progressive Architecture* (January 1990), p. 104.

7. The Life and Death of Modernism

128 "Since my early youth . . . beauty of old, preindustrial towns." Walter Gropius, *Scope of Total Architecture* (New York: Harper and Row, 1955), p. xiii.

"A 'Bauhaus Style . . . an 'International Style.'" Gropius, p. 8.

129 "There is no . . . living value." Gropius, p. 179.

130 "The house is . . . pure spirit." "Houses — Architect and Client," *Architectural Forum* (October 1951), pp. 156–62.

"The art . . . chosen few." Le Corbusier, *Towards a New Architecture* (1923; reprint, London: Architectural Press, 1946), p. 96.

135 "Every so often . . . visible again." Gropius, p. xvii.
"I believe . . . key to release it." Gropius, p. 38.

136 "In the sixties a certain confusion . . . superficialities of all kinds." Siegfried Giedion, *Space, Time and Architecture* (Cambridge: Harvard University Press, 1967), p. xxxii.

137 "The Flamingo sign . . . towards a new architecture." Robert Venturi, Denise Scott Brown, and Steven Izenour, *Learning from Las Vegas: The Forgotten Symbolism of Architectural Form* (Cambridge: MIT Press, 1972), p. 161.
"The contemporary movement . . . within all of us." Giedion, *Space*, p. xxxiii.
"Architects can no longer . . . orthodox Modern architecture." Robert Venturi, *Complexity and Contradiction in Architecture* (New York: Museum of Modern Art, 1966), p. 16.
"To become . . . nineteenth century." Giedion, *Space*, p. li.

138 "It is now time . . . decoration of construction." Venturi, *Las Vegas*, p. 163.
"the dissolution . . . our judgment." John Ruskin, The Seven Lamps of Architecture (1848; reprint, New York: Dover Publications, 1989), p. 3.
"But there is a chance . . . use it universally." Ruskin, p. 206.
"The forms of architecture . . . than any of us." Ruskin, p. 205.
"There is no such thing as liberty." Ruskin, p. 199.

139 "freed from the agitation . . . fenceless plain." Ruskin, pp. 208–9.

140 "Finally we shall argue . . . shelter with symbols on it." Venturi, *Las Vegas*, p. 90.
"Amiens Cathedral . . . building behind it." Venturi, *Las Vegas*, p. 105.

141 "Architects should accept their modest role." Venturi, *Complexity and Contradiction*, p. 44.
"a true concern . . . scale of values." Venturi, *Complexity and Contradiction*, p. 44.
"In Rome . . . the Strip." Venturi, *Las Vegas*, p. 18.
"decoration is cheaper." Venturi, *Las Vegas*, p. 131.
"Why do we uphold . . . through pure architecture." Venturi, *Las Vegas*, p. 130.
"Articulated architecture . . . scale and detail." Venturi, *Las Vegas*, p. 139.

142 "Driving . . . alternative state doesn't occur." Betty Edwards, *Drawing on the Right Side of the Brain* (Los Angeles: J. P. Tarcher, 1979), p. 5.

"Good architecture . . . life itself." Gropius, p. 4.

143 "organic forces." Siegfried Giedion, *Mechanization Takes Command* (New York: Oxford University Press, 1948), p. 6.

144 "I like boring things," Andy Warhol, quoted in Venturi, *Las Vegas*, p. 87.

"Indeed, is not the commercial strip of Route 66 almost all right?" Venturi, *Complexity*, p. 104.

147 "The question . . . buried depths." Giedion, *Space*, p. x.

"A city . . . lead a centered life." Richard Sennett, *The Conscience of the Eye: The Design and Social Life of Cities* (New York: Alfred A. Knopf, 1990), p. xiii.

8. *Paradigms*

148 "You're looking . . . than ever." Edwin Justis Mayer, Waldemar Young, and Samuel Hoffenstein, screenplay for *Desire* (Paramount Pictures, 1936).

"One world was ending . . . its expression in clothes." Coco Chanel, quoted in Jean Leymarie, *Chanel* (New York: Rizzoli, 1987), p. 57.

152 "Victorian architecture . . . symbolism." Jonathan Hale, "Proportion: Building in Touch with Natural Laws," *New Age Magazine* (April 1978), p. 59.

153 "Drawing is not . . . *way of seeing*." Edwards, *Right Side*, p. 4.

156 "The trained drawer . . . which he would express." C. F. Ayer, quoted in E. H. Gombrich, *Art and Illusion* (New York: Pantheon Books, 1960), p. 189.

"Quickly we stick labels . . . taste the wine." Frederick Franck, *The Zen of Seeing* (New York: Vintage Books, 1973), p. 4.

In *On Photography* . . . enhance their subjects. Susan Sontag, *On Photography* (New York: Farrar, Straus, and Giroux, 1977), pp. 78, 121. She also compares damaged photographs to ruins: "Photographs, when they get scrofulous, tarnished, stained, cracked, faded still look good; do often look better. (In this, as in other ways, the art that photography does resemble is architecture, whose works are subject to the same inexorable promotion through the passage of time; many buildings, and not only the Parthenon, probably look better as ruins.)" Sontag, p. 79.

159 "Thinking should be . . . a photograph." Henri Cartier-Bresson, quoted in Sontag, p. 116.

"You do play-by-play . . . you break down." Red Barber on WEVO radio, April 2, 1990.

"The main theme to emerge . . . nonverbal form of intellect." Roger W. Sperry, "Lateral Specialization of Cerebral Function in the Surgically Separated Hemispheres," quoted in Edwards, *Right Side*, p. 29.

Even as far back . . . control speech. Anne Harrington, *Medicine, Mind, and the Double Brain* (Princeton: Princeton University Press, 1987), p. 45.

"That work provided me . . . to spatial, global processing." Edwards, *Right Side*, p. vii.

160 However, as Edwards . . . location for drawing ability. Edwards, *Right Side*, p. vii.

"It is the right hemisphere which controls the crucial powers . . . programs and schematics." Oliver Sacks, *The Man Who Mistook His Wife for a Hat, and Other Clinical Tales* (New York: Summit Books, Simon and Schuster, 1985), p. 2.

"All thinking is sorting, classifying," Gombrich, p. 301.

"In that different subjective state . . . free of anxiety." Edwards, *Right Side*, p. 4.

161 "Chardin's pitchers . . . being looked at?" Wylie Sypher, *Loss of the Self in Modern Literature and Art* (Westport, Conn.: Greenwood Press, 1962), p. 46.

"Notice that no parts . . . 'Noses are curved.' " Edwards, *Right Side*, p. 49.

"If care . . . of themselves," Edwards, *Right Side*, p. 99.

"Nothing is more real than nothing." Samuel Beckett, quoted in Edwards, *Right Side*, p. 99.

"voices of the gods." Julian Jaynes, *The Origins of Consciousness in the Breakdown of the Bicameral Mind* (Boston: Houghton Mifflin Company, 1976), pp. 75, 438.

162 "extraordinary superiority . . . searched for." Colwyn Trevarthan, "Split-Brain and the Mind," in *The Oxford Companion to the Mind*, ed. Richard L. Gregory (New York: Oxford University Press, 1987), p. 744.

"Just as we recognize . . . without even reading it." Thomas Blakeslee, *The Right Brain* (New York: Anchor Press/Doubleday, 1980), p. 145.

163 "When intuition has found food . . . creative vision." Gropius, p. 42.
"Endoceptual phenomena . . . basis for creativity." Klaus D. Hoppe,
"Psychoanalysis, Hemispheric Specialization, and Creativity," *Journal of
the American Academy of Psychoanalysis* 17 (Summer 1989), pp. 253–69.
"You cannot make . . . joyously engaged." Louis Kahn, quoted in John
Lobell, *Between Silence and Light: Spirit in the Architecture of Louis I.
Kahn* (Boston: Shambhala Publications, 1979), p. 6.

9. *Reason*

164 "This City now doth . . . a calm so deep!" William Wordsworth, "Com-
posed Upon Westminster Bridge, September 3, 1802," in *The College
Anthology of British and American Verse*, ed. A. Kent Hieatt and William
Park (Boston: Allyn and Bacon, 1964), p. 304.
165 "a change that lets us . . . serene and endless world." Tony Hiss, *The Ex-
perience of Place* (New York: Alfred A. Knopf, 1990), pp. 33–34.
"But what is this openness . . . in which it rests." Martin Heidegger, *Dis-
course on Thinking* (*Gelassenheit*, 1959), trans. John M. Anderson and E.
Hans Freund (New York: Harper and Row, 1966), p. 65.
"calculative thinking . . . essential nature." Heidegger, p. 56.
166 "The coming period . . . modes of feeling," Giedion, *Mechanization*,
p. v.
"You have to distinguish . . . fundamental principle of democracy."
Campbell, pp. 25, 29.
167 "Man only plays . . . when he plays." Friedrich von Schiller, *On the Aes-
thetic Education of Man,* quoted in Trilling, p. 121.
"There is one point . . . the centre shall hold." Trilling, pp. 92, 99.
"All the heavenly bodies . . . the natural System?" Benjamin Franklin,
quoted in Henry Steele Commager, *Jefferson, Nationalism, and the En-
lightenment* (New York: George Braziller, 1975), p. 83.
168 "Reason and free inquiry . . . of error only." Thomas Jefferson, *Notes on
Virginia,* quoted in Commager, p. 64.
"Humans grope . . . fundamental mystery exists." R. Buckminster
Fuller, *Intuition* (New York: Anchor Press/Doubleday, 1973), pp. 38–39.
169 The corner might be sliced off . . . path of the fairies. John Michell, *The
View over Atlantis* (London: Abacus, 1973), p. 97.
"What-is sprang . . . from What-is-not," Lao-tzu, *Tao Te Ching,* trans.
Victor H. Mair (New York: Bantam Books, 1990), p. 93.

"It is in the spaces . . . usefulness of the room lies." Lao-tzu (Mair), p. 70.

"The more the folk know . . . to govern them." Lao-tzu, *Tao Te Ching*, trans. Raymond B. Blakney (New York: Mentor Books, 1955), p. 118.

"I will not gloss . . . entirely lacking?" Walt Whitman, "Democratic Vistas," in *Leaves of Grass and Selected Prose* (New York: Modern Library, 1950), pp. 461, 463.

170 "The mighty Way declined . . . became the style." Lao-tzu (Blakney), p. 70.

171 "The magnetism . . . but one with them." Ralph Waldo Emerson, "Self-Reliance," in *Essays* (New York: P. F. Collier and Son, 1903), p. 74.

172 "Genius is . . . from within." Emerson, "Nature" (1849), in *Complete Essays*.

"The soul created . . . as near to us as to any." Emerson, "Self," in *Essays*, p. 84.

"Here is my theory . . . make-believe." Horatio Greenough, letter to Emerson, published posthumously in Emerson, "English Traits"(1856), in *Complete Essays*, p. 329.

"Let us encourage . . . philosophy." Horace Bender [Horatio Greenough], *The Travels, Observations, and Experience of Yankee Stonecutter* (New York: G. P. Putnam, 1852) and *Memorial of Horatio Greenough* (Putnam, 1853); excerpts reprinted as *Form and Function: Remarks on Art, Design, and Architecture*, edited by Harold A. Small (Berkeley: University of California Press, 1947), p. 57.

173 "The monuments of Egypt . . . in so doing." Greenough, p. 64.

"Nothing can bring you . . . principles." Emerson, "Self," in *Essays*, p. 88.

"Peace is when I accept life." D. H. Lawrence, "The Reality of Peace" (1917), in *Phoenix: The Posthumous Papers* (1936; reprint, New York: Viking Press, 1972), p. 674.

174 "All man-made things are worthy of life." Frank Lloyd Wright, *In the Cause of Architecture* (New York: Architectural Record, 1975), p. 132.

"form follows function." Sullivan, *Kindergarten Chats*, p. 208.

"Form and function are one." Wright, *Autobiography*, p. 146.

175 "To put anywhere . . . completion of the work." Whitman, *Leaves of Grass*, Preface.

"Power ceases . . .darting to an aim." Emerson, "Self," in *Essays*, p. 77.

"the moment . . . into other forms." Emerson, "Beauty," in *Complete Essays*, p. 313.

"Proceeding, then, . . . sometimes amazed." Wright, *Autobiography*, p. 147.

"In my work . . . element of continuity." Wright, *Autobiography*, p. 146.

176 "The pleasure . . . sublime with expression." Emerson, "Beauty," in *Complete Essays*, p. 313.

177 "I think [Unity Temple] . . . happened to be." Frank Lloyd Wright, *Frank Lloyd Wright on Record* (New York: Caedmon Records, 1957), side 1.

"our conception . . . relation to life." Gropius, p. 8.

178 "Wright's 'time, his day, his age' . . . by his will." Vincent Scully, *Frank Lloyd Wright* (New York: George Braziller, 1960), p. 11.

"Sunk without purpose . . . its own accord." Eugen Herrigel, *Zen in the Art of Archery* (London: Routledge and Kegan Paul, 1953), p. 62.

179 Scully speaks . . . quality of Wright's space. Scully, *Wright*, p. 18.

The Wright plan . . . touch the shore. Scully, *Wright*, p. 18.

"It will seem to us . . . most beautiful." Lawrence, p. 671.

180 "a separation . . . of the body." John Dewey, *Art as Experience* (1934; reprint, New York: Capricorn Books, G. P. Putnam's Sons, 1958), p. 21.

"Wright's Affleck House . . . preside at home." Dolores Hayden, *Redesigning the American Dream* (New York: W. W. Norton and Company, 1984), p. 104.

181 "I told Lloyd . . . who lives in it." Alexander Woollcott, letter to Frank Lloyd Wright, April 15, 1941, quoted in Wright, *Autobiography*, p. 499.

182 "Living in a house . . . my one education." Mrs. Kaufmann, quoted in Donald Hoffmann, *Frank Lloyd Wright's Fallingwater* (New York: Dover Publications, 1978), p. 92.

"Why, then, should we try . . . by machinery?" Frank Lloyd Wright, *The Living City* (1958; reprint, New York: Mentor Books, 1963), p. 91.

"Urban life . . . beauty of environment." Wright, *Living City*, p. 53.

"My father taught me . . . was built." Wright, *On Record*, side 1.

183 "organs do not compose . . . in the whole." Johann Wolfgang von Goethe, in Donald Leslie Johnson, *Frank Lloyd Wright versus America* (Cambridge: MIT Press, 1990), p. 67.

"Even the very word 'organic' . . . part of entity." Wright, *Autobiography*, p. 148.

184 "Now, the house is an idea." Wright, *On Record*, side 2.

185 "I think the plan . . . the thing!" Wright, *On Record*, side 2.

187 "This is the country . . . to be — yourself!" Wright, *On Record*, side 2.

188 "In architecture, plasticity . . . ancient thought." Wright, *Autobiography*, p. 146.

"See all the records . . . admire them lovingly." Wright, *Cause of Architecture*, p. 132.

189 "The space *within* . . . nature studies of Jesus." Wright, *Living City*, p 153.

"We are capable . . . 'at one.' " Wright, *Cause of Architecture*, p. 142.

190 "Architecture . . . men of genius." Mumford, *Brown Decades*, p. 173.

"We see ourselves . . . ought to talk about." Wright, *On Record*, side 2.

191 "I wish to build a city . . . yet everywhere." Wright, *Autobiography*, p. 560.

10. *Can It Happen?*

192 "Can we ring . . . burn the world?" Charles Lamb, letter to George Dyer, Dec. 20, 1830, in *Letters of Charles and Mary Lamb*, vol. 3., pp. 298–99, quoted in Paul Johnson, *The Birth of the Modern: World Society 1815–1830* (New York: HarperCollins, 1991), p. 1000.

193 Emerson calls it degradation. In "An Address" (1838) he said, "The absence of this primary faith [in intuition] is the presence of degradation. . . . The doctrine of inspiration is lost; the base doctrine of the majority of voices usurps the place of the doctrine of the soul. Miracles, prophecy, poetry, the ideal life, the holy life, exist as ancient history merely; they are not in the belief, nor in the aspiration of society; but, when suggested, seem ridiculous." Emerson, *Complete Essays*, p. 71.

194 "The great issue . . . all these things?" Thomas Henry Huxley, quoted in Daniel J. Boorstin, *The Republic of Technology* (New York: Harper and Row, 1978), p. 1.

"To what end, . . . stone hammered?" Thoreau, p. 39.

"Are the solemn temples . . . more than he has been." Carlyle, p. 160.

195 "One bold stroke . . . and thou art delivered!" Carlyle, p. 160.

But can it happen? As Lionel Trilling put it in 1971, "It is the common feeling that some inhuman force has possessed our ground and our air, our men and women and our thought, a machine more terrible than any that Emerson imagined." Trilling, p. 128.

"The doors of the temple ... before every man." Emerson, *Complete Essays,* p. 71.

196 "simply the human spirit ... architectural form." Wright, *Living City,* p. 28.

197 "A correspondent revolution ... influx of the spirit." Emerson, "Nature," in *Complete Essays,* p. 42.

"Buildings public, private ... made of notes." Wright, *Living City,* p. 114.

"Shall we continue ... What shall our dream be?" Sullivan, *Autobiography,* p. 272.

BIBLIOGRAPHY

Some guides to geometry in architecture and nature that I have found particularly useful are Ghyka, *The Geometry of Art and Life*; Doczi, *The Power of Limits*; Lawlor, *Sacred Geometry*; Le Corbusier, *The Modulor* and *Towards a New Architecture*; Michell, *The Dimensions of Paradise*; and Thompson, *On Growth and Form.*

Ackerman, James S. *Palladio.* London: Penguin Books, 1966.

Adams, Henry. *Mont-Saint-Michel and Chartres.* 1918. Reprint. New York: Gallery Books, 1985.

Adams, John Quincy. *The Diary of John Quincy Adams,* edited by Alan Nevins. New York: Frederick Ungar, 1951.

Alexander, Christopher, et al. *A Pattern Language,* New York: Oxford University Press, 1977.

Andrews, Wayne. *Architecture, Ambition and Americans.* New York: Free Press, 1964.

Arnheim, Rudolf. *Art and Visual Perception.* Berkeley: University of California Press, 1969.

———. *Entropy and Art.* Berkeley: University of California Press, 1969.

Berger, John. *Ways of Seeing.* Norwich, Eng.: Penguin Books, 1972.

Berman, Morris. *The Reenchantment of the World.* Ithaca: Cornell University Press, 1981.

Bicknell, A. J. *Bicknell's Victorian Buildings.* 1878. Reprint. New York: Dover Publications, 1979.

Blackmar, Betsy. "Rewalking the 'Walking City': Housing and Property Relations in New York City, 1780–1840." In *Material Life in America 1600–1860,* edited by Robert Blair Saint George. Boston: Northeastern University Press, 1988.

Blakeslee, Thomas R. *The Right Brain.* New York: Anchor Press/Doubleday, 1980.

Boorstin, Daniel J. *The Republic of Technology.* New York: Harper and Row, 1978.

Braudel, Fernand. *Civilization and Capitalism, 15th–18th Century.* New York: Harper and Row, 1979.

Bruce, Vicki. *Recognizing Faces.* London: Lawrence Erlbaum Associates, 1988.

Bush, Donald J. *The Streamlined Decade.* New York: George Braziller, 1975.

Campbell, Joseph, with Bill Moyers. *The Power of Myth,* edited by Betty Sue Flowers. New York: Doubleday, 1988.

Carlsson, I. "Lateralization of Defence Mechanisms Related to Creative Functioning." *Scandinavian Journal of Psychology* 31 (1990): 241–47.

Carlyle, Thomas. "Signs of the Times." In *Essays,* vol. 2. New York: Hurd and Houghton, 1867.

Chang, Amos Ih Tiao. *The Tao of Architecture.* Princeton: Princeton University Press, 1956.

Clark, Roger H., and Michael Pause. *Precedents in Architecture.* New York: Van Nostrand Reinhold, 1985.

Commager, Henry Steele. *Jefferson, Nationalism, and the Enlightenment.* New York: George Braziller, 1975.

Cook, Theodore Andrea. *The Curves of Life.* 1914. Reprint. New York: Dover Publications, 1979.

Coolidge, John. *Mill and Mansion, a Study of Architecture and Society in Lowell, Massachusetts, 1820–1865.* New York: Russell and Russell, 1942.

Cowen, Painton. *Rose Windows.* San Francisco: Chronicle Books, 1979.

Croney, John. *Anthropometrics for Designers.* New York: Van Nostrand Reinhold, 1971.

Dangerfield, George. *The Awakening of American Nationalism 1815–1828.* New York: Harper and Row, 1965.

Deetz, James. *In Small Things Forgotten: The Archeology of Early American Life.* New York: Anchor Books, 1977.

Dewey, John. *Art as Experience*. 1934. Reprint. New York: Capricorn Books, G. P. Putnam's Sons, 1958.

———. *Freedom and Culture*. New York: G. P. Putnam's Sons, 1939.

Dimond, Stuart J., Linda Farrington, and Peter Johnson. "Differing Emotional Response from Right and Left Hemispheres." *Nature* 261 (June 24, 1976): 690–92.

Doczi, György. *The Power of Limits*. Boston: Shambhala Publications, 1985.

Donne, John. *The Poems of John Donne*, edited by H. J. C. Grierson. Oxford: Oxford University Press, 1933.

Drescher, Seymour. *Dilemmas of Democracy: Tocqueville and Modernization*. Pittsburgh: University of Pittsburgh Press, 1968.

Drexler, Arthur. *The Drawings of Frank Lloyd Wright*. New York: Horizon Press, 1962.

Duby, Georges. *The Age of the Cathedrals*. Chicago: University of Chicago Press, 1981.

Dutton, Ralph. *The Victorian Home*. London: B. T. Batsford, 1954.

Edwards, Betty. *Drawing on the Right Side of the Brain*. Los Angeles: J. P. Tarcher, 1979.

———. *Drawing on the Artist Within*. New York: Simon and Schuster, 1987.

Eliot, T. S. "The Metaphysical Poets" (1921). In *Selected Essays of T. S. Eliot*. New York, Harcourt, Brace and World, 1964.

———. *The Waste Land and Other Poems*. New York: Harcourt, Brace and World, 1934.

Emerson, Ralph Waldo. *Essays*. New York: P. F. Collier and Son, 1903.

———. *The Complete Essays and Other Writings of Ralph Waldo Emerson*. New York: Random House, 1940.

———. "Historic Notes of Life and Letters in New England." In *The American Transcendentalists*, edited by Perry Miller. New York: Doubleday/Anchor, 1957.

Fehrenbacher, Don E. *The Era of Expansion, 1800–1848*. New York: John Wiley and Sons, 1969.

Fleming, John, Hugh Honour, and Nikolaus Pevsner. *The Penguin Dictionary of Architecture*. London: Penguin Books, 1980.

Forman, Henry Chandlee. *The Architecture of the Old South: The Medieval Style 1585–1850*. Cambridge: Harvard University Press, 1948.

Franck, Frederick. *The Zen of Seeing*. New York: Vintage Books, 1973.

Franco, Laura, and Roger W. Sperry. "Hemisphere Lateralization for Cognitive Processing of Geometry." *Neuropsychologia* 15 (1977): 107–14.

Freud, Sigmund. *Civilization and Its Discontents.* 1930. Reprint. New York: W. W. Norton, 1961.

Fuller, R. Buckminster. *Utopia or Oblivion.* New York: Bantam Books, 1969.

———. *Intuition.* New York: Anchor Press/Doubleday, 1973.

Galbraith, John Kenneth. *The New Industrial State.* Boston: Houghton Mifflin, 1971.

Gardner, Howard. *Art, Mind, and Brain.* New York: Basic Books, 1982.

Garvan, Anthony N. B. *Architecture and Town Planning in Colonial Connecticut.* New Haven: Yale University Press, 1951.

George, Henry. *Progress and Poverty.* 1897. Reprint. New York: Robert Schalkenbach Foundation, 1937.

Gernsheim, Helmut, and Alison Gernsheim. *L. J. M. Daguerre (1787–1851): The World's First Photographer.* New York: World, 1956.

Ghyka, Matila. *The Geometry of Art and Life.* 1946. Reprint. New York: Dover Publications, 1977.

Giedion, Siegfried. *Mechanization Takes Command.* New York: Oxford University Press, 1948.

———. *Space, Time and Architecture.* Cambridge: Harvard University Press, 1967.

Gill, Brendan. *Many Masks: A Life of Frank Lloyd Wright.* New York: G. P. Putnam's Sons, 1987.

Gleick, James. *Chaos: Making a New Science.* New York: Viking, 1990.

Gombrich, E. H. *Art and Illusion.* New York: Pantheon Books, 1960.

Gowans, Alan. *Images of American Living.* New York: Harper and Row, 1976.

Gregory, Richard L. *The Oxford Companion to the Mind.* New York: Oxford University Press, 1987.

Grillo, Paul Jacques. *Form, Function and Design.* 1960. Reprint. New York: Dover Publications, 1975.

Gropius, Walter. *Scope of Total Architecture.* New York: Harper and Row, 1955.

Gross, Yigal, Rachel Franko, and Isaac Lewin. "Effects of Voluntary Eye Movements on Hemispheric Activity and Choice of Cognitive Mode." *Neuropsychologia* 16 (1978): 653–57.

Gur, Raquel, and Ruben C. Gur. "Defense Mechanisms, Psychosomatic Symptoms and Conjugate Lateral Eye Movements." *Journal of Consulting and Clinical Psychology* 43 (1975): 416–20.

Gwilt, Joseph. *The Encyclopedia of Architecture.* 1867. Reprint. New York: Bonanza Books, 1982.

Halttunen, Karen. *Confidence Men and Painted Ladies: A Study of Middle-Class Culture in America, 1830–1870.* New Haven: Yale University Press, 1982.

Hamlin, Talbot. *Greek Revival Architecture in America.* New York: Oxford University Press, 1944.

Harrington, Anne. *Medicine, Mind, and the Double Brain.* Princeton: Princeton University Press, 1987.

Hayden, Dolores. *Redesigning the American Dream.* New York: W. W. Norton, 1984.

Heidegger, Martin. *Discourse on Thinking,* translated by John M. Anderson and E. Hans Freund. *(Gelassenheit,* 1959). New York: Harper and Row, 1966.

Herrigel, Eugen. *Zen in the Art of Archery.* London: Routledge and Kegan Paul, 1953.

Hills, Chester. *The Builder's Guide.* Hartford, 1834.

Hiss, Tony. *The Experience of Place.* New York: Alfred A. Knopf, 1990.

Hitchcock, Henry-Russell. *In The Nature of Materials: The Buildings of Frank Lloyd Wright — 1887–1941.* New York: Duell, Sloan and Pearce, 1942.

———. *The Architecture of H. H. Richardson and His Times.* Cambridge: MIT Press, 1966.

Hoffmann, Donald. *Frank Lloyd Wright's Fallingwater.* New York: Dover Publications, 1978.

Hofstatter, Hans H. *Living Architecture: Gothic.* New York: Grosset and Dunlap, 1971.

Hoppe, Klaus D. "Psychoanalysis, Hemispheric Specialization, and Creativity." *Journal of the American Academy of Psychoanalysis* 17 (Summer 1989): 153–69.

Huntley, H. E. *The Divine Proportion.* New York: Dover Publications, 1970.

Huxley, Aldous. *The Art of Seeing.* 1942. Reprint. Seattle: Montana Books, 1975.

Irving, Washington. *Rip Van Winkle and Other Sketches.* 1819. Reprint. Boston: Ginn, 1923.

Isaacs, Reginald. *Gropius.* Boston: Little, Brown, 1991.

James, Henry. *The American Scene.* New York: Harper and Brothers, 1907.

James, John. *Chartres: The Masons Who Built a Legend.* London, Routledge and Kegan Paul, 1985.

Jaynes, Julian. *The Origins of Consciousness in the Breakdown of the Bicameral Mind.* Boston: Houghton Mifflin, 1976.

Johnson, Donald Leslie. *Frank Lloyd Wright versus America.* Cambridge: MIT Press, 1990.

Johnson, Paul. *The Birth of the Modern: World Society 1815–1830.* New York: HarperCollins, 1991.

Kappraff, Jay. *Connections.* New York: McGraw-Hill, 1990.

Kennedy, Roger G. *Greek Revival America.* New York: Stewart, Tabori and Chang, 1989.

Kepes, Gyorgy. *Module, Proportion, Symmetry, Rhythm.* New York: George Braziller, 1966.

Kidder, Tracy. *House.* Boston: Houghton Mifflin, 1985.

King, Moses. *King's Handbook of New York City.* Boston: Moses King, 1893.

Krier, Rob. *Architectural Composition.* New York: Rizzoli, 1988.

Kuhn, Thomas S. *The Structure of Scientific Revolutions.* Chicago: University of Chicago Press, 1962.

Lancaster, Clay. *Nantucket in the Nineteenth Century.* New York: Dover Publications, 1979.

Lao-tzu. *Tao Te Ching,* translated by Victor H. Mair. New York: Bantam Books, 1990.

———. *Tao Te Ching,* translated by Raymond B. Blakney. New York: Mentor Books, 1955.

Larkin, Jack. *The Reshaping of Everyday Life 1790–1840.* New York: Harper and Row, 1988.

Laver, James. *Costume and Fashion: A Concise History.* New York: Oxford University Press, 1983.

Lawlor, Robert. *Sacred Geometry.* London: Thames and Hudson, 1982.

Lawrence, D. H. "The Reality of Peace" (1917). In *Phoenix: The Posthumous Papers.* 1936. Reprint. New York: Viking Press, 1972.

Le Corbusier. *The Modulor.* London: Faber and Faber, 1954.

———. *Modulor 2.* Cambridge: Harvard University Press, 1958.

———. *Towards a New Architecture.* 1923. Reprint. London: Architectural Press, 1946.

———. *When the Cathedrals Were White.* New York: McGraw-Hill, 1964.

Levitt, Helen. *A Way of Seeing.* Introduction by James Agee. 1946. Reprint. New York: Horizon Press, 1981.

Levy, Jerre. "Lateral Dominance and Aesthetic Preference." *Neuropsychologia* 14 (1976): 431–45.

Lobell, John. *Between Silence and Light: Spirit in the Architecture of Louis I. Kahn.* Boston: Shambhala, 1979.

Lowell, City of, Division of Planning and Development. *The Lowell Building Book.* Lowell, Mass., 1982.

Lynch, Kevin. *The Image of the City.* Cambridge: Technology Press and Harvard University Press, 1960.

———. *What Time Is This Place?* Cambridge: MIT Press, 1972.

Maddex, Diane. *Built in the U.S.A.* Washington, D.C.: Preservation Press, 1985.

Margolis, Howard. *Patterns, Thinking, and Cognition: A Theory of Judgment.* Chicago: University of Chicago Press, 1987.

Mark, Robert. *Light, Wind, and Structure.* Cambridge: MIT Press, 1990.

Marx, Leo. *The Machine in the Garden: Technology and the Pastoral Ideal in America.* London: Oxford University Press, 1964.

McCarter, Robert, ed. *Frank Lloyd Wright: A Primer on Architectural Principles.* New York: Princeton Architectural Press, 1991.

Michell, John. *The View over Atlantis.* London: Abacus, 1973.

———. *The Dimensions of Paradise.* San Francisco: Harper and Row, 1988.

Mumford, Lewis. *The Brown Decades.* New York: Harcourt, Brace, 1931.

———. *Technics and Civilization.* New York: Harcourt, Brace, 1934.

Muschamp, Herbert. *Man About Town: Frank Lloyd Wright in New York City.* Cambridge: MIT Press, 1983.

Neutra, Richard. *Survival Through Design.* 1954. Reprint. London: Oxford University Press, 1969.

Newcomb, Rexford. *Franciscan Mission Architecture of California.* 1916. Reprint. New York: Dover Publications, 1973.

Nicholson, Peter. *The Carpenter's New Guide.* London, 1793.

Peterson, John M., and Leonard M. Lansky. "Left-Handedness among Architects: Some Facts and Speculation." *Perceptual and Motor Skills* 38 (1974): 547–50.

Peterson, Merrill D. *The Jefferson Image in the American Mind.* New York: Oxford University Press, 1962.

Prude, Jonathan. *The Coming of Industrial Order: Town and Rural Life in Rural Massachusetts, 1810–1860.* Cambridge, England: Cambridge University Press, 1983.

Rapoport, Amos. *House Form and Culture.* Englewood Cliffs, N.J.: Prentice-Hall, 1969.

Riley, Terence. *The International Style: Exhibition 15 and The Museum of Modern Art.* New York: Rizzoli/Columbia Books of Architecture, 1992.

Ruskin, John. *The Seven Lamps of Architecture.* 1848. Reprint. New York, Dover Publications, 1989.

Russell, Peter. *The Global Brain.* Los Angeles: J. P. Tarcher, 1983.

Rybczynski, Witold. *The Most Beautiful House in the World.* New York: Viking, 1989.

————. *Home: A Short History of an Idea.* New York: Viking Penguin, 1986.

Sacks, Oliver. *The Man Who Mistook His Wife for a Hat, and Other Clinical Tales.* New York: Summit Books, Simon and Schuster, 1985.

Safdie, Moshe. *Form and Purpose.* Boston: Houghton Mifflin, 1982.

Saint George, Robert Blair, ed. *Material Life in America 1600–1860.* Boston: Northeastern University Press, 1988.

Schlesinger, Arthur M., Jr. *The Age of Jackson.* New York: New American Library, 1949.

Schmookler, Andrew Bard. *The Parable of the Tribes: The Problem of Power in Social Evolution.* Berkeley: University of California Press, 1984.

Schon, Donald A. *Technology and Change.* New York: Delacorte Press, 1967.

————. *The Reflective Practitioner.* New York: Basic Books, 1982.

Schwaller de Lubicz, R. A. *The Temple in Man.* Brookline, Mass.: Autumn Press, 1977.

Scully, Vincent. *Frank Lloyd Wright.* New York: George Braziller, 1960.

————. *The Architecture of the American Summer: The Flowering of the Shingle Style.* New York: Rizzoli, 1989.

Sennett, Richard. *The Conscience of the Eye: The Design and Social Life of Cities.* New York: Alfred A. Knopf, 1990.

Small, Harold A., ed. *Form and Function: Remarks on Art, Design, and Architecture.* Introduction by Erle Loran. Berkeley: University of California Press, 1947. (Includes excerpts from Horace Bender [Horatio Greenough], *The Travels, Observations, and Experience of Yankee Stonecutter* [New York: G. P. Putnam, 1852]; and *Memorial of Horatio Greenough* [Putnam, 1853]).

Sontag, Susan. *On Photography.* New York: Farrar, Straus, and Giroux, 1977.

Sperry, Roger. *Science and Moral Priority.* New York: Columbia University Press, 1983.

Springer, Sally P., and Georg Deutsch. *Left Brain, Right Brain.* New York, W. H. Freeman, 1989.

Stilgoe, John R. *The Common Landscape of America 1580 to 1845.* New Haven: Yale University Press, 1982.

Stoddard, Whitney S. *Art and Architecture in Medieval France.* New York: Harper and Row, 1972.

Storrer, William Allin. *Frank Lloyd Wright: A Complete Catalogue.* Cambridge: MIT Press, 1979.

Stroud, Dorothy. *The Architecture of Sir John Soane.* London: Studio Books, 1961.

Sullivan, Louis. *The Autobiography of an Idea.* 1924. Reprint. New York: Dover Publications, 1956.

———. *Kindergarten Chats and Other Writings* (1886–1924), edited by Isabella Athey. 1947. Reprint. New York: Dover Publications, 1979.

———. *A System of Architectural Ornament, According with a Philosophy of Man's Powers.* New York: Eakins Press, 1967.

Summerson, John. *The Classical Language of Architecture.* Cambridge: MIT Press, 1963.

Sypher, Wylie. *Loss of the Self in Modern Literature and Art.* Westport, Conn.: Greenwood Press, 1962.

Tanizaki, Junichiro. *In Praise of Shadows,* translated by Thomas J. Harper and Edward G. Seidensticker. New Haven: Leete's Island Books, 1977.

Temko, Allan. *Notre Dame of Paris.* New York: Viking Press, 1955.

Thompson, D'Arcy Wentworth. *On Growth and Form.* Cambridge: Cambridge University Press, 1971.

Thoreau, Henry David. *Walden.* 1854. Reprint. Boston: Houghton Mifflin, 1960.

Thornton, Tamara Plakins. *Cultivating Gentlemen: The Meaning of Country Life among the Boston Elite 1785–1860.* New Haven: Yale University Press, 1989.

Tocqueville, Alexis de. *Democracy in America,* vol. 1, 1835; vol. 2, 1840. Reprint. Cambridge, Mass.: Sever and Francis, 1863.

Tompkins, Peter. *Secrets of the Great Pyramid.* New York, Harper and Row, 1971.

Trilling, Lionel. *Sincerity and Authenticity.* Cambridge: Harvard University Press, 1972.

Tufte, Edward R. *The Visual Display of Quantitative Information.* Cheshire, Conn.: Graphics Press, 1983.

———. *Envisioning Information.* Cheshire, Conn.: Graphics Press, 1990.

Upjohn, Everard M. *Richard Upjohn, Architect and Churchman.* New York: Columbia University Press, 1939.

Upton, Dell, and John Michael Vlach, eds. *Common Places: Readings in American Vernacular Architecture.* Athens, Ga.: University of Georgia Press, 1986.

Venturi, Robert. *Complexity and Contradiction in Architecture*. New York: Museum of Modern Art, 1966.

Venturi, Robert, Denise Scott Brown, and Steven Izenour. *Learning from Las Vegas: The Forgotten Symbolism of Architectural Form*. Cambridge: MIT Press, 1972.

Vidler, Anthony. *Claude-Nicolas Ledoux*. Cambridge: MIT Press, 1990.

Walter, Eugene Victor. *Placeways: A Theory of the Human Environment*. Chapel Hill: University of North Carolina Press, 1988.

Ware, William R. *An Outline of a Course of Architectural Instruction*. Boston, 1866.

Weil, Simone. "Chance." In *Gravity and Grace*. New York: G. P. Putman's Sons, 1952.

Whitman, Walt. *Leaves of Grass and Selected Prose*. New York: Modern Library, 1950.

Whyte, William H. *City: Rediscovering the Center*. New York: Doubleday, 1988.

Williams, Raymond. *Culture and Society 1780–1950*. New York: Doubleday, 1960.

Wilson, Christopher. *The Gothic Cathedral: The Architecture of the Great Church 1130–1530*. London: Thames and Hudson, 1990.

Wittkower, Rudolf. *Architectural Principles in the Age of Humanism*. New York: W. W. Norton, 1971.

Wolfe, Tom. *From Bauhaus to Our House*. New York: Farrar, Straus and Giroux, 1981.

Wood, Gordon S. *The Radicalism of the American Revolution*. New York: Alfred A. Knopf, 1992.

Wright, Frank Lloyd. *An Autobiography*. New York: Duell, Sloan and Pearce, 1943.

———. *Frank Lloyd Wright on Record*. New York: Caedmon Records, 1957.

———. *In the Cause of Architecture*. New York: Architectural Record, 1975.

———. *The Living City*. 1958. Reprint. New York: Mentor Books, 1963.

———. *The Natural House*. New York: Bramhall House, 1954.

———. *Writings and Buildings*. New York: Meridian Books, 1965.

ACKNOWLEDGMENTS

This book was supported by grants from the Graham Foundation for Advanced Studies in the Fine Arts and the National Endowment for the Arts. I am very grateful for both of them.

Most of all I thank my wife, Roberta Reich, for her enthusiasm, friendship, and belief, as well as for her tireless reviewing and editing. I would like to thank several other members of my family: my son, Alexander Reich Hale, for his patience and his presence; my mother, Carol Hale, for her strong interest and help; my uncle, John Bick, for his contributions on automobile design; and, in memory, my father, Edward Hale, who was my first teacher of architecture, music, and writing.

It has been my great good fortune to work with Dick Todd, my editor at Houghton Mifflin, who certainly has a place up there with the angels of sanity. Also at Houghton Mifflin I have greatly appreciated Mindy Keskinen's help; thanks also to Peg Anderson, Bob Overholtzer, Mark Caleb, Julia Hanna, and Patti Peterson.

For their encouragement and support, I would like to thank Robert Neiley, Randolph Langenbach, Eduard Sekler, Dan Pinck, and Richard Bertman; and, in memory, Jeanne Davern and Walter Wagner. My thanks to Joseph Darby for his valuable legal and literary advice. Several people who

have been helpful at key moments have been Stephen Kliment, Elizabeth Manny, and, through the National Writers Union, Peter Desmond, Stephen Simurda, and Christine Ammer. The Panopticon photo laboratory made many excellent prints from my sometimes challenging negatives.

I would like to thank a number of historians, teachers, and researchers: Jack Larkin and Myron Stachiw at Sturbridge Village; Peter Spang at Deerfield; John Stilgoe and Ann Harrington at Harvard; Margaret Henderson Floyd at Tufts; Robert Gross at William and Mary; Hal Glickman and Betty Edwards at the Center for the Educational Applications of Brain Hemisphere Research of California State University.

My thanks to Edgar Tafel for his information on Wright and Sullivan; Emily Wright for her material on the Jaffrey Meeting House; Eugene Victor Walter for sharing his insights on the loss of the old way of seeing; and Riva Poor for teaching me firsthand about paradigms of the self.

Many libraries have been helpful in my research. The Watertown Free Public Library, and through it the Minuteman Library System, has been a major resource; particular thanks to Eloise Lyman. My thanks also to the libraries at the Boston Architectural Center and Harvard's Graduate School of Design and to Countway Library at Harvard Medical School, the Boston Athenaeum, and the Boston Public Library. And thanks to the public libraries of Belmont, Brewster, Concord, and Quincy, Massachusetts; Brattleboro and Craftsbury Common, Vermont; and the Library of Congress.

My thanks to the Society for the Preservation of New England Antiquities and its librarian, Lorna Condon; and to Bruce Blanchard, curator of Rocky Hill Meeting House; Virginia Stiller at the Old York, Maine, Historical Society; the Currier Gallery of Art; and the Boston Society of Architects.

ILLUSTRATION CREDITS

All illustrations are by Jonathan Hale except as noted below.

page

10 Courtesy Society for the Preservation of New England Antiquities

29 Courtesy Library of Congress

34 Courtesy Society for the Preservation of New England Antiquities

46, *bottom* From *Bicknell's Victorian Buildings,* Dover Publications, 1979

47 Photo by Paul Warchol

55 From *Franciscan Mission Architecture of California* by Rexford Newcomb, Dover Publications, 1916

56 Historic American Buildings Survey collection, Library of Congress

62, *bottom* From *The Geometry of Art and Life* by Matila Ghyka, Dover Publications, 1946, 1977

63 Drawing by Tad Mann from *Rose Windows* by Painton Cowen, Thames & Hudson, 1979, 1992

64 Bruce Alonzo Goff, Eugene Bavinger House, Bartlesville, Oklahoma, 1950: elevation showing bridge, gift of Shin'enKan, Inc. Courtesy Art Institute of Chicago; first-floor plan with paving pattern, gift of Shin'enKan, Inc. Courtesy Art Institute of Chicago

65 © 1994 Artists Rights Society, New York/SPADEM, Paris

68 Courtesy Photofest

69 From *Trees for Architecture* by Robert L. Zion, Reinhold, 1968

71 From *The Divine Proportion* by H. E. Huntley, Dover Publications, 1970

78 From *The Encyclopedia of Architecture* by Joseph Gwilt, Crown/Bonanza, 1867, 1982

79 From *Living Architecture: Gothic* by Hans H. Hofstatter, Grosset & Dunlap, 1971. Regulating lines added by the author

80 Drawing by Viollet-le-Duc. Courtesy Caisse Nationale des Monuments Historiques et des Sites, Paris. Regulating lines added by the author

82 From *The Power of Limits* by György Doczi, © 1981 by György Doczi. Reprinted by arrangement with Shambhala Publications, 300 Massachusetts Avenue, Boston, Massachusetts 02115

93 Historic American Buildings Survey collection, Library of Congress

95 Photograph by Eugene Atget. Courtesy Photothèque des Musées de la Ville de Paris

97 Courtesy Thomas Crane Public Library, Quincy, Massachusetts

99 © Kindra Clineff

115 © Alan Karchmer

118 Courtesy Historic American Buildings Survey collection, Library of Congress

119 From *American Architect and Building News*, Sept. 16, 1992. Courtesy Society for the Preservation of New England Antiquities

125 Photo © Tom Bonner 1990

133 Photo by David Bohl. Courtesy Society for the Preservation of New England Antiquities

139 Courtesy of the Harvard University Archives

150 From *The Streamlined Decade* by Donald Bush, George Braziller, 1975

184 Ezra Stoller © Esto

187 The Currier Gallery of Art: Bequest of Isador J. and Lucille Zimmerman

INDEX

Automobile, paradigm for, 149–52, *150*
Ayer, C. F., 156

Babbage, Charles, 43
Bach, Johann Sebastian, and Wright, 183
Bacon, Roger, 43
Bank building
 in Aurora, N.Y., 19, *19*
 Prescott Bank (Lowell, Mass.), 33, *34*
Bank War, 39–40
Barber, Red, 159
Barcelona Pavilion (Mies, 1929), 144
Barnes, Djuna, 106
Bartlesville, Okla., Price Tower in, 106
Bauhaus Style, 128–35
Bavinger House (Goff), *64*
Bayard Building (Sullivan), 100–101,
 102–3, 104, 106
Beaune, France, Hôtel-Dieu in, 77–78,
 79
Beauty
 as specialists' province, 7
 versus egalitarianism, 100
Beckett, Samuel, 161
Beethoven, Ludwig van, and Wright, 183
Bel Geddes, Norman, 148
Belmont, Mass., 20–25, *23*
 and Kentlands, 114
 Neo-Colonial houses in, 15, 16, *16, 17,*
 17–18, 21, 22, *50*
 1930s house in, *50*
 Stone House in, 15–18, *16*, 21, 24, 37,
 49, 57, 97, 142
Berlioz, Hector, 43
Bernstein, Leonard, 21
Biddle, Nicholas, 28, 29, 39–40
Blackmar, Betsy, 40
Blakeslee, Thomas, 162
Body, proportions of, 58
Boston, Mass.
 Federal Reserve Building in, 105

neighborhoods protected in, 109
 Suffolk University in, 111, 112
Brain, right side of, 153, 159–60, 162, 163
Breuer, Marcel, 132–33, 135, 141
Brewster, Mass., Winslow House in, *93*
"Broadacre City" (Wright), 182
Buehrig, Gordon, 151
Buffalo, N.Y., Guaranty Building, 84, *85*
Builder's Guide, The (Hills), 31
Bulfinch, Charles, 111
Burtch House, Quechee, Vt., *92–93*
Butler, Samuel, 184

Cabrini Green project, Chicago, 131
Calculating or calculative thinking, 38,
 165
Cambridge, Mass., house by Hale in, 53,
 54, 56–57
Campbell, Joseph, 166
Capitol, Rome, 152
Carlyle, Thomas, 32, 40, 43, 195
Carpenter's Guide, The (Nicholson), 30
Carpentry, 31
Cartier-Bresson, Henri, 159
Cathedrals, 81–82
 Gothic, 94–96, 106–8 (*see also* Gothic
 style)
 as skyscrapers, 106
 and Wright, 188
Chambered nautilus, *62*
Chanel, Coco, 148, *149*
Chapels
 at Ronchamp, France, 143, *143*
 Saint George's, Windsor, England, 77,
 78
Chardin, Jean-Baptiste, 161
Chartres Cathedral, 61, 107
 Golden Section spirals in, *63*
 imperfections of, 94
 and vesica piscis, 77
Chelsea, Vt., office building in, *51*

Cheyenne, Wyo., church in, *46*
Chicago
 Cabrini Green project in, 131
 Robie House in, 2, *56*, *57*
Chichen Itza, Yucatán, 117
Chrysler Building (Van Alen), 86
Church(es)
 in Cheyenne, Wyo., *46*
 in Jaffrey, N.H., 13–15, *14*
 medieval, 15
 Renaissance, 188
 of Saint-Severin, Paris, *95*
 of San Vitale, Ravenna, 188–89
 See also Cathedrals
Cities
 and Modernism, 131
 and Wright, 182
Classical idiom, and authority, 70
Classical tradition, 98
Code(s)
 design regulation through, 116
 for old way of seeing, 116–17
Coleman homestead, Nantucket, Mass.,
 118
Colonial style, 19
 and Kentlands, 115
 and Newburyport, 11
 and Shingle Style, 120
 See also Neo-Colonial houses or style
Commercialism, 8, 38–42, 194
 and equality, 204n
Commercial strip (strip mall), 98, 126,
 144, 196
Community(ies), 108
 and façade, 122
 in Kentlands, 114
Conch, *64*
Conscience, private vs. public, 100, 203n
Contextualism, 109–10
 and pattern, 112–13
 and planning, 114–17

and reconstructions, 111–12
and Zimmerman House, 184
Control
 and Belmont Centre houses, 21
 and Gropius vs. Wright, 177–78
 in new way of seeing, 193
Cooper, James Fenimore, 32
Cornell, Joseph, 24
Crane Library (Richardson), Quincy,
 Mass., 96, 97
Currier Gallery of Art, Manchester,
 N.H., 184

Daguerre, Louis-Jacques-Mandé, 43
Darkness, 90–91
DC-3 airplane, 151
Deadness, 100
Death, 100
 and Gothic cathedrals, 94
Decoration, 67–70
 by Sullivan, 176
Degas, Edgar, 91
Democracy, 39
 in Age of Jackson, 204n
 and commercialism, 39
 Enlightenment, 169
 goals of, 195
 Jeffersonian, 166, 170–71, 179
 and reason, 166
 restrictions on, 169–70
 Tocqueville on, 39, 193
 and Whitman, 169, 174–75
 and wisdom vs. power, 171
 Wright's architecture of, 174, 175, 179,
 181, 189, 191, 196
Design, 2–3
 change in meaning of (1820s), 26
 codes to regulate, 116
 self expressed in, 167
Dewey, John, 180
Dietrich, Marlene, 148

Diner, in Rutland, Vt., 98–99, *99*
Divine Proportion, 61. *See also* Golden
 Section
Donne, John, 87–88, 89, 161
Doric style, 6
Drawing on the Right Side of the Brain
 (Edwards), 153–63
Duany, Andres, 114, 116, 117, 178
Dulwich Picture Gallery (Soane),
 London, 144–45, *145*, 146
Durand, Jean-Nicolas-Louis, 36, 37

Edwards, Betty, 141–42, 153–55, 157,
 159–61, 163
Egalitarianism (social equality)
 and commercial activity, 204n–5n
 and dullness, 37
 and Gropius, 132
 and mediocrity, 193
 versus beauty, 100
Eliot, T. S., 89
Emerson, Ralph Waldo
 on architecture, 172, 176
 and commercialism, 39
 on 1820–1840 period, 42, 43
 on influx of spirit, 197
 and Intuition, 166, 172, 215n
 on normality, 193
 on power, 175
 and reason, 171–72, 173
 on self, 189–90, 190–91
 as unhappy observer, 195
 and Wright, 174, 189, 190
Enlightenment, 167
 American, 172
 democracy of, 169
 and Nature, 168
Eyebrow windows, 96

Façades, 121–23
 in Belmont, Mass., 16, 18, 22, 24

Factories, 41–42
Fairness, 180–81
 and Age of Jackson, 170
 as goal of democracy, 195
Fallingwater (Wright), Bear Run, Pa.,
 181–82
Farnsworth House (Mies), Ill., 130
Fast food restaurants, 99
Feininger, Lionel, 134
Fibonacci series, 61, 65
First Church, Congregational, Jaffrey,
 N.H., 13–15, *14, 50*
Form, 74
 and design as rare or special, 7
 and function, 172, 174
 and Gropius on human abilities,
 135
 and Post-Modernism, 140
 and sacred ratios, 75
 as social symbol (Hayden), 180
 space as element of (Wright), 189
 as visual pattern (Wright), 180
 See also Geometry of architecture;
 Pattern; Shape
Franck, Frederick, 156
Franklin, Ben, 167
Freedom
 and comfort vs. form, 75
 mediocrity as price of, 193
 and uncommonness, 190
French Revolution, 69
Fuller, Buckminster, 166, 168, 184
Function
 and form, 172, 174
 images attached to, 32
 of structure, 126
Functionalism, and Modernism, 131

Gable, and regulating lines, 45, 53, *54*, 81
Gaithersburg, Md., Kentlands in, 114–16,
 115, 117

Maple leaf, *72*
Marseilles, France, Le Corbusier apartment house in, 65–66
Massachusetts Institute of Technology, 36
Materials, Wright's vs. others' treatments of, 176–77
Mathematics, for Greeks, 74
Measure
 ancient canon of, 59–60, 86
 Modulor as system for, 66
Mechanization of thought, 37
Medieval church, 15. *See also* Gothic cathedrals
Memorial Hall (Ware), Harvard University, 36–37, *139*
Michelangelo, 2
Michell, John (author), 59
Midway Diner, Rutland, Vt., 98–99, *99*
Mies van der Rohe, Ludwig, 130, 131, 144
 and architectural education, 8
 death of, 140
 Farnsworth House by, 130
 on heroic gesture, 142
 Seagram Tower by, 106, 144
 success of, 135
 Tugendhat House of, 151
Mill, John Stuart, 37, 39
Mission San Gabriel, Calif., 49, 53, 55
Modernism, 7, 105, 130–31
 and Bayard Building, 101
 of chapel at Ronchamp, *143*
 and city planning, 131
 end of, 136–47
 and International Style, 130
 simplicity of, 130
 and symbol, 140, 141
 and Wright on cities, 182
Modulor, *65*, 65–66
Morse, Samuel, 43

Moss, Eric Owen, *125*
Mozart, Wolfgang Amadeus, on silence, 182
Mumford, Lewis, 32, 42–43, 100, 178, 190
Music, and architecture 58, 59, 183
Musical intervals, and Gothics, 73
Mystery
 and Gothic cathedrals, 94
 and old way of seeing, 37
 and rules of proportion, 73–74
Mysticism, 169, 170–71

Nantucket, Mass., Coleman homestead in, *118*
National Gallery of Art (England), Sainsbury Wing of, 144–45, *145*, 146
Nature
 in Belmont streetscape, 21
 and Enlightenment view of reason, 168
Nautilus, *62*
Neatness, 99–100
Neo-Classicism
 of eighteenth-century buildings, 115
 embellishment forms of, 70
Neo-Colonial houses or style, 19, 44
 in Belmont, Mass., 15, 16, *16*, *17*, 17–18, 21, 22, *50*
 and Golden Section, 56
 and Shingle Style, 120
 and symbols, 123
 and Victorians, 117
 See also Colonial style
Neo-Gothic style, 138
Neo-Nothing, 99, 117
Neutra, Richard, 67, 141
Newburyport, Mass., 2, 11–13, *12*
 buildings close together in, 114
 commercial building in, *46*
 commercial center of, *10*, 12

freedom and discipline in, 113
and Gothic cathedral, 107
Victorian house in, 35
New (modern) way of seeing, 40, 86,
 193, 197
New York City
 Bayard Building, 100–101, *102–3*, 104
 grid plan for, 35–36
 new buildings, 111
 old Broadway buildings, 100
 Seagram Tower, 106, 144
 skyscrapers, 105–6
 social divisions in, 40
Nicholson, Peter, 30, 31
Nonintuitive paradigm, 189
Normalcy, 21, 123
Nothing, the, 87–89, 161, 169, 177
Notre-Dame Cathedral, Paris, *80, 81,* 94,
 152

Oak Park, Ill., Unity Temple in, 175, 177
Office buildings
 in Chelsea, Vt., *51*
 in Los Angeles, *125*
 and spaces, 121–22
O'Herlihy, Lorcan, 47
O'Herlihy House, Malibu, Calif., *47,* 145
Old way of seeing, 166
 and Bauhaus/Gropius, 129
 as child's way, 165
 code for, 116–17
 and commercialism, 194
 and culture of agrarian age, 169
 efforts to recapture, 6–7, 44
 and harmony, 67–68
 loss of, 1, 26, 37–38, 193–94
 failure to explain, 6, 35
 hollowness from, 44
 and population growth, 42
 and Ruskin, 138
 and Modernism, 132, 136

in Newburyport, 13
 as openness to own experience, 123
 and pattern, 2, 6
 and professionalism, 32
 and proportion, 3
 regaining of, 192, 193, 195–97
 Wright's architecture as, 189
Ordinary places, 5
 Aurora, N.Y., *19,* 19–20, *20*
 Belmont Centre, Mass., 20–25, *23*
 Jaffrey, N.H., 13–15, *14*
 Newburyport, Mass., *10,* 11–13, *12*
 Stone House, Belmont, Mass., 15–18,
 16, 21, 24, 49, 49, 57, 97, 142
Organic architecture (Wright), 183
Orgonome, 82–83
Ornament, 68–70. *See also* Decoration

Paine, Thomas, 168
Palazzo Tarugi, 137, 142
Paradigm(s), 148–49
 for automobile, 149–52, *150*
 for building, 9, 35
 for democracy, 171
 of drawing and subject, 153–58, *154,
 155*
 of self, 167, 192
Paris
 Church of Saint-Severin, *95*
 Notre-Dame Cathedral, *80, 81,* 94, 152
Parthenon, 61, 98
Pattern(s), 2, 3, 9, 25, 26, 47
 and Aurora bank versus post office,
 19, *19,* 20, *20*
 in Belmont Neo-Colonials, 22
 and changed way of seeing, 33
 and contextualism, 110, 112–13, 117
 Golden Section, 56, 61–65 (*see also*
 Golden Section)
 and harmony, 67–68
 human, 24